ROBERT WIGHT AND THE
BOTANICAL DRAWINGS OF RUNGIAH & GOVINDOO
BOOK 3

MAP OF INDIA
illustrating the localities in the
PLANTÆ ASIATICÆ RARIORES
and in the Lithographic Catalogue of the Company's
Herbarium in the Museum of the Linnean Society.
Dedicated to the Honble Court of Directors
of the United East India Company,
by their most grateful Servant,
N. Wallich
London, Augt 1832.

Robert Wight and the
Botanical Drawings of Rungiah & Govindoo

BOOK 3

JOURNEYS IN SEARCH OF ROBERT WIGHT

H. J. NOLTIE

Royal Botanic Garden Edinburgh

MMVII

First published 2007
by the Royal Botanic Garden Edinburgh
© all rights reserved

ISBN 978 1 906129 01 9

Designed and typeset in Verdigris by Dalrymple
Printed in Belgium by Die Keure

Frontispiece: Map of Peninsular India from
Wallich's *Plantae Asiaticae Rariores*.
Wight's Journey of 1826–7 is
shown in red.

A walk around Edinburgh

The concluding volume of this Wight trilogy, describing a series of journeys in search of Robert Wight in the 'cabinet' and in the 'field', is highly personal, and I should perhaps start with an attempt to justify its inclusion. Living in Edinburgh and, especially, working at the Royal Botanic Garden I feel privileged to find myself in many respects an inheritor of Wight's tradition, and one that is still very much alive. With interests in taxonomy and the arts, and the advantages of modern travel, I have felt driven to make connections between the disparate elements of Wight's collections, to try to restore their historical and geographical context, and to bring them to the attention of a wider audience – taking them out of the closet of the herbarium, archives and libraries where they have been hidden, to all but a few, for the last 150 years. The point of the Indian travelogue is, in part, to show that Wight's project can now, in postcolonial times, be seen to have been a joint one between Scotland and India. Whatever the original motivation for making the collections and commissioning the paintings, the results now form part of a rich hybrid culture shared between the two countries. It is impossible not to feel the connections between past and present, and the possibility of using botany and the work of Wight, Rungiah and Govindoo to weave a fabric to celebrate this shared inheritance.

There is a recognised psychiatric condition called *beziehungswahn* – a mania for making connections – of which I learned (perhaps unsurprisingly) in a biography of Bruce Chatwin. This I undoubtedly suffer from, though it seems a relatively benign affliction and contributes to a sense of belonging and at least an illusion of understanding. So, for example, in an attempt to extend the enjoyment of a Wightian research trip to Calcutta on returning to a gloomy February Edinburgh, a sepulchral visit took me to the Dean Cemetery, a ten minute walk from my flat. It didn't take long to find what is supposed to be the tomb of Sir John Peter Grant, one time President of the Agricultural and Horticultural Society of India, but surely (unless he was pickled *en route*) a memorial: a starkly rectangular sarcophagus on a stepped plinth in a style that would not be out of place in Lutyens's New Delhi. Wight, significantly, is not buried here, but while looking for Grant I came across the grave of one of Wight's colleagues and sparring partners, the cryptogamist R.K. Greville, who through his wife was related to no fewer than four grandee Indian-administrators and (North-)British intellectuals that played roles in the wider story of the times (Gilbert Elliot, 1st Earl of Minto, one time Governor-General of India, his brother Hugh, Governor of Madras when Wight first went there; George Eden, 1st Earl of Auckland, Governor-General who took a not entirely positive view of Wight's economic work; and Henry Brougham, 1st Baron Brougham & Vaux, whose views on the role of illustration in the popularisation of science were opposed to those of Wight).

However, I don't have to leave my flat to be aware of the strength of the connections between Scotland and India that made Wight's

career possible. The Georgian tenement I live in forms part of the north-east pavilion of Melville Street, a name that commemorates the title taken by a branch of the powerful Dundas family who over two generations occupied a central role in Indian affairs. The father, Henry Dundas, 1st Viscount Melville, played a key part in the preparations for William Pitt's India Act of 1784, which resulted in the setting up of the Board of Control to bring the East India Company to heel. Dundas was the Board's first President, which extended geographically the enormous influence he already had over matters of patronage in Scotland, and that he used for the benefit of large numbers of Scots, including members of Wight's maternal family the Maconochies. The centrepiece of Melville Street is a statue of his son Robert, 2nd Viscount Melville, who also held the post of President of the Board of Control, and was responsible for the legislation that in 1813 removed the EIC's Indian trading privileges. There are also visible links with nineteenth-century Indian historiography. Almost directly opposite my dining room window is 14 Melville Street, where in the 1820s William Erskine, having retired from Bombay (under a cloud), lived and edited the autobiography of the Moghul Emperor Babur. Coincidentally the view from my parents' house in Broughty Ferry includes the ruins of Erskine's theologian half-brother Thomas's mansion of Linlathen, and much of my early botany was done in its park. The fact that I know about William Erskine shows the continuation of these processes, as it emerged while walking down Melville Street chatting to John Malcolm. I met John and his wife Bini in the wake of my work on Alexander Gibson, as they contacted me after visiting the exhibition of the Dapuri drawings at Inverleith House in 2002. John is writing a biography of his eponymous forebear, who founded the Dapuri garden, and was probably the only person then in Edinburgh, and most probably on the planet, to whom the name 'Dapuri' meant anything at all before visiting the exhibition. John knew the address, because Erskine corresponded with his ancestor, and with Malcolm's widow after his death over his completion of her husband's great biography of Robert Clive.

Had I looked out of my drawing room windows when the flat was first built, I could have seen, a mere hundred yards away, the rear of Henry Cockburn's house in Charlotte Square (the view was blocked in the 1860s by David Bryce who built tenements on the yard where John Steell carved the sculpture of Walter Scott and his deerhound Maida for the Scott Monument). Cockburn is remembered as a pioneering urban conservationist, but professionally was a lawyer and it is in his memoirs, possibly written in that very house, that are to be found some of the most charming vignettes of Wight's cousins Meadowbank, and of Lord Glenlee who employed Wight's father after his bankruptcy.

Let us take an indirect walk from my flat to the Botanic Garden and see what Wight connections can still be found in Edinburgh's

Georgian New Town. Wight knew its streets of hard granite setts and the grey facades of its houses and tenements, but the stones yield their stories as grudgingly as its people – the process of discovery is a slow one, and luck and persistence are needed to get to know either. If we venture eastwards into Charlotte Square, on this Wight pilgrimage, contemporary developments in Indian historiography come to mind, for this is the site of Edinburgh's great annual book festival. A group of brilliant writers have in recent years brought this subject to a huge audience while maintaining the highest of academic standards: Charles Allen, William Dalrymple and John Keay have all talked in the marquees erected every August around Edinburgh's Albert Memorial. Most festival goers are probably unaware that this is what this group of statuary is, for it is far more understated than Gilbert Scott's more famous gothic extravaganza in London. Suitably, for the Athens of the North, this monument is in

the Classical style – an equestrian statue – but the bronze relief on the western face of its plinth bears a link with Wight, as it shows the opening of the Great Exhibition, to which Wight contributed plant products from Madras in 1850. The north side of Charlotte Square is a monumental palace facade, cleverly divided into manageable town houses for the Scottish gentry, one of which was owned by Sir John Peter Grant and was the birthplace of his daughter, the diarist Elizabeth; its architect was Robert Adam, great uncle of Sir Fred Adam, who gave Wight his economic botany job in Madras in 1836. The house next door (now the official residence of Scotland's First Minister) once belonged to Sir John Sinclair – originator of the *Statistical Account of Scotland* that inspired the work of the Indian surveyors such as Buchanan, and Wight's work in the Palni and Sivagiri Hills. On the south side of the square, number 26 once belonged to Lady Seaforth, and also has Wight connections as she must have

Fig.1. A specimen and document from the collection of the Royal Botanic Garden Edinburgh. *Oxalis* (now *Biophytum*) *sensitiva* collected by Wight before 1831, and the page of his lithographed herbarium catalogue with the relevant entry (under no. 462).

been visited there by her son-in-law, James Stewart-Mackenzie – he later became Governor of Ceylon and corresponded with Wight over the introduction of tea to the island. It was this house that in 1822 was rented by the Duke of Atholl, Wight's clerical brother-in-law's patron, for the royal visit of George IV. Wight was by this time in India, but his father must have sent him news of this great public spectacle.

From Charlotte Square the vista eastwards along George Street, the central axis of Edinburgh's Hanoverian New Town, is surveyed from the far end by the commanding figure of Henry Dundas atop the Melville column in St Andrew's Square. Each of the three cross streets has a link of some sort with Wight. The first is Castle Street, where Sir Walter Scott lived from 1802 to 1826. As a Writer to the Signet, Scott must have been on at least nodding acquaintance with Wight's father Alexander, and it was here that he started to pen the Waverley Novels, the authorship of which was first publicly announced by Wight's second cousin Alexander Maconochie. The three intersections are all punctuated with a bronze statue – a divine, a prime minister, and a king respectively: that with Frederick Street (where my great great grandfather, who visited Madras in 1802, was born, and where the first Lord Meadowbank lived at the time of Wight's baptism), is of William Pitt. Wight could even have witnessed its unveiling, for he was back in Edinburgh in 1833, and like the statues of Pitt's ally Dundas, and those of Sir Thomas Munro and James Anderson in Madras, is the work of Sir Francis Chantrey. Both Lord Meadowbanks were sculpted by Chantrey, and the younger was one of his more significant Scottish patrons, responsible for the commissioning both of the Pitt statue and that of George IV, which marks the next street eastwards – Hanover Street. The latter commemorates the tartan extravaganza of the 'King's jaunt' to Scotland in 1822 orchestrated by Scott. Looking north down Hanover Street, over the present Botanic Garden, is the Firth of Forth and, beyond its silver ribbon, are the hills of Fife. At a point midway between the brow of Benarty and the pap of West Lomond, lies hidden George Walker-Arnott's estate of Arlary, where so much of his and Wight's great *Prodromus* was written, but, because of numbering changes, it is possible only to speculate on which block was the one with the house or flat occupied by the Wight family in the 1790s. In the middle of the north side of the last block on George Street is the handsome portico and pencil-thin spire of St Andrew's Church, where Wight was almost certainly baptised in 1801. Opposite this is the Royal Society of Edinburgh, whose second charter was drawn up by the first Lord Meadowbank, and where an original plaster copy of Chantrey's bust of him may still be seen.

On this roundabout walk to my workplace I will refrain from being led too far astray, though were I to head southwards to the Old Town it is still possible to see some of the buildings in which

Wight was educated – his old school, and the original Surgeon's Hall where he received his licence in 1817. The lecture rooms he attended, however, were rebuilt soon after he finished University, and practically all of William Adam's Infirmary, which he attended for practical classes, has long been demolished. Instead I will continue north and east along York Place passing Sir Henry Raeburn's house and studio, where Lord Meadowbank sat for his lugubrious portrait, and down Leith Walk to the old Botanic Garden where Wight went for his botanical classes in 1817. All that survives there is the old gardener's house – a small, but once handsome two-storey building, originally the centrepiece of the Leith Walk frontage planned by John Hope in 1763, but now looking as though it has been hammered into the ground, though it is actually the level of the street that has been hugely raised.

It is not only Craigleith stone and mortar that has survived, and living connections with Wight and his patrons are still to be found. In the course of the travels we will meet the Maconochie-Welwoods at Meadowbank and Alistair Hay, descendent (and heir presumptive) of one of Wight's less supportive Governor's, the 8th Marquess of Tweeddale. I was looking for a portrait of Sir Fred Adam to reproduce in the book, for it was his enlightened outlook that allowed Wight to abandon doctoring sepoys for the more congenial pursuit of economic botany. It so happened that I was also trying to find a potter to make a tray for a zoomorphic Wedgwood crocus pot in the form of a hedgehog. These searches coincided with Janet Adam at the Stockbridge Pottery, whom I knew belonged to the Blair Adam family. She knew all about Sir Fred, his marriage (one of three) to a bearded lady of Corfu, and produced a post-card showing a statue of her forebear, dressed in a toga, in front of the palace he occupied as Governor of the Ionian Isles. This would not quite do for reproduction, but she kindly allowed me to borrow a beautiful wash drawing of Sir Fred made only two years after his brave exploits on the field of Waterloo. It turned out that her new town flat was directly opposite the lodgings occupied by Wight in March 1833.

The botanic garden moved north-westwards to Inverleith under the direction of Robert Graham while Wight was working in the Northern Circars. Graham's extremely grand house in Great King Street, where Wight stayed in 1831, still stands but let us head straight to Inverleith Row, where Wight might have dropped in to see his old headmaster James Pillans at No. 43. It is here, in the Garden's herbarium and library that are to be found Wight's greatest memorials – his herbarium and the paintings made for him by Rungiah and Govindoo. Here, every day of my work as a taxonomist I am in contact with the specimens Wight and his Indian collectors made in Southern India more than a century and a half ago, and working with colleagues who are his intellectual descendants. It is such links between plants, people, places, past and present that, for me, make botany such a rewarding subject.

PART I
IN THE CABINET

*It is only in the cabinet that one can traverse
the universe in every sense*

GEORGES CUVIER

The Herbarium

It is not always necessary to travel far to seek out traces of a man's life and work, even a well travelled one such as Wight, and such was the case with this project. Despite being based on collections made in distant India more than a century ago this voyage of discovery started in the vast *wunder-kammer* that is the herbarium of the Royal Botanic Garden Edinburgh. Untold treasure is stored in initially offputting, battleship-grey, metal cabinets – some two and a half million specimens representing the whole of the plant and fungal kingdoms in desiccated, two-dimensional, form. This gigantic filing system of biodiversity is also, however, a repository of social and scientific history, representing the collecting effort of around ten generations of botanists, explorers and naturalists, drawn from the whole of the vegetated globe. From the concise and highly coded labels and annotations on the herbarium sheets, tales of adventure, travel, and even intrigue, can be elicited when one knows how to decipher them. However, in the past these historical aspects have been largely ignored by taxonomists who have tended to treat the specimens solely as scientific objects. In fact much information has been lost when collections have been added to the ever-growing taxonomic series arranged purely according to the identity of the plant on the sheet.

The oldest specimens in the Edinburgh herbarium from the area this book is concerned with were collected by Dr Edward Bulkley in 1702 at Fort St George, the trading and military base of the East India Company founded in Madras in 1640. Bulkley (like Wight) was a botanically-minded surgeon, who sent pressed herbarium specimens back to Britain. In his case to London at an important period in the history of science, soon after the foundation of the Royal Society, when scientific clubs met in coffee houses, and received specimens from parts of the world being opened up as a result of trading activities. These exotic plants were described in the publications of botanists such as Leonard Plukenet and John Ray, on which Linnaeus was able to build his encyclopaedic taxonomic edifice later in the eighteenth century. Although specimens may be sent by plant collectors directly to great herbaria such as Edinburgh, or made by its own members of staff, such institutions have also grown by generous gifts of specimens or entire collections from individuals and institutions. Our Bulkley specimens are a case in point, being duplicates donated in the nineteenth century by the University of Oxford. One of the greatest of such gifts came in 1966 when the University of Glasgow placed on permanent loan its herbarium of foreign flowering plants, the major part of which had been assembled by George Arnott Walker-Arnott, one of the giants of nineteenth-century Scottish botany. The herbarium is to this day the basis for the taxonomic research that underpins all our biodiversity studies, and I became familiar with the riches of the Indian collections while working on a project documenting the plants of the Himalayan kingdom of Bhutan. Robert Wight's is one of the names most frequently met with on our Indian specimens, and many of these had come with Arnott's herbarium. My interest in these specimens intensified greatly with the discovery of many hundreds of related original paintings commissioned by Wight in the Garden's library, the combination leading eventually to this book and its companion volumes.

So in June 2002, for the reasons given in the introduction to the first volume, I began the project on Robert Wight and his Indian collections. The first thing was to establish just how many Wight specimens there were, by counting the number in a random sample of a hundred cabinets. This gave an astonishing estimate of 23,000 specimens of flowering plants (excluding ferns and other non-flowering plants, such as lichens, mosses and seaweeds, which Wight also collected). Wight is without doubt the most important taxonomist ever to have worked on the flora of South India, and between 1830 and 1853 (either on his own, or in collaboration) described no fewer than 1266 species and 110 genera new to science. Many of his specimens are therefore 'types' – the original vouchers on which the descriptions of his new species were based. Types are of special importance and given extra protection in the herbarium, enclosed in red-edged folders – the idea being that, in the unthinkable event of a fire, taxonomists could rush around pulling out the red covers. To prove that a particular specimen is a type, however, often requires detective work. The original publication must be found (and some of Wight's species were described in rare and obscure periodicals) and the wording studied closely to see which specimens were actually used in making the description – this might be a reference to a uniquely numbered specimen, but in Wight's case was usually far vaguer, amounting only to the name of the locality where his specimen was collected. The specimens with matching data must then be searched for in the herbarium, examined for annotations made by Wight (or Arnott – a joint author of many of the species), and, finally, checked to make sure that the specimens agree with the published description and illustration. These processes are by no means always as simple as they sound. In Wight's case complications emerged from his prolific collecting habits, and the complex history of the distribution of his numerous duplicate specimens. For example, the various collections he gave to Arnott, and those he kept for himself that mostly ended up at Kew. Because very little taxonomic work had ever been undertaken at Edinburgh on plants of the Indian Peninsula (other than on a limited number of plant families), most of Wight's types had never been recognised as such and lay undistinguished among the 'ordinary' specimens. It soon became obvious that to do adequate justice to Wight's life-work, the project would have to be split into two parts. Firstly a combined curatorial and nomenclatural project on his herbarium collections and the new species he described, identifying which of the Edinburgh specimens were types (almost 2000 was the eventual answer). Secondly,

the present work, on Wight's biography and the drawings he commissioned.

As already suggested, the Wight collections at Edinburgh turned out to be complex, but fascinating. Although many of the specimens came originally from Arnott's collection, there are many that belonged to other botanists, and which have been added to the herbarium over the years as gifts by individuals, or through the amalgamation of collections. Wight was a compulsive collector. For example, when he came home on a three-year leave in 1831 he brought with him 100,000 specimens weighing two tons! Such numbers were possible because he used a small team of Indian collectors, who roamed over a large part of southern India. Wight wanted his specimens to be used by as many botanists as possible,

but needed help to identify them and distribute the duplicates. So in 1832 he made contact with Arnott, whom he had known at school and university in Edinburgh, and who for the next 15 years was to work on Wight's collections – explaining the special importance of those kept by Arnott in his own herbarium.

When an individual forms a herbarium he obviously knows it is his, and so frequently adds no identifying mark. The problem comes when such a collection is given to a large, composite herbarium such as Edinburgh's, where it is split up, each sheet being filed away in its proper place in a single taxonomic sequence. Nowadays such sheets are marked with their origin before incorporation, but in the past this was not always done. Herbarium sheets are fascinating artefacts in their own right, quite apart from their impor-

Fig.2. *Impatiens rivalis* Wight. One of the type specimens from Arnott's herbarium collected at Courtallum in August 1835; the drawings are by Rungiah.

Fig.3. *Parnassia wightiana* Wight & Arnott. A sheet from R.K. Greville's herbarium. The right hand specimen is one of the types distributed by Wight & Arnott 1831–4, the left hand one is a later one collected by Wight in the Nilgiri Hills, and the central one was collected by Joseph Hooker and Thomas Thomson in the Khasia Hills of N E India in 1850.

tance as biological specimens. Even the mounting paper used – its dimensions, colour (now always white or cream, but then often various shades of blue or grey) and watermark – can all provide clues. The annotations on the sheets represent the work of generations of botanists, and so each sheet becomes a palimpsest recording often contradictory opinions. Herbarium sheets, in fact, are unique in terms of museum objects in that even today a botanist is allowed to add his opinion, though these days on a glued piece of paper called a 'determinavit slip' rather than written on the sheet itself.

The primary information is that given by the original collector and contemporary with the specimen – written either in the field or, more usually, after preliminary curation and identification. The names of the localities themselves can provide vicarious pleasure for the armchair traveller and Wight's, with their archaic transcriptions of South Indian place names, conjure up an exotic and enticing world: Courtallum, the Malabar Coast, Quilon, the Pulney Mountains, the Neilgherry Hills, Ceylon, the Hill of Thakoomolayala, the curious 'Nopalry' … all of which I was keen to see for myself one day. Localities also serve a biographical function in allowing us to know where Wight was at particular times in his frustratingly poorly documented life. It has to be said that Wight, even for the standards of the time, gave particularly generalised localities for his specimens, which fall far short of the standards of precision now required. The early ones are not even dated, though after his return to India in 1834 (perhaps under the influence of Arnott's rigour) Wight improved, and many bear dates between 1835 and 1837 when he and his collectors were particularly active. It still seems exciting to be studying, under a cold northern sky, specimens collected in southern India 170 years ago, and which remain in remarkably good (if discoloured) condition. Neither did Wight bother much about habitats (perhaps because he had not seen many of them in the wild himself), but usually gave altitudes for montane species. Many of the sheets bear additional slips of paper written either by a clerk or one of Wight's collectors; these give the collecting locality and often a vernacular plant name, transcribed from Tamil. Some of these local plant names are extremely long – the equivalent of pre-Linnean Latin phrase names (e.g., nawree kulokulopu sady), others seem to have far too many vowels (seeroocoorooja), and some are in a bizarre hybrid Tamenglish ('munjul kulokulopay nother kind'). These last two would seem to give some justification for Wight's doubts over the value of vernacular names, as they are both applied to what is scientifically known as *Crotalaria longipes*. The most interesting labels encountered were made of small rectangles of dried leaf from the palmyra palm (*Borassus flabellifer*), the traditional writing material of South India – inscribed with vernacular names by a metal stylus. Although most of the contemporary annotations are strictly factual, the occasional one hints at an anecdote behind the dull routine of collecting. On one specimen of a balsam Wight wrote a note to Arnott: 'I am too sorry that I have not better specimens of this to send. It is truly a beauty and to get it I put my life in danger'.

It is still the case that when collecting a plant in a remote place one often has no idea of its precise identity. This was even more often so in Wight's time, when a smaller proportion of plants had been described and named, and their means of identification were fewer and harder of access. Wight had a basic botanical library with him in India, and did his best to match plants with written descriptions (usually in Latin), but to identify his specimens accurately there was no choice but to take them back to Britain and compare them with material in the great herbaria such as those of Linnaeus and Sir Joseph Banks in London, and of W.J. Hooker in Glasgow. It was perhaps Wight's greatest achievement to make Indian botanists more self-sufficient in this respect by publishing detailed botanical drawings, which are the closest substitutes for real specimens when making accurate identifications. Sometimes, however, even on first sight, one can have a sixth sense that a plant is new and undescribed, and it is possible to sense Wight's excitement when he annotated a specimen with the magical mantra 'n. sp.' (*nova species*). Whether further research shows this to be true or not, such annotations are telling indicators of the slow steps by which knowledge is built up.

The purpose of Wight's home leave (*furlough*, in Anglo-Indian terminology) of 1831–4 was thus to identify, curate and distribute his already vast herbarium, for which he enlisted Arnott's help. This process of curation starts with the identification of a specimen as

Fig.4. Palm leaf label from one of the type sheets of *Argyreia aggregata* var. *canescens* (now *A. osyrensis*).

belonging to an already known species, or, where necessary, describing it as new and giving it a name. Wight & Arnott assigned each *species* a unique number as it was identified, and the vast numbers of specimens were sorted into sets of duplicates [fig.1]. The numbers and names were listed in a Catalogue, which was printed in Edinburgh using the then relatively new process of lithography – the Catalogue being sent to the large number of botanists (from Boston to St Petersburg) who received sets of specimens. This way of numbering is not the method used now, when each *specimen* is given a unique number in the field. Identification is a more subjective process than is commonly supposed, and in many cases specimens that have been lumped together under a single name and

number may, with later study, be found to belong to more than one similar species.

Wight & Arnott had labels printed for these specimens on which they wrote by hand the species number, but usually no other information, to send with the duplicate specimens [fig.1]. The labels on the specimens kept by Arnott himself are filled out in his own hand and often have additional details, and it is these that are now in the RBGE herbarium [figs.2,5]. After Wight returned to India in 1834 he continued to send Arnott huge volumes of specimens (3½ barrel-bulk representing 15,000 specimens in 1836; 6¾ barrel-bulk representing 20,000 specimens in 1837...) and Arnott struggled to curate and distribute these. To these later collections unique collecting

Fig.5. *Lopholepis ornithocephala* (Hooker) Steudel. Specimens collected by Wight at Palamcottah in October 1835 and sent back to Arnott in Glasgow where they remained unmounted until 1903.

Fig.6. *Sargassum cervicorne* Greville. The type of one of the seaweeds described by Greville based on Wight's collections from the Coromandel coast.

numbers were given, as a stop-gap prior to giving them a species (Catalogue) number, leading to complications of a dual numbering system, which can fortunately be largely resolved by looking at Arnott's papers, many of which have survived. These papers demonstrate his meticulous nature (he trained as a lawyer), and include, among others, lists of specimens received from Darwin's Beagle voyage sent to him by the Rev J.S. Henslow. They also reveal other human interests – Arnott was an active freemason and one such list is written on the back of a draft for a Masonic Diploma Certificate. These labels and lists therefore document Wight & Arnott's long friendship and productive collaboration that resulted in several important publications. The most important of these was a Flora de-

scribing the plants of Southern India with the impressive title *Prodromus Florae Peninsulae Indiae Orientalis*, published just after Wight had returned to India in 1834. Arnott was the driving force behind this work, but sadly it was all that appeared of two intended volumes; after this he became bogged down by the deluge of Wight's specimens, and suffered what would now be called a nervous breakdown when he failed to succeed Hooker in the Chair of Botany at Glasgow in 1841 in what was a political appointment, rather than one on botanical merit.

If a specimen does not match an existing species, it must be described as new and given a name. The names chosen by botanists for plants provide an endless source of fascination. Some are purely botanical – from the prosaic (e.g., Wight & Arnott's *Streptocaulon* = twisted-stem, or *Toxocarpus* = poison-fruit) to the mildly salacious, and politically strictly incorrect (Graham's *Hebradendron* = Jew-tree, from the circumscissile dehiscence of the anthers). Names commemorating people reveal stories of patronage, friendship and loyalties. One of the most fascinating to come to light in this project was Wight's genus *Hortonia* named after 'Lady Horton for the lively interest she takes in Botany'. She was married to a Governor of Ceylon and noted for her beauty: she was also Byron's cousin, and it was of her that he wrote in his poem 'She walks in beauty as the night'. Wight almost certainly met Lady Horton during his visit to the island in 1836, but he was probably unaware that the cupboard of Monimiaceae, the family to which *Hortonia* belongs, is one of the most sweetly scented in the entire herbarium.

Other interesting tales emerged from a detailed study of the Wight collections. For example among them is some older material, collected in the late eighteenth and first decade of the nineteenth centuries by German missionaries based at the Danish colony of Tranquebar on the Coromandel Coast. The first of these missionaries was J.G. König, a disciple of Linnaeus, and first holder of the post of EIC Madras Naturalist, to which Wight would one day succeed. These specimens bear evocative labels in old Continental script testifying to the camaraderie of these 'United Brethren'. Many in J.G. Klein's herbarium are annotated 'ab amiciss[imo] Heyne' [from my dearest friend Heyne], and the new names they created were collectively attributed – 'nobis' ('ours') – rather than to individuals. They remind us of the scholarly pursuits and educational activities of these early missionaries – the last of the line being J.P. Rottler who translated the bible into Tamil, and from whom Wight acquired these specimens.

The international botanical community of the 1830s was small and reticulate, and its members actively exchanged herbarium specimens. Scotland at this period was a hotbed of such activities – W.J. Hooker and Robert Graham occupied the botanical chairs of Glasgow and Edinburgh respectively, and both had large and important herbaria. There were others such as Robert Kaye Greville, and (at this stage) Arnott, who did not hold one of the very few professional botanical posts then available, but who were highly competent botanists with large private herbaria. Greville specialised in non-flowering plants, but at this time (and to Wight's chagrin) was more concerned with his work in the anti-slavery movement, which left little time for the work he had promised Wight on his seaweeds and ferns [fig.6]. Greville's herbarium contained copious Wight material, as did that of John Hutton Balfour (who succeeded Graham at Edinburgh), and both these collections were later incorporated into the RBGE herbarium. The case of Robert Graham's herbarium

Fig.7. *Zornia gibbosa* Spanogue. One of Wight's earliest specimens, collected at Samulcottah in October 1822. This bears names from the works of Willdenow and Persoon, two of the few botanical reference books then available to Wight.

is interesting. At this time professors were usually men of means, sometimes from family wealth, but if not, then enrichment was possible through their Chairs (by student fees in the case of Hooker, and private medical practice in Graham's). The herbaria and libraries they built up were paid for out of their own pockets, and therefore their own private property. Both Hooker and Graham were generous with access to their herbaria, but the problems of private ownership became apparent with changes in circumstance – thus when Hooker left Glasgow in 1841 his herbarium went with him to Kew, and when Graham died in 1845, impoverished from unwise Australian investments, his widow had to sell his collection, which was split up and lost to Edinburgh. A sale catalogue for the auction has survived, but the fate of the specimens that Wight sent to Graham was unknown. In 1966 the University of St Andrews gave its herbarium of foreign plants to Edinburgh, among which were many Wight specimens labelled in a neat copper-plate hand, but with nothing to indicate in whose herbarium they had originally been before going to St Andrews. The identification of the copper plate writing as belonging to Graham's wife Elizabeth, who evidently acted as his secretary, revealed this to be none other than Graham's set of Wight plants, which had thus returned to Edinburgh 120 years later, but continued to lie in the herbarium unidentified as such for a further 40 years [fig.1]. The travels of this collection had been even more circuitous, as the collection was given to St Andrews by Dundee University, and it appears to have been part of a herbarium formed by the Maclagan family, an extraordinary medical, military and ecclesiastical dynasty of Victorian Edinburgh, one of whom probably bought it at the Graham sale.

There was another mystery Indian collection, lacking a collector's name, incorporated within the Edinburgh herbarium. The rather scrappy specimens are mounted on small sheets of a thin Indian paper and were collected between 1821 and 1823 in the area around Samulcottah [fig.7]. Botanically this is a famous locality, as it was here that William Roxburgh, the 'father of Indian botany', had his experimental plantations of pepper and other economic plants in the 1780s. Roxburgh was one of Wight's predecessors, both as an Edinburgh medical student, and as EIC Madras Naturalist. However, these collections clearly had nothing to do with Roxburgh, who died in 1815, but close examination of the handwriting showed it to be Wight's, whose first posting was to this region, known as the Northern Circars. In these early days Wight was botanically inexperienced, with limited access to books, and these specimens are classified according to Linnaeus's sexual system. He is known to have sent specimens from this period to Graham that were said to have been lost in a shipwreck. It is recorded that Wight was later embarrassed by his early collections, and it is possible that he deliberately pretended they had been lost at sea and that these are they.

After almost three years of work, the history of the various Wight collections at Edinburgh had been worked out, the type specimens identified as such and entered into a database. Gratifyingly the types of nearly all of the species described jointly by Wight & Arnott were found; it was then necessary to undertake a similar operation at Kew, the other major repository of Wight specimens.

KEW

When Wight retired to Reading in 1853 he renewed his contacts with the Hooker family, by now based at the Royal Botanic Gardens Kew, where Sir William was Director and his son Joseph working on the enormous collections he had recently brought back from the Himalaya. The London botanical community elected Wight a fellow of the prestigious Royal Society, though in fact he gave up botany almost entirely and concentrated on farming. Despite this, Wight extended a warm welcome to any botanist who wanted to use his herbarium at Grazeley Lodge. But this was not enough and Wight wanted to make his specimens as widely available as possible, and realised that the best way of doing this was by giving his collection to Kew, by now beyond any doubt the botanical centre of the British Empire.

A visit was therefore necessary to find what Wight treasures the Kew herbarium might contain. I always look forward to Kew visits – not so much to the garden itself, with its pagoda and glass palaces, but to the secret world hidden behind a mellow brick facade on Kew Green. The building itself is hidden behind a row of venerable plane trees and some mighty iron railings. Hunter House is a handsome early eighteenth-century building that was sold by George IV to the Commissioner of Woods and Forests in 1823, who allowed the Duke and Duchess of Cumberland to live there from 1830 to 1851 – the Duke was William IV's brother and after 1837 also King of Hanover. In the year of the Great Exhibition the Duke-King died, and, coincidentally, Sir William Hooker moved from West Park at Mortlake to 49 Kew Green, temporarily housing his vast herbarium in a cottage in the garden. The following year Hooker was allowed the use of the ground floor of Hunter House for his vast herbarium, which was still his own personal property. This was therefore the Kew herbarium to which Wight returned in 1853. The building still has a grand oak staircase, and the bow-ended Keeper's office retains its Georgian elegance, but most of the building has been turned into offices, and retired members of staff with an unquenchable thirst to continue taxonomy find themselves in an attic corridor known affectionately as 'Death Row'. It is behind this building that today's herbarium starts, in what is confusingly called 'Wing C', added by Joseph Hooker in 1877 – a spectacular space around a central atrium, with galleries on three floors linked at each end by a pair of ample cast iron spiral staircases painted a rich raspberry red. On the ground floor are the mahogany cabinets that house part of the herbarium Illustrations Collection; on each of the galleries rows of white painted cupboards project peninsula-like from the walls and it is these that house the herbarium specimens. The cupboards tower well above head height and precarious ladders are required to reach the upper ones. The spaces between the rows of cupboards are know as 'bays' – incredibly cramped spaces, like burrows, in which taxonomists and even artists lurk and do their work. The herbarium is still arranged to Bentham & Hooker's system, and the brown manilla genus folders, and cream paper species folders, are annotated with botanical names and changes of opinion by generations of botanists that one comes to regard as old friends. One of the most touching of such links with the past came while I was looking for Wight's balsams. These were genus covers written in the shaky hand of the 90-year old Joseph Hooker, who was still working on this difficult genus, *Impatiens*, at 'The Camp, Sunningdale', at the time of his death in 1912.

Kew's collections are as varied as Edinburgh's and were amassed in a similar way – by gifts, staff collection and purchase – given a bump start in the mid-nineteenth century. Firstly, in 1854, George Bentham gave his large collection on condition that he could continue to work on it at Kew for the rest of his life. This provided a

slightly alarming precedent, for when Sir William Hooker eventually died in 1865, aged 80, Joseph, his successor as Director wanted to sell his father's vast collections to the nation – having rather less ample private means than Bentham. In fact all went well and in 1866 the Government agreed to pay £7,000 for the magnificent collection of herbarium specimens, archives and drawings (which already included much Wight material). Needless to say Hunter House and the first 'Wing' rapidly filled up – for example with the great collections from the India Museum (including Griffith's specimens and the Roxburgh Icones) that had been added in 1858, and the first batch of Wight's own great donations. Other wings were therefore gradually added – Wing B in 1902, in pared-down English baroque style facing the Green to the west of Hunter House and, in 1932, Wing A in what might be called functional Art Deco style. In 1969 the quadrangle was completed on the north side, overlooking the Thames with its osier clothed islands where cormorants dry their wings and disconsolate herons stand. It is here in Wing D that some of the most important parts of the collection are housed: the monocot specimens on the top floor, the magnificent library on the first, and the archives on the ground.

Wight gave his herbarium material to this ever expanding national collection in two batches – firstly, from 1863 onwards, a vast miscellaneous collection 'enough to supply half the Herbaria of Europe', which was duly distributed under Joseph Hooker's direction (20 sets, as far afield as Australia, South Africa, and India). Wight had not mounted these specimens, and one cannot be certain of the extent to which he had used them in making his descriptions of new species (that is, their type status). Hooker kept the best set of this material and vast numbers of them are scattered through the Kew herbarium, identified by a specially printed label. Each species was given a number and a second 'Wight Catalogue' prepared – a source of confusion as these numbers bear no relation to those in the first Catalogue. In October 1871, as his health failed, Wight finally donated his 'working herbarium'. This contains the types of the species he described in the great works he published on his own in India – the six-volume *Icones Plantarum Indiae Orientalis* and two-volume *Illustrations of Indian Botany*. Most nineteenth century herbaria were mounted on folio sized (approximately A3) sheets of paper, but the specimens Wight 'glued down' and kept in his working herbarium are unusual in being on sheets half this size. This was not only for reasons of economy, in days when good quality paper was expensive and difficult to obtain in India, but also for reasons of space and portability given Wight's at times peripatetic lifestyle.

However, many Wight specimens had already reached Kew before these later donations, such as the sets sent by Wight & Arnott to W.J. Hooker and to George Bentham in the 1830s. Another important, and previously unknown, collection emerged as a result of this work. George Gardner was a botanical protégé of Hooker's from Glasgow days, who made a name for himself as a plant collector in Brazil. In 1844 he was appointed to take charge of the Botanic Garden at Peradenyia in Ceylon, only to discover that its herbarium

had been lent to Wight for identification. Reclaiming this gave Gardner the excuse to visit Wight in Coimbatore in 1845, and their shared passion for botany was the basis of a friendship that ended with Gardner's untimely death four years later, aged 37. Wight allowed Gardner to take copious duplicates from his herbarium, many of which he sent back to Hooker and Bentham in London; this material is also scattered through the Kew herbarium, but its significance had never been recognised, and includes types of many of Wight's species.

Wight's friendship with the prodigiously talented botanist William Griffith also ended with a premature death, at Malacca in 1845, when Griffith was only 34. He sent Wight numerous specimens from the later travels of his ten-year Indian career, notably from the Khasia Hills of north-east India, from Burma and from Malaya. His death meant that Griffith himself published only little of his innovative and meticulous work, and his manuscript notes were posthumously edited by his friend John McClelland in what, given the circumstances, could only be a less than ideal form. Griffith's herbarium collections also suffered, being sent to the India Museum in London, where they languished in damp cellars until rescued by Joseph Hooker in 1858. Duplicates of some of these specimens sent by Griffith to Wight in Coimbatore, however, had already been used by Wight as the basis of new species, but the types of these in Wight's herbarium had not been recognised as such.

The end product of this work on Wight's herbarium collections was an extremely dry unillustrated tome – a catalogue of all the names published by Wight (& Arnott), giving the types on which they were based. Also included is related information, such as a gazetteer of his collecting localities, a list of botanical collaborators, and a complete bibliography of his publications. It is hoped that this will be of use to taxonomists and to the large number of herbaria all over the world that, as a result of his hard work and immense generosity, contain duplicates of Wight specimens.

The other collection at Kew of relevance to this story is the great herbarium of the Honourable East India Company. When Nathaniel Wallich returned to his post of Superintendent of the Calcutta Botanic Garden in 1832, having spent four years of leave curating this collection, the EIC generously decided to give the top set of specimens (with all the original field labels) to the Linnean Society. The Society sent out a circular soliciting donations for the £300 required to house the magnificent collection of 8000 species (for each of which there are multiple specimens) in suitably grand wooden cabinets. The response was generous – Hooker and Graham each gave £10, as did Charles Lyell of Kinnordy, the great geologist and mentor of Darwin; Arnott and 'poor as a church mouse' Greville both gave £5. The collection was first housed in Soho Square, then moved to Burlington House, before finally reaching Kew in 1913. There it remains in Wing B, in its majestic mahogany cupboards, so well made as to be almost dust-proof, and the sheets still in pristine condition, including many specimens sent by Wight (his own, and those of the Tranquebar Missionaries and Patrick Russell) to London in 1828.

Libraries and Archives

The bare bones of Wight's life were known, largely from an excellent obituary written by Hugh Cleghorn, his friend of 30 years, and the basis of most subsequent works such as the article in the first edition of the *Dictionary of National Biography*. By its very nature the obituary is condensed, and the question was how to expand it and put some flesh on the bones. There are major difficulties in trying to discover details of the life and character of a relatively obscure figure such as Robert Wight, who has made it only into the footnotes of biographies of some of his more illustrious contemporaries, for example the 'lives and letters' of Charles Darwin, George Bentham and Ferdinand von Mueller. In Wight's case the sources of further information are lamentably few. We know that a diary kept during Wight's whole time in India was available to Cleghorn, and private letters would be another potential source – if only they were extant and could be found. Wight published a large number of scientific books and articles, and although 'science' was then a much broader field, the publications are still almost entirely factual, with only the odd personal detail hinted at. For example, what might lie behind the unusually precise locality given for the orchid *Disperis neilgherrensis*: 'behind Kelso Cottage'? It was thus necessary to seek out and list all of Wight's publications, including those in obscure periodicals, both British and Indian, not only to give credit to the man's extensive output and broad interests, but also for any biographical crumbs they might contain. The most obvious source for more direct biographical information lay in the records kept by the organisation that employed Wight for 34 years in India and paid his pension for the remaining 19 in England – the Honourable East India Company, and these were to be found in London and Madras.

THE BRITISH LIBRARY

For this a series of visits to the British Library had to be made, to discover more about these official relations with the EIC. The Company was renowned for its documentation, consisting of records copied on large folio sheets in wonderfully clear 'copper-plate' by 'writers' in India and clerks in London, and bound into large tomes – a boon to historians of the Subcontinent, but at the time a necessity arising partly from the complexity of the Company's organisational structure. In Wight's time this consisted of the Court of Directors in London, the Supreme Government of India in Calcutta, and the Government of Fort St George in Madras, the three being linked by an extensive paper chain. The records sent back to the Court survive in the India Office Collections, now housed in the externally offputting brick hulk of the British Library at St Pancras. The Indian records occupy fourteen kilometres of shelving to which researchers have no direct access, and the difficulty is in finding the relevant material from the rudimentary indexes. These indexes are consulted to find promising sounding volumes, which are then summoned using an excellent computer system, but it is rather like fishing in a paper ocean, and what appears on the end of the line is unfortunately not always quite what one wants. Despite this, much about Wight's professional life was retrieved, and leads for following up in India discovered.

Here was his 'service record', the outline of his varied career as surgeon, Madras Naturalist, economic botanist and supervisor of the American Cotton Experiments, and also allusions to his work as a taxonomist. The earliest are the fascinating documents required for obtaining what was a highly sought after post, that of an Assistant Surgeon in the Company's service: a copy of the record of his baptism in Edinburgh (which oddly did not happen until he was five years old), a letter from Sir Robert Preston asking for his protégé's posting to be changed from Bengal to Madras, and certificates testifying to his proficiency in Medicine and 'Hindoostanee'. There was also a copy of the record of his marriage, which took place in the Cathedral of St George in Madras.

The majority of references to Wight are to be found in three series of records. Firstly the 'Madras Despatches' (copies of the letters sent from the Court to the Madras Government commenting on documents – reports, requests and such like, that they had submitted for the Court's inspection and approval). In these were references to intriguing incidents such as difficulties Wight had with some obstreperous American Planters employed to teach the Indian *ryots* about cotton planting and ginning techniques. There were also references to Wight's botanical work, which, although undertaken in his own time, was supported by the EIC to the extent of guaranteeing to purchase 50 copies of each of his illustrated publications. Hence references to the sending of copies of the *Icones* and *Illustrations* to London, but also related requests for sending lithographic and drawing paper, and even camel hair brushes, out to Madras. In May 1852 was a reference to 14 medals awarded by the Commissioners of the Great Exhibition sent to Madras for Wight, Cleghorn and others.

The second series of records containing numerous references to Wight is called the 'Madras Proceedings', or public consultations – copies of letters to and from the Madras Government on various subjects. In these are many items of great interest relating to the post of Madras Naturalist, including its rules of operation, both in Wight's time (1826–8), and in that of his predecessor James Shuter. This includes a wealth of detailed information showing that the Madras Government rented once again for Shuter's use the garden they had used in the 1790s for rearing the cochineal insect, known as the Nopalry. By the 1820s this was known as Mooniapillay's House and garden, and its location given as Saidapet – here was something to seek out in Madras. Shuter lasted only a short time in the post and went home on sick leave where he died shortly thereafter. Sir Thomas Munro, Governor of Madras, appointed Wight in his place, but did not want Wight to run the former Nopalry as a

botanical garden, as the ground was only rented. Here also were fascinating lists of the items Wight needed for a great excursion around South India in 1826 [frontispiece], when he collected not only plants but insects, birds, 'spirituous preparations', shells and minerals. He required tents, plant presses, and took with him his draftsman (doubtless Rungiah) and a travelling assistant. Interestingly Wight also intended to purchase 'specimens illustrative either of the Mythology of the Arts or of the Antiquities of the Hindoos'. Then came a bombshell in 1828 when the Governor scrapped the post to save 15,000 rupees (£1500) a year, and ordered that the Naturalist's collections be packed up, within a month, and shipped back to London.

Due to the limitations of indexing, the last of the series of records in the India Office collections containing information about Wight has only very recently become available. These are called the 'Board's Collections' and consist of collections of papers on particular subjects gathered together, accompanied by only the most inadequate of indexes. Professor David Arnold of the School of Oriental and African Studies at London University, who has written so interestingly about Indian environmental and medical history, realised the importance of these collections and initiated a project to catalogue them. As a result of work undertaken by Richard Axelby and Savithripreetha Nair much new information on Wight has become available, for example on his cotton and other economic botanical activities. Here also was an interesting paper demonstrating Wight's humanitarian interests and social conscience, in which he recommended what would now be called community service for convicts.

KEW ARCHIVES: LETTERS TO THE HOOKERS

It has been possible to find only a little over a hundred of Wight's autograph letters, which represent the merest fraction of those he is known to have written. By far the richest cache of these is at Kew. Here are a few letters written by Wight to various botanists in India (five to William Munro, one each to Wallich and Griffith) and London (two to John Lindley and three to Bentham), but the majority are in that amazing archival treasure, the 'Director's Correspondence'. These letters, addressed to the Hookers (father and son) from correspondents worldwide, document a most exciting period of botanical exploration and commercial development of plants, the whole of which should be transcribed and made available on the web as a matter of urgency. Among these is an interloper, a letter from Wallich to Wight, on which is found the following blood-curdling note:

> Recd. from Mr J.H. Knowles of Messrs. Dulau 26. 2. [19]26. It was given to him by a member of Wight's family. Mr Knowles witnessed the destruction of most of Wight's correspondence.

What can have been the reason for this holocaust, and why did Mr Knowles, who was head of the natural history department of the noted firm of London antiquarian booksellers, manage to rescue only a single letter? We will never know, and as Wight's diaries have not come to light, these were presumably also consigned to the flames.

Given this we can be only the more grateful for the fact that the correspondence with the Hookers survives, and especially since W.J. Hooker seems to have elicited a confessional style of writing from many of his correspondents stuck in lonely corners of the world. At Kew are 68 letters to W.J. Hooker, from the first one that Wight wrote from Negapatam on 6 October 1828, up to the time of Hooker's death in 1865. These overlap slightly with the correspondence with Joseph Hooker, of which there are 15, taking us almost to Wight's death in 1872. Despite its boldness and superficial neatness (Book 1 Fig.16), Wight's handwriting is not particularly easy to read: good progress is made for several lines at a time, to be brought up sharp by a word that remains stubbornly indecipherable no matter how much one goes back over the sentence, trying to guess it from the context. Thus the process of transcription proceeds, slowly and jerkily. Fortunately few of Wight's letters are 'crossed' (that is written in two directions, at right angles to each other, superimposed on the same sheet), but his style is lamentable – almost devoid of punctuation, and extremely prolix. This also adds to the difficulties of reading and comprehension, and his own admission that his style was 'not the most condensed in the world' is something of an understatement. Hooker evidently also found it infuriating, swamped as he was by letters from all over the world, as in an article he published announcing Wight's immanent return to Britain in 1853 he justly, if somewhat unkindly, accused him of 'a want of attention to style and composition'. Through this correspondence we can track Wight's botanical work – starting with his sending of specimens and drawings to Hooker for publication in the early days, his plans for publications, and details of where he was sending collectors. Hooker's repayment was in the form of much needed botanical books and drying paper sent to Wight in India, and the offer to draw on a sum of £100 to defray collecting costs. The correspondence carries on through the important period of Wight's furlough in Britain, as Hooker was based in Glasgow while Wight was constantly travelling between London, Edinburgh, Kinross-shire and Blair Athol. We also learn of Wight's sitting to the artist Daniel MacNee in Glasgow, for Hooker's collection of portraits of botanists. For Wight's second Indian period there are unfortunately rather fewer letters, but these few are full of interest; for example information about the houses he occupied, which I hoped, in due course, it might be possible to locate. His house at Ootacamund in the Nilgiri Hills was described as 'on the slope of a hill about 100 or 150 feet above the lake', where he was able to have a 'well-stocked garden at all seasons while below everything is cut down with frost'. In Coimbatore Wight built a large house, at the enormous cost of £1000, and was evidently particularly proud of its 32 × 20 foot herbarium room, the dimensions of which he mentioned on several occasions.

Insights into Wight's character also emerge from the letters, especially his tendency at times to what can only be described as a morbid sensitivity. This could be triggered by various stimuli – for example, if specimens or letters were not acknowledged he assumed that he must have been at fault and caused offence. Wight was well aware of this failing and its potentially disastrous consequences, revealed in an extraordinary confessional letter written to Hooker from London in 1832. In this he revealed that such sensitivity had even, on one occasion, prevented him from marrying. It might also have had botanically disastrous consequences, as it nearly stopped his contacting Arnott whom, through a misunderstanding, he thought had failed to acknowledge specimens he had asked to be forwarded to him. Fallings out with other individuals come to light in the letters, explicitly or in veiled hints, for example in 1845 with his old colleague Wallich whom Wight thought had posthumously maligned his closer friend Griffith. On the plus side, however, it was a second falling out with the Governor of Madras, S.R. Lushington,

which led to the enormous botanical benefits of Wight's home leave in 1831. These tensions are a repeated feature of Indian botanical history, and are both interesting and difficult to explain. Are taxonomic botanists a particularly touchy breed? Or did they arise from the isolation they must have felt, coupled with difficulties in communication. We should remember the incredible slowness of the postal service in Wight's day – when he first arrived in India it took four months for a letter to reach England, though by the end of his stay this was down to about seven weeks, and in 1867 a letter from Calcutta could reach Grazeley in 28 days. Wight can have had no conception of the volume of Hooker's worldwide correspondence, but for him in his isolation the failure to reply (doubtless when Hooker was simply overwhelmed) must have seemed personal. Letters could also go adrift, and one written by Hooker on 6 December 1839 did not reach Wight until 20 December 1841, and in the intervening period Hooker had lost both his eldest son and youngest daughter. An even more extreme example is a letter written by Wight in 1829, which did not reach its recipient, Wallich, until 1839! Today a quick email or telephone conversation can nip potential sore points or misunderstandings in the bud before they develop into festering sores and feuds. The sorts of difficulties I would encounter in Madras, resulting from differences of British and Indian mindsets and bureaucracy, coupled with the periodically extremely unpleasant climate (and in Wight's time the additional problem of illness) must also go far towards explaining the frustrations that manifested themselves in such blow ups.

The letters continue after Wight's retirement to Grazeley in 1853, a period for which, as both his publications and his links with the EIC effectively ceased, we know next to nothing. Those that have survived document a declining interest in botany after a mysterious affair over an apparently ill-advised or intemperate taxonomic paper that Hooker declined to publish. Domestic interests come to the fore and it is touching to hear of Wight sending Hooker the products of his 'agri-horticultural' activities, such as a basket of Jerusalem artichokes. After Sir William's death, the correspondence is addressed to Joseph Hooker, among which is a fascinating letter offering Rosa Wight's expertise in inducting Mrs Hooker into 'the hidden mysteries of curry making'. As the writing gets shakier, the main topic of correspondence concerns the donation of the herbarium collections to Kew.

GLASGOW AND GEORGE WALKER-ARNOTT

Also at Kew are many letters from Arnott both to Hooker, and to George Bentham, with whom Arnott was on much closer terms. Arnott, who spent his whole life in Scotland and has been almost entirely forgotten, but his rigorous methodology (he was a brilliant mathematician, and originally trained as a lawyer before turning to botany) was a major influence on Wight. These letters show what an incredible workhorse he was for Hooker, and the shattering effect of his not succeeding to the Glasgow chair when Hooker left for Kew in 1841. This was for political reasons: Arnott being a Tory, the job went to the Whig candidate J.H. Balfour. From the letters emerge the details of Wight & Arnott's collaboration, and the enormous trouble and expense to which Wight's prolific collections put him. On the topic of botanical illustration another fascinating fact came to light. When Arnott did eventually get the Glasgow chair in 1845 (on Balfour's translation to Edinburgh – another contentious appointment, as the international botanical community thought the

job should have gone to Joseph Hooker), Hooker sold him the collection of teaching diagrams that were a key part of making his own lectures so attractive and lucrative. The majority of these were painted for Hooker by Walter Hood Fitch, whom Hooker had discovered drawing designs for a Glasgow calico factory. They were evidently largely copied from prints, though some were probably made from plants growing in the Glasgow Botanic Garden, and were designed to show plants at a large scale, especially ones that could not be demonstrated from living specimens. In 1845 Arnott paid the enormous sum of £200 for the collection (Hooker keeping only those of *Rafflesia* and *Victoria*), at a time when the annual professorial salary was £200 (though made up to approaching £400 with various emoluments and student fees). Whether or not they still existed was unknown.

I had first got to know of Arnott's work in Glasgow in 1985 when I had a stopgap job running a Youth Opportunity Scheme trying to persuade 12 unemployed youths to perform the scarcely compatible tasks of surveying the flora of the verges of Glasgow's urban motorways, and entering data from the British herbarium (including Arnott's) onto an electronic database. The challenges of this may be imagined, added to which I had to share an office with the wives of the Botany Department's two professors, both of whom had nepotistical jobs, and with whom I had to play Cox and Box at the single large desk in what I had been told was 'my' office! While there I discovered that on the open shelves in the departmental library was a significant part of Arnott's botanical library, the margins and interleavings of the books covered in his notes. Candolle's *Prodromus*, Roxburgh's *Flora Indica*, the '*Wallich Catalogue*', Hooker & Arnott's *British Flora*, Wight & Arnott's *Contributions* and *Prodromus*, his collection of books on diatoms, and much else besides. These lodged in my memory and a decade later I persuaded Glasgow University to send the Indian works to RBGE on permanent loan to rejoin Arnott's foreign herbarium which had been deposited with us in 1966. This was greatly helped by finding a letter in the Glasgow archives from J.D. Hooker urging that when the University bought the herbarium from Arnott's widow, it was essential that they should also buy the books with which they were intimately connected and that the library and herbarium should not be separated. As Glasgow had retained Arnott's British herbarium, the same could not be argued for the British Floras, nor for the scrapbooks of Arnott's successor Frederick Orpen Bower. On 24 October 2001 these went up in a conflagration that consumed the Botany Department, along with the superb portrait of Bower, resplendent in scarlet Oxford DCL robes by his cousin Sir William Orpen, and a portrait of the palaeobotanist John Walton (son of the 'Glasgow Boy' painter E.A. Walton) by Alberto Morocco.

Since this appalling event visits to Glasgow have been tinged with melancholy, but I returned in November 2004 to see an exhibition in the Hunterian Museum celebrating 300 years of Botany at Glasgow and the restoration of the renamed 'Bower Building'. The title of the exhibition was unpromising ('Glasgow Bloomers'), but turned out to be excellent and my heart missed a beat when one of the first exhibits I noticed was a teaching diagram of the orchid *Cycnoches loddegesii* that could only have been painted by Fitch (further research showed it to have been copied from an illustration in the *Botanical Register*). The Hooker/Arnott collection had indeed remained in the department, at least until the mid 20th century, when many such collections (including part of J.H. Balfour's similar

one at Edinburgh) were destroyed with the advent of modern techniques of lecture-illustration by means of projectors and 35mm transparencies. However, a dozen had survived first this destruction, then the fire, and were shown to me by Professor Richard Cogdell, Hooker Professor of Botany. One of the survivors turned out to be an old friend in a new guise, being based on a drawing Wight had sent Hooker from India. It showed the intriguing submerged aquatic plant *Vallisneria spiralis*, with its coiling filiform female peduncles that lengthen or contract so as to keep the flower floating on the surface – whatever the depth of the water. Sadly the aquatic realm had attempted to reclaim the drawing, which was greatly damaged by the issue from a fireman's hose [fig.8].

THE BOTANICAL DRAWINGS
Edinburgh

The final archival part of the project related to the botanical drawings that had first stimulated my interest in Wight and started the whole project. These drawings had been treated as scientific specimens, glued to folio herbarium sheets, and filed in a large (250,000) collection of miscellaneous illustrations, according to the name of the species depicted. Several years previously I had realised the importance of these beautiful works, extracted them, and reformed a 'Wight collection', but only now did detailed work on them

Fig.8. *Vallisneria spiralis*. Teaching diagram made, probably by Walter Hood Fitch, for W.J. Hooker. The central figure is copied from a drawing by Rungiah. Glasgow University, Department of Botany.

become possible. The first step was to have the drawings removed from their acidic backing sheets and conserved. Those that had been folded had to be flattened, and tears repaired, though the drawings were in fact in remarkably good condition, and as they had never been exposed to light their colours were completely unfaded. The Eddie Dinshaw Foundation once again came to the rescue and generously paid for the enormous work of removing some 710 drawings from their backings, undertaken by Audrey Wilson, a paper conservator, who works in an intriguing converted Georgian wash-house in Portobello. Because of the size of the collection it was decided not to mount the drawings in the traditional method (in acid-free window mounts and stored in Solander boxes), as the resulting bulk would have stretched storage limits in the RBGE library beyond breaking point. Another reason for not choosing this method was that many of the sheets have drawings on both sides. They have therefore been placed in transparent plastic envelopes so that both sides can be safely and easily examined.

The greatest excitement of this phase of the work came when unknown drawings were revealed on the backs of sheets that had been stuck down by all four edges, the best such hidden gem being a plump pumpkin fruit that entirely filled the page (Book 2 plate 54). There were also revealing annotations, such as: 'Etterazooloo, Dr Wight's writer, Medl. Board Office', which provides the name of another Indian employed by Wight, this one evidently a clerk. Freeing the drawings from their backings also meant that watermarks could be read. Wight was thrifty; the drawings are mainly on rather small sheets, and he obviously bought a large supply of drawing paper early on in his time in India, as the commonest watermark is from 1819. Some are even on reused herbarium paper, which, from annotations, must once have borne specimens of British plants. Many of the drawings are paired, the plant habit being shown on a larger sheet, and the magnified floral details on a smaller slip of paper. Wight had originally stitched these pairs together, usually with cotton thread, but for some he had used a long, slender thorn!

When a colleague was clearing his room prior to retirement, a bundle of drawings emerged from the accumulated strata of a working life. Among these were many orchids that had been separated at some stage from the Wight collection and thus spared from being glued down. With these was a fascinating miscellany of other material, all of which seemed to be connected with Wight – for example, copies of Roxburgh drawings of various species of pepper (*Piper* spp.). There were also some botanical prints that were just possibly collected by Wight as models when he was contemplating embarking on his own *Illustrations* and *Icones*. Here also were the dismembered botanical remnants of an album that had clearly belonged to a Victorian lady, including some paintings of exotic fruits, Indian in style. One of these, of a rose apple (*Syzygium malaccense*), confirmed the connection with Wight, as it was annotated by the album's owner as being 'copied by Gooindoo [sic]'. Two of the album's drawings were nostalgic reminders of 'home' – a lily of the valley by E. Lang and a single yellow rose. On the back of the latter is the name 'Miss Ford', which proves beyond reasonable doubt that this collection is the botanical element of an album made by Wight's wife, Rosa Harriette (née Ford).

Finally the plants shown in the drawings had to be identified, and those published by Wight in his *Illustrations* and *Icones* correlated with the printed versions. Identifications were not nearly so hard as had been the case with the Dapuri drawings, as they were

GOSSYPIVM·BARBADENSE

SACCHARVM·OFFICINARVM

CALOTROPIS·PROCERA

CAMELLIA·THEA

Fig.9. Four of the economic plants on which Wight worked, as painted by Charles James Lea *c*.1880 on the ceiling of the central hall of the Natural History Museum. © The Natural History Museum, London.

mostly annotated with names by Wight, Arnott and more recent botanists. Moreover practically all the plants depicted were natives of South India, so it was possible to check their identities using the modern Floras that, thanks largely to the efforts of the Jesuits (Fathers K.M. Matthew and C.J. Saldanha), cover this part of India so well. The drawings are extremely important taxonomically as in many cases they were drawn from the original specimens and published along with the descriptions of the new species and therefore have type status. Numerous interesting stories emerged such as the drawing of the laurel *Phoebe wightii*, showing objects like strangely fringed scale insects on the undersides of the leaves (Book 2 plate 116). The annotations tell us that this drawing was sent to the great German botanist Christian Nees von Esenbeck in Breslau, who realised that the objects were the fruiting bodies of a fungus and described the new species *Aecidium periphericum* based on this drawing.

Another previously unknown cache of 'Wight' drawings came to light on a visit to Edinburgh University Library to trace Wight's university career. It was well known that Wight reproduced more than four hundred of the unpublished Roxburgh drawings at Calcutta in his own *Icones*; nothing, however, was known of the details or practical arrangements of this process. It therefore came as a revelation when two portfolios catalogued under Roxburgh's name, and containing 381 pencil drawings, proved to be the very ones sent to Wight for this purpose by Wallich from Calcutta. The annotations show that it was Wallich who chose which should be reproduced, doubtless those he thought most important taxonomically. The copies are pencil tracings of the coloured original drawings, with beautifully added shading, but much simpler than the facsimile (coloured) copies that were made from the originals by artists in Calcutta at various times for a variety of individuals.

Kew

In 1828 S.R. Lushington, Governor of Madras, ordered the abolition of Wight's post as Madras Naturalist, and the despatch of its 'Collection of Curiosities' to the India Museum then located in Leadenhall Street in the City of London. Among this was a large and miscellaneous herbarium, which arrived in London just in time to

Fig.10. Some of Sir Joseph Banks's mahogany herbarium cabinets. Department of Botany, Natural History Museum, London.

be worked on and distributed by Wallich from his 'botanical laboratory' in Frith Street. However, also included were 150 botanical paintings that in 1879–82, with the final tragic dispersal of this much abused museum, were sent to Kew, annotated with Wight's name. As at Edinburgh these had been incorporated into a large, taxonomically-arranged, illustrations collection. Fortunately the more important parts of this collection had been at least partly catalogued, so it was fairly easy to find 99 of this other collection of Wight drawings. These differ somewhat in style from Rungiah's later drawings at Edinburgh, being more heavily worked and densely painted, but appear to represent his earliest work.

In the late 1820s Wight sent paintings to W.J. Hooker in Glasgow, the more interesting of which Hooker published, with Wight's accompanying descriptions, in various of his botanical periodicals. I suspected that these too should have survived in the Kew illustrations collection, but as these had not been annotated with Wight's name, this had not been previously realised. Knowing the species depicted from the engravings that Hooker had made from them by Joseph Swan, it was possible to search for these, and 58 have now been found.

The Natural History Museum

After the Great Exhibition of 1851, to which Wight contributed plant products from Madras, the Commissioners, under the guidance of the Prince Consort, acquired the land between Hyde Park and the Cromwell Road and developed it as an extraordinary centre of culture and learning. It is here that are to be found two ports of call necessary for the Wightian journey. The location of the first would have surprised him, and the second will be left until later.

The Natural History Museum, Alfred Waterhouse's vast cathedral-palazzo with its Rhenish towers that loom over South Kensington, was opened in 1881. The vision of the anatomist Richard Owen, it was designed to house the natural history collections of the British Museum, which since the foundation of the museum with the bequest of Sir Hans Sloane's vast and heterogeneous collections in 1751, had been kept in Montague House – a seventeenth-century mansion in Bloomsbury. It has always struck me as a rather unsatisfactory building, not only from its rupturing of the enlightenment ideal of a single museum housing the arts and sciences, but also its rather ludicrous architecture – its dishonest terracotta-clad iron structure and awkward plan – the galleries a series of parallel cul-de-sacs, that look from the air like so many railway sheds – a stultifying triumph of Owen's even then outdated classificatory schema. To reach the botany collections is an un-necessarily long and complex, if visually eventful, journey ascending almost to roof level by means of a theatrical bridge and flying staircase to a much-loved exhibit, the calibrated section of a giant redwood trunk. Here one can appreciate the exquisitely painted ceiling, its two-dimensional coffers filled with depictions of economic plants, with gilded highlights [fig.9]. Appropriately for this particular journey the panel above the modest little door, through which, on ringing a bell, one is admitted to the Botany Department, is painted with the Sea Island Cotton, *Gossypium barbadense*, one of the species Wight experimented with in Madras in 1837. Although Sloane had large collections of dried plants, which still survive in numerous, bulky, bound volumes, the Botany Department was really the creation of Sir Joseph Banks, and its official name is still the Banksian Department. When he died in 1820 the Banksian herbarium was one of the greatest in the world,

with 23,400 specimens housed in 67 cabinets. This was left to the nation on condition that his trusted librarian Robert Brown (like Wight a pupil of Daniel Rutherford) should be its first Keeper. It took seven years to persuade Brown to become a civil servant and move the collections from Banks's Soho mansion to Bloomsbury, so that when Wight came to consult it in 1832 the herbarium had been at Montague House for only about five years. The collection has now grown almost beyond recognition and occupies what was intended as a long exhibition gallery, though Wight would recognise the beautiful cabinet doors of flame mahogany with gilded brass fittings that continued to be copied long after Banks's day [fig.10]. The figuring of the wood became plainer with time, until replacements were made in metal, and more recently compactor units installed. Wight would still also recognise Banks's original sheets, though these are now hugely diluted among 5.2 million sheets in what, after Kew, is the second largest herbarium in Britain. These are of a large size (and, in a trap for the unwary, labelled on the verso), reflecting the nature of the collection of which they originally formed a part – that of an eighteenth-century grandee, with a spectacular and expansive library designed for him by Robert Adam. Those of Hooker's herbarium are conspicuously smaller, representing a new generation of wealth based on industry (Hooker's money came from brewing), the growth of botany as a science, and the massive increase in the size of a collection that it was possible for an individual to assemble in the mid-nineteenth century. Such simple differences in paper size have had serious consequences and have been a significant factor in their not being, as has been suggested over the years, amalgamated with the Kew collection to form a single national herbarium.

At the end of the long herbarium is the departmental library, the spines of the books stamped with a curious motif – what initially looks like a pineapple plant is really a *Banksia*, a reminder of Banks's voyage with Captain Cook and the collections he made in Australia. In the library are three boxes holding about 740 Wight drawings and miscellaneous manuscripts including those of some of Wight's papers published in the *Madras Journal of Literature and Science*. The drawings are closely related to those in the Edinburgh collection, and it is not known how, when, or why the collection came to be split. What is most interesting is that these ones have never been mounted on herbarium sheets, and are stored in the way Wight arranged them, in folders of thin Indian paper bearing the family name. Unlike the majority of those in the Edinburgh collection few of these drawings were published by Wight, and they seem to represent a 'reserve' collection. Among them are some delicate drawings made in the Himalaya by M.P. Edgeworth, Bengal Civil Servant and half-brother of the novelist Maria Edgeworth, and many tracings of her orchid drawings sent to Wight by Ann Maria Walker from Ceylon. The Natural History Museum kindly agreed to lend this collection for me to catalogue in Edinburgh and one of the most exciting moments of the project came when I turned over drawing number 464 and discovered the faintest of pencil sketches showing the profile of a beautiful young Indian man, turbanned and ear-ringed. This was long after I had returned from my Indian travels and given up any hope of finding anything out about Rungiah or Govindoo, but could I at last be face to face with one of them? Perhaps unlikely, but at least a visual contact with one of Wight's elusive Indian household – it must certainly be by one of Wight's artists (and Govindoo is the more likely) and could be a portrait of one of the servants, but being a profile is unlikely to be a self-portrait.

PART II
IN THE FIELD

British Excursions

The botanical riches of Glen Fee were first shown to me by Ursula Duncan on a memorable expedition in 1971. She was a botanist of the old school, unmarried and scholarly, shy and reserved, thin and elegant with a ramrod straight back, hair scraped into a bun, dressed at home for work in her library and herbarium in an ancient green blazer. She was also a landed proprietor and it was at Parkhill that as a child I unknowingly experienced for the first time the botanical connections with the Orient mediated by Scottish surgeons working for the East India Company. Ursula's great great grandfather Alexander Duncan (1758–1832), was one such surgeon, based for a time at Canton. He made a fortune and in 1799 bought the estate of Muirhouse near Arbroath, which he renamed and developed, rebuilding the house as an austere Georgian box in red sandstone. The house still had the furniture with which he fitted it out, and the armorial china he brought back from China. Duncan was interested in botany and corresponded with Sir Joseph Banks, who made him a Fellow of what was effectively his private club, the Royal Society. He introduced the tree paeony to Britain, and a descendent of the original plant that persisted in the old walled garden at Parkhill has since been given to the RBGE, along with a collection of paintings of Chinese plants made by 'the best artists of the day during the years 1794–5–6'. Ursula did not, however, rest on her inherited position and despite a martinet of a father who believed in neither school nor university for his two daughters, after his death she obtained under her own steam not only two external degrees from the University of London (in Classics), but became an expert botanist, specialising in obscure groups – bryophytes and lichens, and among the flowering plants genera such as *Potamogeton* and *Carex*. One of her many virtues, despite painful shyness, was her encouragement of young botanists, and an apostolic zeal to show the botanical treasures of her beloved county of Angus to others, amateur or professional. It was on this first visit to Glen Fee that I learned a never-to-be-forgotten lesson in plant biodiversity. Although, with family encouragement, I had always been interested in flowers, I had no inkling of the importance or interest of cryptogams and was as much taken aback as my eleven-year old brother when he was gently but very firmly reprimanded for idly removing chunks of moss and lichen from a boulder for the thrill of watching them spin through the air. It was in these groups that Ursula had made her greatest contribution – they too were plants and had names – the moss was *Rhacomitrium* and the lichen a *Stereocaulon*! On this trip we were introduced to the silvery communities of arctic willows on the upper slopes of Corrie Sharroch, among which sheltered a trio of beautiful alpine sedges – *Carex norvegica*, *C. capillaris* and *C. atrata*. On this occasion we did not, however, make the necessary detour to see *C. grahamii*, the other sedge speciality of this Corrie, which was postponed for another excursion several years later. Ursula was a stickler about Latin pronunciation and another lesson she taught me was that every vowel must be enunciated, with no question of concessions to the vernacular pronunciation of a dedicatee's Scottish surname – it was *Carex* 'grayham-ii' and not 'grayumi' (similar arguments still go on – is *Menziesia* 'Men-zees-ia' or 'Ming-is-ia'?).

After the indoor work in the herbarium and library, some fresh air seemed in order in the form of a trip to Corrie Sharroch to revisit Graham's sedge, to make a bond with Wight over a living plant on the very spot where he discovered it in 1832. This was a pilgrimage in the footsteps of generations of botanists, the riches of the Clova Mountains having been first discovered in the late eighteenth century by George Don, one time Principal Gardener of the RBGE. Its romantic place names are immortalised on countless herbarium specimens – Craig Maud, Craig Rennet, the Burn of Fialzioch and the ravine of the White Water. Many such names, including Glen Fee, are map-maker's debasements of Gaelic names and therefore variously spelt (in Wight's day it was often 'Phee'), just as Wight's Indian ones are transliterations from Tamil. Arnott explained in a letter to Hooker that the etymology of the last was 'Fiadh', the glen of the deer, though it might well have been named for the eagles and peregrines that still rule the skies above it. One July day I made the trek, noting changes such as now having to pay to use the Forestry Commission's car park, and how the *Pinus contorta* that was then shorter than I, had now far overtaken me. What appeared to be late snow patches along the path ascending the waterfall at the head of the corrie were in fact sacks of materials air-dropped for mending the path, indicating increased pressure from hikers. Other than this, the panorama from the deer fence into the glen was the same – from the conical boss of Craig Maud, the pale scree below the *Oxytropis* rock, the ledge with the eagle's eyrie, the overhanging rock that marked the site of the rare fern *Woodsia ilvensis*, the rich cliffs of mica schist, and finally round to Corrie Sharroch and its willows. As there seems little risk of extirpation of what some might consider a dull plant [fig.11], I will risk giving the directions that allowed me to go straight to the spot after a gap of 30 years. It has, after all, survived in a single patch for at least 170 years, as have the other botanical treasures of Clova, many of them much more spectacular. Across the mouth of the corrie is a characteristic alignment of large boulders; one takes their line and climbs the corrie wall until level with the famous *Oxytropis* rock, and in Ursula's case extra precision was provided in the form of an antique brass aneroid barometer. The heather was alive with baby frogs, and ripe blaeberries provided tasty snacks. The slopes were still festooned with the trailing clubmoss *Lycopodium annotinum*, punctuated with the miniature Christmas-trees of *Equisetum sylvaticum*, and clumps of fleshy roseroot. Slippery tussocks of greater woodrush and, on the cliff ledges above, magenta splashes of wood cranesbill and fruiting heads of globe flower, were reminders that these slopes were once wooded. At last I reached the marshy slope where the sedge was still

Fig. 11. *Carex × grahamii* Boott, photographed at Wight's original site in Glen Fee, Angus.

in good health, with its gracefully nodding, madeira-flushed female spikes. Later, in distant Calcutta, I would read about Wight's exploits on this very slope – his friend Robert Greville writing to Nathaniel Wallich about the antics of 'Wightia scandens' astonishing those left down below.

ROOTS

The East Lothian Wights

I was keen to visit Wight's birthplace and the roots of his father's family in East Lothian, and a sunny summer's day found me in the fertile plain between the Lammermuir Hills and the coast of the Firth of Forth. This is a classic landscape of the improving lairds of the eighteenth century, among whom the Cockburns of Ormiston loomed large – Alexander, Robert's great grandfather, was one of John Cockburn's tenants at Eastmains of Ormiston. The countryside is undulating and the description made by the Rev Alexander Colvill in the *Statistical Account* of 1790 is still apt – 'inclosed with hedges of white thorn, mixed with sweet briar, honeysuckle, and hedge-row trees. A stranger entering the parish is apt to mistake it for England'. Milton [fig.12], the house where Wight was born in 1796, still stands, on a river terrace above the Saltoun Water. It is attractive, and has been lovingly restored, its cream painted harling (Anglice 'pebbledash') disguising an evidently complex building history. Of two stories and basically L-shaped, with what is doubtless a stair tower in the internal angle, but with a curious T-shaped addition to the north. It appears to be largely eighteenth-century, but the plan suggests a seventeenth-century origin; decidedly large for a farmhouse of the time, it was more likely a small laird's house. Like many East Lothian steadings in the Edinburgh commuter belt, the adjacent barns and granaries have recently been subjected to an unfortunate makeover, their brashness detracting somewhat from the old house. The barley fields surrounding the buildings are the successors of those that Wight's father brought to a state of cultivation 'not surpassed, if equalled, in any part of the country'. The sizeable burn, which rises in the nearby Lammermuirs, and passes the big wood of Saltoun, is lined with alders, and in childhood Wight doubtless explored its flora, though he would have been surprised by the rare hybrid hogweed (between the native *Heracleum sphondylium* and the giant *H. mantegazzianum* from the Caucasus) that now grows by the handsome bridge beside the nearby barley mill (now also domesticated) from which the 'big house' takes its name. I also visited Duncrahill, his grandfather James's farm nearby: further inland and higher up, and now devoted to beef and potatoes. Wight, with his love of new technology would doubtless have approved of the windmills of Sutra visible on the horizon.

The Midlothian Maconochies

Diane Baptie's genealogical delvings on my behalf in the National Archives of Scotland had uncovered fascinating and previously unknown information about Wight's maternal family, the Maconochies. The name was familiar from an extant Wight family tree, and from the India Office I knew that one Allan Maconochie was a witness at Wight's baptism in 1801. The compiler of the family tree stated that Wight's mother Jean was a niece of Lord Meadowbank, and he turned out to be one and the same as Allan Maconochie. Diane had traced the family back to James Maconochie, a wealthy tailor in the Canongate, the lower part of the 'Royal Mile', in the Old Town of Edinburgh, who must have been born around 1660. James speculated successfully in land in Perthshire and Fife, and in 1703 bought the estate of Meadowbank on the border of Midlothian and West Lothian. His first wife Marjorie Smith and three of their four children all died young, doubtless due partly to the unhealthy conditions of the overcrowded Old Town, but at the age of around 50 James remarried Jean Henderson who bore him a flourishing family of seven, their vigour doubtless helped by the healthy Midlothian air. It was one of these, William (who remained in trade, as a wright or builder, in Edinburgh) who was Wight's maternal grandfather. An elder son of James Maconochie, Alexander, took to law as a 'writer', and it was his son Allan (named for his mother's maiden name), who became the first Lord Meadowbank. Meadowbank was therefore Jean Wight's cousin, but the 15 year age difference no doubt explains the avuncular designation, and it is likely that Wight also regarded him as an 'uncle'.

Consulting obvious references such as Burke's *Landed Gentry* I discovered that Meadowbank's son also became a judge, the 2nd

Fig.12. Milton House, near Saltoun – Wight's birthplace.

Fig.13. Meadowbank House, Kirknewton – home of the senior branch of the Maconochie family.

Lord Meadowbank, and adopted the name Maconochie-Welwood. Early editions of the work give a romantic origin for the family, making no mention of an Edinburgh tailor, but tracing them to the Campbells (alias Maconochie) of Inverawe, one of whom lost his lands and was executed in 1661 for his part in the Marquis of Argyle's uprising, and that the money to purchase Meadowbank originated in financial compensation for the loss of the Lochawe lands. Diane dismissed this as an unlikely myth, and it is discreetly dropped from later editions of Burke. Both of the Lords Meadowbank merited entries in the *Dictionary of National Biography*, and the wonderful new edition of this work records that both were painted by Raeburn.

A visit to Meadowbank was thus essential and I drove out there one Sunday afternoon. It was easily found and I somewhat tentatively drove up the sweeping drive to find a picturesque and rather unusual house, set in beautiful and well-tended grounds. I took fright at the large number of Range Rovers and other similar four-wheeled symbols of prosperity parked outside the house, assuming that it must have been bought and done up by an Edinburgh fund manager, and beat a discrete retreat. On the way home I happened to drop in on some friends who, by an amazing coincidence, had been to a wedding reception there only the previous weekend, and

told me that it was owned by a charming couple called Welwood. The converted stables are run as a function suite, and were the reason for the Range Rover fleet. Phone calls rapidly ensued and a more official visit made. Mr and Mrs (Maconochie-)Welwood could not have been more welcoming and were (fortunately) completely unfazed by my exploding of the myth of the family origins. They had both been brought up in Kenya, though there was a faint connection with my purpose in that Charles's father had gone to Kenya after damaging his back in a polo accident while a tea planter in Assam in the 1920s. The explanation for the picturesque appearance of the house as it stands is that a large 1835 wing by W.H. Playfair was demolished to little more than its foundations in 1947, but a massive balustraded screen from this period, forming a courtyard round the rear quarters of the early eighteenth-century house, had been left.

It is seldom in such research that one finds what one dreams of, but here was the exception. The Raeburns of the two Lord Meadowbanks had gone, the family story being that the present owner's grandfather had sold them along with the other family Raeburns when the income tax rate went up from 2/– to 2/6 in the pound shortly after the First World War; grandmother, however, managed to rescue two from consignment to the saleroom by smug-

Fig.14. Allan Maconochie, 1st Lord Meadowbank. Oil on canvas, 636 × 764 mm. By Sir Henry Raeburn. Scottish National Portrait Gallery.

Fig.15. Sir Robert Preston. Oil on canvas, 610 × 750 mm. Anonymous, *c*.1770. Mr & Mrs Maconochie-Welwood.

gling them into the attic and putting their faces to the wall. The exquisite and deeply felt study of Allan Maconochie's wife, Elizabeth Welwood, as a mature matron, was therefore still there, and a Google search, and some other digging around, revealed that *pater* was not far away, in the Portrait Gallery in Edinburgh [fig.14], and *filius* had crossed the Atlantic and was now in the Met in New York. A stunning portrait of a much younger Mrs Allan Maconochie by James Northcote has ended up in the Art Institute of Chicago.

Another portrait attracted my attention, a stout and self-satisfied gent in an armchair upholstered in damasked silk, labelled 'Sir Robert Preston, Captain of Asia Indiaman' to which someone had added in biro, in a fit of wishful thinking, 'Zoffany?' [fig.15]. It was almost certainly painted in Calcutta, whose river and shipping appear beyond the balcony on which Preston sits. Preston was captain of the 'Asia' in 1767–8 and 1770–1, but Zoffany did not go to Calcutta until 1783, and Tilly Kettle seems a more likely attribution. The name was familiar, as it was Preston who had written that letter in the India Office asking if Wight could be appointed to Madras (rather than Calcutta), and I had been intrigued that the letter heading was 'Downing Street' – clearly written by a man of some standing. But what was he doing at Meadowbank? The answer was soon discovered – he was Lady Meadowbank's uncle and owned the estate of Valleyfield in Fife, which he had inherited with a baronetcy on the death of his brother Charles in 1800. Valleyfield is well known in the annals of garden history as Repton's only Scottish garden. It was the man known to his contemporaries as 'Floating Bob', who had commissioned Repton, and who had developed the extensive coal reserves beneath the estate.

The two Lords Meadowbank were both also sculpted by Chantrey – that of the first has ended up in Montreal, and that of his son has recently been acquired by the National Galleries of Scotland. While I was photographing 'Floating Bob' Mr Welwood disappeared into the attics, and by time I had finished, a plaster copy of Chantrey's bust of the second Lord M had miraculously appeared on the kitchen table. My hosts then took me outside (despite appalling weather) to see the garden front of the house, the central part of which is an attractive early eighteenth-century bonnet laird's house, in honey coloured stone, which must once have been harled. But what was scratched onto the window lintels? A series of marriage stones, a tradition that has charmingly been continued to the present day. One of these read 17 * IM MS * 05, another IM * 1718 * IH, and here was the proof, literally carved in stone, that this was the house built by Wight's great grandfather James Maconochie, the Canongate tailor, recording his two wives Marjorie Smith (presumably when the house was first built, as they were actually married in 1683) and Jean Henderson (carved in the year of their tenth wedding anniversary). The Welwoods were equally thrilled, as they had no idea whose initials these were. The final port of call was the family burial ground, hidden in a thicket of yew and beech deep in a wood. It was by now pouring with rain and perishing cold, so the visit was brief. It was a traditional walled burial enclosure, of the sort found in many Scottish estates, but the plan of this one was extremely curious. Over the gate were the family arms, supported by kilted highlanders (doubtless Lochawe braves), and the inscription: 'The burial place of the Maconochies of Meadowbank was in the old church of Kirknewton till in 1790 Allan Maconochie, a senator of the College of Justice, selected this place for the family cemetery'. The original enclosure was evidently octagonal in plan, but with the alternate walls curved, in which stood the first Lord M's memorial, a plain, free-standing obelisk, with a much later inscription. The graveyard had evidently been enlarged with the addition of an asymmetrically placed rectangle to allow for later burials including that of the second Lord M, whose mural monument was a much grander architectural structure than his father's (two obelisks, a broken segmental pediment, swags, guilloche moulding …), speaking eloquently of the rising social status of the family. Even in this hurried visit two stones leapt out as being of Indian interest – firstly one to Henry Dundas Maconochie, 'Assistant Magistrate of Cuttack … seized by the ruthless malady of India' in 1844. This was the second Lord M's third son and his name speaks volumes of the family's social circle and political allegiances, as he was clearly named for Henry Dundas, 1st Viscount Melville, 'uncrowned king of Scotland' and fellow Midlothian landowner (Melville Castle was part of his wife's dowry). His influence in the matter of Scottish and Indian appointments has already been mentioned, and Allan Maconochie owed his Chair of Public Law at Edinburgh to Dundas. The second stone of interest was another testament to the importance of Dundas's patronage, as it was through him that Robert Maconochie (1778–1858) obtained his posting to the Madras Civil Service in 1808. Robert was Allan Maconochie's second son, and the stone recorded that he became 'Master of the Madras Mint'.

Blair Atholl

At several points during his furlough of 1831–4 Wight paid lengthy visits to his sister Anne, and her husband the Rev John Stewart, at the manse of Blair Athole (as it was then picturesquely spelt). He took part of his herbarium with him and Hooker once wrote to Wallich saying that 'Blair in Athol is highly honoured by possessing such a valuable herbarium within its boundaries'. It was there that Wight did some of his work on Indian Asclepiadaceae; he also explored nearby mountains such as Beinn a'Ghlo and local sites such as the Falls of Bruar, so a visit to the house in which he stayed seemed called for. The Old Manse lies at Baluain, and I must have passed it dozens of times driving north on the A9, never imagining that I might one day have a reason for visiting it. It is a handsome Georgian house [fig.16], covered in climbing roses, set behind

Fig.16. The Old Manse of Blair Atholl.

paddocks grazed by handsome, chocolate-coloured Arab horses. From friends nearby I had gathered that the owners, Alan and Denny Russell were approachable, but nothing could have prepared me for the hospitality I received on ringing the bell, unannounced, one Sunday morning, shortly after my visit to Meadowbank. It was a week of Raeburns, as the first thing I saw when the front door opened was one of his most magnificent half-length portraits, of John Clark, holding a violin. Even more surprisingly the Russell's were the proud owners of Raeburn's steel-rimmed spectacles in a shagreen case, possibly the very ones through which he studied Lord Meadowbank's solemn visage. It was deeply satisfying to be able to show the current owners reproductions of Rungiah's drawings that had almost certainly been silent guests in their house 170 years previously. The Russells rescued the house from near dereliction and have restored it lovingly over the last twenty years in the most stylish manner. The original layout of the rooms has changed somewhat, but the original three-bayed main block of 1827 probably had four rooms up and down, with a kitchen wing attached to the rear. A large three bayed wing to the left must have been added very soon after the main block to house the Stewarts' large brood of children and their tutor. One could only speculate as to which was the room that Wight had fitted out with shelves for his herbarium, but it could

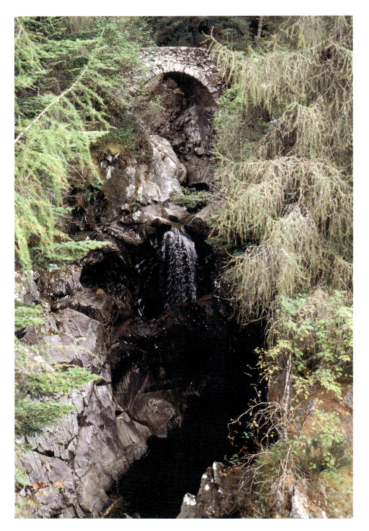

Fig.17. The Falls of Bruar

well have been one of the snug ones in the back wing over the kitchen, which would have been drier than the rest of the house in days before central heating. I'm sure that Wight and his Presbyterian minister host would have been astonished by the sumptuousness of the present interiors, made possible by the twentieth-century phenomenon of the North Sea Oil boom; he would also have been pleasantly surprised by the improved communications – the greatly upgraded road, that has now fortunately been rerouted on the other side of the River Garry, and, given his early advocacy of railways in India, the main line to Inverness that passes immediately behind the house.

Having explored the forbidding lumps of Carn Liath and Beinn a'Ghlo on previous occasions (like most Scottish botanists in a vain search for *Rubus arcticus*), I did not revisit them this time, but used the opportunity to visit the Falls of Bruar [fig.17], a famous beauty spot, forested by the great 'Planting' fourth Duke of Atholl (who had inducted Stewart into the parish) at the suggestion of Robert Burns. Like the Hermitage at Inver, which was given a similar treatment, the falls are spectacular – when broken the water is like sparkling milk, but flowing over the scoured and polished rocks and falling into deep pools it has the rich colour of an *oloroso* sherry. Two picturesque single-span bridges of rough stone cross the burn, the occuli of the upper one indicating its eighteenth-century date, though in our safety conscious age the holes have been filled in. From this upper bridge, hoary with lichens, was the wonderful sight of two cock bullfinches greedily devouring rowan berries – a shocking colour combination like that of the spindle fruit – strawberry-mousse feathers against orange berries. Some late dragonflies cruised menacingly, but the handsome conifers (drooping larches, glaucous Scots pine, and dark Norway spruces) softened the scene as Burns had wished, and reminded me of Bhutan.

On the way home I stopped off at the parish church, which had been built for Stewart by his Duke, and opened in 1825. It is a strange building externally, consciously rustic in style, and hard to believe that it was designed by that suave classicist Archibald Elliot. (Internally it has been democratised, with the removal of the ducal pew). On a previous visit I had failed to locate a memorial to Wight's sister and her husband, which I thought must surely be there. A book on the inscriptions in Perthshire graveyards subsequently confirmed that there should have been a monument against the north wall. This time the reason for my initial failure became apparent – the villain was a large ivy plant, raised slightly at one point into a suspicious hump. The ivy was almost impenetrable, but determined hands managed to prise it apart (releasing that wonderful sandalwood smell), and there was the stone. The scandal relating to the Minister's burial has already been told, and in the light of this it was not so surprising that the adjacent stone to his daughter (Mrs Campbell) had recently fallen, face-down, from the wall. This was unfortunate as I was keen to see if it confirmed whether her husband 'Colonel James Campbell', might be one and the same as the Captain James Campbell, Wight's botanical companion in his early Madras days. (When one discovers that there were four Robert Wights all at Edinburgh University at the same time, one becomes reluctant to make assumptions from common combinations of Scottish names). The grave of Wight's distinguished military nephew, by contrast, remains suitably erect – born at Blair Manse in 1811, served in the Royal Scots Fusiliers, present at Alma, Balaclava, Inkerman (where he commanded his regiment), and at the siege

and fall of Sebastopol, and who as a General held the command of the troops in Scotland 1875–8. As he died at Norwood (in 1889) it seems somewhat surprising that he should have been buried almost 500 miles away, but such things became possible with rail transport.

DESCENDANTS: JOURNEY TO STRATHTAY

Given the Blair connection, it was another rather extraordinary coincidence to discover that an email sent by Wight's descendants 170 years later emanated from a farmhouse just across the hill, a mere nine miles away as a raven might fly. Middleton, the temporary home of the Moore family, lies above the village of Strathtay, overlooking one of the most beautiful stretches of the River Tay, just downstream from Cluny, that most Himalayan of Scottish gardens. Gillian had been clearing her father's house on Skye and had come across some intriguing relics in a garden shed bearing the name of Robert Wight – a wooden snuff box and two bronze medals. These brought back dim recollections of tales of a botanical ancestor; Google did the rest and resulted in the email quoted in the introduction to the first volume sent by her daughter Lindsey. The snuff box was particularly interesting, the work of Charles Stiven, an ingenious boxmaker of Laurencekirk famous for his carved wooden hinges. Its material, oak, however, was unusual, and presumably significant – perhaps salvaged as a souvenir from a historic building or ship, or from a tree planted by an eminent personage. 'R. Wight' is engraved on a silver escutcheon, and the Royal warrant stamped on the inside of the lid showed it to date from after 1837. Perhaps it was sent out to Wight in India by his sister Anne, and one could imagine Wight thinking fondly of her while taking consoling pinches of snuff during long evenings spent working on his books and collections in Coimbatore or Ootacamund.

Both medals were designed by William Wyon (1795–1851), the leading designer of coins and medals of his day, and both bear stunning profile portraits: Linnaeus on one, Albert, Prince Consort on the other. The former was awarded to Wight by the Society of Apothecaries of London. The latter 'for services' by the Commissioners of the Exhibition of the Works of Industry of All Nations – for Wight's role on the committee that sent natural products from Madras to the great glass palace built by Joseph Paxton in Hyde Park in 1851. The Moores also had a few manuscripts and papers, including some in Wight's own hand – drafts of letters written to *The Times* in his old age about his cotton work. More interesting were some papers on evolution, which had been preserved by Gillian's uncle, Henry Cecil Cosens (a Ceylon tea planter and a great grandson of Wight) and written up in *Nature* by T.E.T. Bond in 1944. These concerned an eccentric Irish doctor with the apparently not inappropriate name of Henry Freke. The Moores also had what has proved to be a remarkably accurate family tree compiled in Sussex in 1935 by an Anglican vicar (the Rev J.S. Roper), a descendent of Wight's eldest, military brother James. Wight's own line was decidedly sparse, but his siblings James and Anne spawned large clans, dispersed as far as Honololu and Melbourne, and showing a heavy military bias and generations of service in India, liberally peppered with Colonels and even several Major Generals. There were also some intriguing blacksheep such as Wight's fourth son Charles Field (1851–1923) denominated 'not a satisfactory member of the family' and a grandson Robert Leslie Wight, a Lieutenant in the Royal Navy, who in 1927 went ashore at Shanghai 'to dine with friends and after taking his leave was never heard of again; it is thought either murdered or drowned'. Other tragedies were recorded, such as Wight's youngest son, Ernest Octavius who perished in the First World War 'while tending wounded in France'. Another relation who perished in this same conflict was altogether more interesting – none other than Oswald Fitzgerald, Lord Kitchener's ADC and 'constant companion of nine years' who went down with him on HMS Hampshire off Orkney in 1917 – he was also descended through James, and was Wight's great great nephew. Some

Fig.18. Bronze 'For Services' medal issued to Wight in 1852 by the Commissioners of the Great Exhibition.

Fig.19. Bronze medal issued to Wight by the Society of Apothecaries (post-1838).

medico-botanical genes perhaps still run in the family, as Lindsey, Wight's great great great great granddaughter turned out to have studied herbal medicine at Napiers of Edinburgh, and her sister Fiona is currently doing a doctorate in psychology at St Andrews.

LONDON

Beside the noise and bustle of Piccadilly is a remarkable scholarly haven, the Linnean Society of London, and everyone who goes through the archway of Burlington House to see the Royal Academy's latest blockbuster exhibition passes its discrete front door. The origin of this Society lies in the purchase by a young James Edward Smith (another Edinburgh-trained medic), for the sum of £1088 5s, of Linnaeus's collections from his widow, as the result of a breakfast conversation with Sir Joseph Banks on 23 December 1783. Smith founded the Society five years later, and later sold it the Linnaean collection, though when Wight was made a Fellow on 17 January 1832, it was based in Banks's former house at 32 Soho Square. Shortly after Wight's return to England the Society moved to Piccadilly where it held its first general meeting in 1857 (and where the famous Darwin-Wallace papers were read the following year). The Society moved out of the original neo-Palladian Burlington House (which became the Royal Academy) in 1873, into the handsome rooms it now occupies on the opposite side of the quadrangle, built for the Learned Societies by an enlightened government.

A visit was due to see what traces of Wight the ever-helpful librarian, Gina Douglas, could unearth. The process for election of members is the same today as it was in Wight's time, involving a proposal signed by existing Fellows. Fortunately the election certificates are kept, and give a fascinating insight into the relationships between these men of science. There was also a letter from Wight to his friend Nathaniel Bagshaw Ward, inventor of the Wardian Case that played such an important role in the translocation of plants across the Empire, and another letter to Francis Boott asking if Wight could borrow the Society's specimens of Indian Asclepiadaceae. Best of all was a deeply moving photographic portrait. The only image I had previously seen of Wight was a lithograph published by Hooker, showing him in the prime of life, aged 36; but here was Wight after a further 17 years' exposure to the Indian sun. The photograph is in a volume of profoundly characterful studies made in 1855 by George Henry Polyblank for the Literary and Scientific Portrait Club, which also includes iconic images of Huxley, Hooker and Darwin. Evidently the strangely named Polyblank took several versions (though all seated in the same cumbersome Victorian chair), and this one is apparently unique in showing Wight holding a herbarium specimen. This prop was doubtless specially chosen, so it is maddening not quite to be able to make out what the species is.

In December 2005 I was invited by the Linnean Society to give the Hooker Lecture, a lecture originating in a bequest by Sir Joseph Hooker, and given from time to time on a subject related to Hooker's own interests. I chose as my subject his friend 'Robert Wight and the Illustration of Indian Botany'. Lecturing in a place so laden with history was somewhat nerve-wracking, but was made easier by the portraits surrounding the audience. Before entering the room I had passed a bust of Alexander Macleay, whose Quinarian System of classification was used by Wight, and on the walls of the room no fewer than nine of the portraits were of men known to Wight – J.J. Bennett, George Bentham, Robert Brown, Charles Darwin, J.D. Hooker, W.J. Hooker, Archibald Menzies, Nathaniel Wallich and N.B. Ward.

While in London another essential pilgrimage was to look for 9 Queen Street, Soho, the house rented by Wight in 1831 for sorting his herbarium specimens. This was deliberately chosen to be close to Wallich who had rented 61 Frith Street, just around the corner, as a base for his labours on curating and distributing the great EIC herbarium. However, Wight found it 'too dark and confined a habitat' and did not go back to it when he returned to London from Scotland in July 1833. Soho today has a reputation for sleaze, but in the late eighteenth and early nineteenth centuries it was an altogether more distinguished *quartier* with houses of grandees such as the one on Soho Square built by Robert Adam for Sir Joseph Banks. The parish church of St Anne is noted for its unique bulbous steeple, designed by Samuel Pepys Cockerell, better known for the extraordinary house of Sezincote in Gloucestershire, in hybrid Moghul-Georgian country-house style for his brother, a Calcutta nabob. Soho was then also a district of skilled craftsmen such as musical instrument and cabinet makers. Also here were booksellers such as William Pamplin (in Frith Street), who played such an important role in the literature-based science of botany, though one that has been largely overlooked, no doubt for snobbish reasons. Not only did they supply books and journals to literature-hungry botanists in distant corners of the world, but they also dealt in other essential raw materials for the taxonomist – botanical prints, drawings and even herbarium specimens. Interestingly, from letters to Wallich, it appears that, after Wight had finished with it, Pamplin and John Hunneman used 9 Queen Street as a base for distributing books and specimens until at least 1840. On my first visit to Frith Street I was taken aback in failing to locate Queen Street, so had to look up a Victorian 'A to Z', to discover that it has since been renamed Bateman Street. Sadly Wight's house has been demolished, the site occupied by a small but bombastic building in Art Deco style, part of which is occupied by a characteristic sign of our times – a branch of a sandwich shop chain. Although Wight's base has gone, Wallich's 'botanical laboratory' survives – a typical narrow, London eighteenth-century brick house, opposite one once lived in by the writer and painter William Hazlitt.

A letter to Henslow

Judicious use of the internet has transformed research, not only through increased access to information, but for those of an acquisitive nature, in the increased scope it allows for the formation of collections. In the case of books one used to depend on catalogues from booksellers of whom one happened to have heard, or the time-consuming and highly inefficient pastime of browsing in dusty bookshops. Through the internet the whole world of books, both old and new, is now available at the click of a mouse. During the course of this research I frequently typed Wight's name into 'abebooks.com', which allowed me to find, at a knock-down price in Australia, a pristine copy of Wight & Arnott's *Prodromus*, and, during a visit to New York, a copy of the first volume of the *Icones* (including rare introductory material) that, being on Long Island, was delivered the next day. More curious were the three Parliamentary 'blue books' containing the story of Wight's cotton work in Coimbatore. These I needed so that their indigestible contents could be perused in the silent privacy of my own study, rather than among the distractions of a public library. I noticed that their source

Fig.20. Birds collected by Wight on his 1826–7 expedition in South India. Natural History Museum Bird Room, Tring.

comparing his specimens with those in the Banksian and Linnean collections and working on Asclepiadaceae, commenting on the difficulties of studying the minute parts of the Asclepiad flower in 'the bad light which candles afford'. This was just at the point Wight was about to start the great collaboration with Arnott, and had recently accompanied a depressed Wallich to Deal, to see him off on the ship 'Exmouth' that took him back (*sans* wife and family) to India.

Tring: an ornithological interlude

In a letter written from Blair Atholl in 1833, Wight contemplated obtaining specimens of waterhen and woodcock for Hooker's young son William. We also know that he shot birds in India for the Madras Naturalist's Collection – but had any of these survived? The obvious place to try was the Natural History Museum, and it was satisfying when the answer from Robert Prys-Jones, head of the Museum's Bird Group, was 'yes'. They had records of Wight specimens sent to the India Museum in 1829, and passed on to the British Museum with the dispersal of the India Museum between 1860 and 1880. The Museum's bird collections are now housed in the Walter Rothschild Zoological Museum at Tring, Hertfordshire. This museum was started as a private venture by the second Lord Rothschild, head of the English branch of the banking family, but a keen and prolific taxonomic zoologist, best known for his work on birds of paradise. He was also something of an eccentric and is famed for having once driven a carriage down Piccadilly drawn by two pairs of zebra! The public part of the museum was, as expected, a wonderful piece of Victoriana, with some spectacular taxidermy including displays of jewel-like hummingbirds and a very large case demonstrating the astonishing morphological diversity of man's best friend. Behind the scenes, however, it is the very model of a modern, scientific museum, with thousands of ornithological study skins – bird kebabs on wooden skewers, arranged in serried ranks in shallow drawers. Mrs Warr had kindly looked up the old registers and waiting for me was a tray of nine specimens collected by Wight on his great tour of southern India in 1826–7 [fig.20]. And not just nondescript 'little brown jobs'. After months of looking at discoloured, dried and flattened plants, it made a refreshing change to see some brightly coloured three dimensional zoological specimens still in surprisingly good condition, ranging downwards in size from a magnificent, softly plumaged brown fishing owl, to a brilliant green and red crimson-fronted barbet. There were also treepies, a nightjar and a distinctly primeval-looking grey hornbill.

It was now time to follow Wight eastwards to India, to discover if any trace of him or his artists could still be found there, and to see the places where he lived and worked, and the most productive of his collecting localities.

was a bookseller in Leeds, which turned out to be in the next street to the one where I was born, the bookseller's store being in a curious building, once a private gymnasium where I had been sent to play as a child forty years ago. Illustrations and manuscripts also sometimes turn up on 'abebooks.com', and it was in this way that a copy of the only print in Wallich's *Plantae Asiaticae Rariores* to be based on a drawing of Rungiah's came to light, as did a relic of Wight's Queen Street days. The latter was advertised as a manuscript letter addressed to a 'Professor Winslow' of Cambridge (Book 2 fig.16). This sounded like a misreading of Henslow, Darwin's mentor, but puzzlingly the letter was said to mention a visit of Wight's to Holland. A momentary panic – how could I have overlooked a visit to Holland? Could he have made a foray there to visit Carl Ludwig Blume? The letter arrived a couple of days later from America, and was indeed to Henslow, but the location of the projected visit had been misread by the dealer (easily done with Wight's scrawl), and was (reassuringly) to Scotland rather than Holland. The letter's survival was possibly due to its having been one of the Henslow letters that Dawson Turner acquired for his autograph collection. Turner was W.J. Hooker's father-in-law (and Joseph Hooker would marry Henslow's daughter) and Wight at one time considered marrying his daughter Eleanor. The letter, written on 15 November 1832, was apparently a one-off rather than part of a regular correspondence, and as such of particular interest. It gives a glimpse of Wight's London stay –

Fig. 21. A post-monsoon view of the Tamil Nadu State Archives, Madras

An Indian Excursion

I had always had a certain interest in Madras from a bloodthirsty incident in the youth of my great great grandfather, which took place there in June 1802, when he was twelve years old. Here is the tale in his own words:

> Mr John [Farquharson] afterwards being appointed to another [EIC] ship called the *Perseverance*, in 1800 he persuaded my father to let me go with him as his servant, promising to put me into a respectable situation. My father, having agreed to his proposal, I was sent to join him in London where I arrived in the beginning of Jany. 1802, and soon after sail'd for Madras and China, and having a crowded ship with soldiers going to Madras, the typhus fever carried off a great many of both soldiers and sailors, and out of about 500 men aboard there was hardly as many in health, as was necessary to bring the ship to anchor. When we arrived in Madras Roads, I had a severe attack, and then a relaps, and being in a helpless state, and while absent in my attendants arms from my hammock, a black rascal stole my bed cloths and had cleverly disposed of round his body, so that he could not be easly detected. However, the alarm being given, he was caught as he was going over the ships side and was put in irons, in the poop. The next day the Captain order'd him to get two dozen of lashes with the thieves catt, and as I was a kind of favourite with Capt. Tweed[a]le, he desired me to be carried and seated on the quarter deck beside the Officers, thinking I would like to see the black flogg'd. But he was mistaken, for I was so disgusted with the horrid spectacle that I begged the Capt. to forgive him. But no, an example must be made to deter others from stealing. I was so weak and shock'd at the bloody spectacle that I nearly fainted, and was allow'd to be carried to my hammock. When I was able to walk, I was taken ashore to the Captains House, and a number of sailors was sent to the Hospital where we was oblig'd to leave a good many of them, and several died there.

Scarcely an auspicious precedent, perhaps. My own visit began in October exactly, and coincidentally, two centuries later, at what turned out to be the worst possible season to visit Madras (the reasons for calling it Chennai are not unchallenged even in India, so I won't), in the throes of an extremely violent north-east monsoon. It was not, however, only the weather that gave me a jaundiced view of the once great city. As will become apparent I rapidly discovered the *Rough Guide's* description of Madras as 'hot, fast, congested and noisy… the attractions of the city itself… sparse' to be only too accurate, and that it was for very good reasons that 'most travellers stay just long enough to book a ticket for somewhere else'. Unfortunately I could not do this – the city was the nerve-centre of the administration for which Wight worked, and he must therefore have left a legacy in the EIC's records kept in what is now the Tamil Nadu State Archives [fig.21]. The city was also Wight's base at two points in his Indian career, firstly as Madras Naturalist between 1826 and 1828, and then as what would now be called an economic botanist from

1836 to 1842. Throughout his career Wight was on the Madras medical establishment and his official posting during his economic work was as Garrison Surgeon of Fort St George, the military and administrative headquarters of the Madras Presidency and even now for its successor, the state government of Tamil Nadu. This second period was one of great significance for Wight as it was then that he was married in the Cathedral, became secretary of the Agri-Horticultural Society, and started to publish his great solo botanical works, the *Icones* and *Illustrations*. Traces of all these activities were indeed still to be found, but somewhat against the odds.

The Tamil Nadu Archives

After the relatively benign experiences of the Maharashtra State Archives in Bombay while researching the Dapuri book, I had not worried unduly about the prospect of using the Madras ones, and made preparations accordingly – asking the local British Council (BC) to set up the visit, and taking with me the documents required in Bombay – a letter from the BC, and one from my own institution, the RBGE. This was not to be enough, and nothing could have prepared me for the events of the next few weeks. The science staff at the BC were not used to dealing with such requests and had not really made adequate enquiries, and neglected to tell me before setting off from Scotland that for 'Aliens' to work in the Madras Archives another crucial piece of documentation was required – a statement from the Indian Consulate in their country of origin that they were *bona fide* students, which could easily have been obtained before leaving Edinburgh.

So I arrived at the Tamil Nadu State Archives, the largest in South Asia, a brick building in the Indo-Saracenic style, purpose-built in 1909 as the Madras Record Office. It has a long central corridor on either side of which lie a series of large halls, filled with miles of shelving, on which sit the huge and grubby folios. The building was not under-staffed; I counted 16 employees standing around in the main corridor at one point, but they spent most of their time arguing noisily among themselves, and doing nothing in the way of work. The first room on the left is the grandiloquently named 'Research Hall', painted an ugly shade of pale green, lit by searing-white, epilepsy-inducing, fluorescent lights a few feet above head height. These were attached to a false ceiling, designed to reduce the volume of the room for some ill-fated air conditioning system, but as this no longer worked, it served merely to reduce natural air circulation, and the only fans were noisy contraptions at the front of the room for the sole benefit of the staff. The best position I eventually found was tucked away in a back corner as far as possible from the clanking fans, but where there was an inkling of a through-draft between windows opening onto the corridors. The temperature and humidity were almost unendurable, and one had to rest one's hand on a hanky to prevent sweat from getting onto the huge,

browning pages of the archival volumes. Zoological distractions came in the form of bloodthirsty mosquitoes, and a relentless chorus of chinking palm squirrels. The reading desks were too high, and the stiff wooden chairs too low, even for the long-of-back. But these difficulties were as nothing to those presented by the staff. They were not to blame for my lack of proper documentation, but this got us off on the wrong footing. In charge of the Research Hall was a wizened woman with a high-pitched screech, who resembled an unwrapped Egyptian mummy. She was actively antagonistic and did everything in her power to prevent my working there; her male underlings, responsible for collecting request forms and transferring them to those who fetched the volumes from the stacks, were merely sullen and lacking in energy – affable-enough when one had proved one's persistence through 'trial by bureaucracy'.

Even in the cold light of day, four years later, the eight-day battle that ensued is painful rather than amusing to recall. Difficulty after difficulty was produced. The registration fee given as 100 rupees in the rules had inexplicably doubled. The letter I brought from the BC, was signed, but didn't bear a rubber stamp, and could therefore have been faked, so had to be taken back to the other side of town and amended. Even obtaining a meeting with the Commissioner of Archives was a struggle, due partly to the brevity of his working hours. When this eventually occurred, he turned out to be under the thumb of his Assistant Commissioner (Education). The Commissioner eventually agreed to my starting work on the basis of the papers I had, but Additional Commissioner (Education) was not to be thwarted and waited until the Commissioner had left for the day to write a letter, ostensibly on his behalf, countermanding the verbal permission he had given pending the arrival of a letter from the Consulate in Edinburgh. Remote co-ordination necessary for obtaining this letter was the next challenge, but six days later the required document was eventually faxed; the Regius Keeper having had to write another *bona fide* from the RBGE, to which, for a consideration of £15, the Consul had added his mark. I bore this fax in triumph to the Mummy, who on sight of it fizzed visibly with rage and insisted on taking it and me to her crony the Additional Commissioner (Education), who in turn insisted that nothing could be done before my seeing the Commissioner again the following day. Even then there were still two further rites of passage, expeditions to the distant General Post Office, and to find someone in the maze that is Madras to take a passport photograph for a security pass. The point of the first was to open a savings account in which the sum of 500 rupees was to be deposited. My first visit to the Post Office was at 4 o'clock, to discover that such an account could only be opened between the hours of 10 and 3. The pass book still lies in a steel *almirah* in the Archives, guarded by the Mummy; the money in the Post Office, perhaps even accumulating some interest, though I have no intention of ever reclaiming it or of revisiting the Tamil Nadu State Archives.

Thus it was that more than a week after having expected to start work, a requested volume arrived in the Research Hall and I could embark on my search for Wight. Although records had started to arrive, the problems had by no means ended. The people fetching the volumes from the stacks made up their own rules about when, and how many they would vouchsafe – these almost never came before mid-afternoon, and most days the ration was five. The trouble with this was that in order to get at the records, one first had to consult index volumes, which were treated the same as those containing the records and rationed accordingly. For some years a single department could have ten index volumes and 50 of records. It can be seen that if the five-volumes-per-day rule was stuck to, for this year and department it would take two days merely to obtain the index volumes to discover which record volumes were required. The project had the ghastly prospect of stretching out into infinity. The indexes could be scanned rapidly, leading to much hanging around and frustration. Enquiries addressed to the men at the desk ('when will they come?', 'how long will it take?') elicited prevarications, downright lies, and a small repertoire of disyllabic responses: 'you sit', 'you wait', 'half-hour'. One day such a charade went on for five hours. They were not to be blamed for their lack of English; I was for my lack of Tamil, but this was not only a problem for foreigners. One day a history lecturer from Mangalore showed up – to do his research he had taken time out of a short vacation, and made a 12 hour rail journey only to face equal difficulties, speaking 'only' Kannada and English, but no Tamil.

Another problem was that nobody on the staff knew (or at least was prepared to communicate) any details of the contents of the Archives. The only 'finding-aid' I was allowed was a single, pitifully inadequate, printed index referred to gnomically as 'GL45' dating from the late 1940s. This listed and gave reference numbers for the main series of volumes for the various departments, but not for material such as maps, or any material that had come to the archives in the previous half century, all of which was therefore inaccessible. Neither was there any information about microfilms of any of the records, though from annotations on some of the volumes, some had evidently been made.

The records themselves are in the form of 'Consultations', being summaries of the Fort St George Government's daily deliberations within the various departments, those of Revenue, Public and Military being the ones most relevant to my quest. These, and the Proceedings of the Revenue Board, which were also useful, contained no original documents, but were transcriptions of such, made by writers. The system was thus, rather surprisingly, different to that used in Bombay. It was a hard system to crack, partly as the indexes varied in detail and completeness. Even if one had a year reference, sometimes the dates given in the indexes were later found to be wrong, and some of the reports I wanted to see proved incredibly difficult to trace. At times it seemed like chasing so many wraiths. After the long waits it was maddening when a volume eventually came, only to find that it didn't contain what one expected, or merely referred back to an earlier date, entailing a wait of at least another day. It was sometimes by no means even obvious as to which department would have dealt with a particular subject, and I never found a report Wight is known to have written on the germination of teak seed for H.V. Conolly.

Wight's work was highly regarded at the time and the EIC permitted publication of several of his government reports, so what I was looking for, in addition to biographical information, were items that had never made it into print. Given the incompleteness of Wight's known bibliography, however, some of the things I found and got excited about, thinking them to be new, with further research proved to have been published in obscure places. Among these were letters about printing illustrations of lichens in 1837, and a report Wight made on the management of the Horticultural Garden at Ooty in 1852. Much of the material in these Archives was copied and sent back to the Court of Directors in London, and

therefore also to be found, with much less pain, at the British Library. However, I did find unique material in Madras that made all the hassle worthwhile, for example, letters on a subject of great importance at the end of his time in India: the question of timber for railway sleepers. And also things to follow up on my travels, the most unexpected and fascinating of which was what might be called the Mysore Episode.

In 1824 it emerged that Wight was employed on a cattle breeding establishment at Seringapatam. This seemed almost incredible, but the documentation was eventually found and revealed that he was employed not only as a medic responsible for the establishment's large staff, but, being trained in anatomy, to investigate the diseases of cattle. Even more interestingly it turned out that here Wight had employed a native draftsman. No name was given, nor any information on what this man was to draw, though inevitably his salary was recorded and the bills for his materials. The parallel rulers and colouring box (rather than Winsor & Newton paints), suggest, however, that he was probably making diagrams rather than painting pathological dissections, but it seemed possible that he drew more interesting things for Wight as a sideline. Wight, however suffered from the unhealthy climate of this swampy place and succumbed to malaria, which clarified a previously obscure reference in a letter to W.J. Hooker written nine years later. When laid up with a cold 'accompanied with much fever which almost made me fear that Seringapatam was about to visit me even at Blair Atholl'.

Wight made a short visit of less than a week to the Shevagherry Hills, 50 miles north of Courtallum in August 1836. He never revisited them, but ten years later could still describe them as 'the richest station in proportion to the extent explored I ever visited'. It was therefore of great interest to discover a report of 14 manuscript pages that he submitted to the Government on this area immediately after the visit, but which had never been published. This showed Wight's considerable, but previously unknown, geological interests, and that the hills were not only botanically rich, but what would now be called a centre of endemism. However, of the Animal Kingdom 'one individual of it only forced itself on my consideration, with truly disagreeable pertinacity... the jungle Leech'.

By far the most important find was a fascinating 50 page report 'On the means of inducing the Native of India to devote more time and attention to the culture of commercial or mercantile produce than they have hitherto done'. This appears never to have been copied to London and was written at Palamcottah in 1836, one of Wight's first acts after becoming an economic botanist. Despite its appalling grammar and lack of punctuation, it demonstrated an unguessed at knowledge of agricultural economics, no doubt originating in childhood experiences in East Lothian, and perhaps even from discussions with his cousin Lord Meadowbank. It also showed a sincere concern for the poor tenant farmers (ryots), the effects of famines, and recommended laws to control the usury that was beggaring the ryots. The literary failings made for somewhat laborious reading and transcription, which took some 8½ hours.

Work at the Archives was also hampered by the monsoon. For example the seven centimetres of rain that fell in one two-day period, coupled with the non-functional Madras drainage system, led to considerable transport difficulties. Scooter-rickshaws plunged like vaporetti through wheel-deep water, fares rocketed, and the normally half-hour journey from the New Woodlands Hotel to Egmore on one occasion took 1½ hours. On arrival the courtyard of the Archives was knee-deep in brown water, contaminated by heaven knows what human and other waste products. There was, however, a benefit in the form of a fabulous frog chorus rising from the temporary lake. This happened on only a single day, when the amphibians had been stirred from their slumbers, and covered a gamut of sound, from high pitched continuous whines, to an incredible sound that resembled the rapid mooing of a rather butch cow.

During the early days of hanging around, the library attached to the Archives became my place of refuge. Once the library of the Secretariat of the Madras Government, it contained much of interest, but in poor condition and near-random order. However, the staff were not nearly so obstructive as those in the Archives, and it was run by a genial but eccentric librarian, who told me he spent much time in meditation and had been in touch with the 'cosmic universe', which revealed that he had a special connection with certain plants. These included tulsi (*Ocimum basilicum*), *Solanum trilobatum* and *Clitorea ternatea*, all of which he cultivated in the ground outside the library hut. He was (despite his fondness for *Clitorea*) a self-professed misogynist, but this seemed to me an entirely defensible viewpoint when it turned out that one of the three *bêtes-noires* who had ruined his life was none other than the Assistant Commissioner (Education). (The others were rather bigger fish: the late Indira Gandhi and Jyalalithaa, then the Chief Minister of Tamil Nadu). Given the chaotic shelving, I asked if it were possible to have access to the stacks, to which he kindly agreed (if only this had been possible in the Archives!), and I soon found a real gem. This was what is probably the only surviving copy of Wight's work on the forest trees of South India, which was indexed but misplaced, and so could not be found by the staff. When it came to asking for it to be xeroxed, however, the 25 pages took seven days to appear. There were other rare and interesting books. The old Madras Almanacs were fascinating repositories of information – beyond statistics astronomical and historical, were lists of Army personnel and inhabitants of Madras, and even a plan of Fort St George. There was much about the Agri-Horticultural Society (including its Rules), and a fascinating article on horticulture to which Wight had added copious notes, including a defence of a lizard called the 'bloodsucker' revealing his strong belief in God the Creator and natural theology. Another useful book was on cotton cultivation in Madras by J. Talboys Wheeler (1862), which conveniently summarised Wight's experiments in Coimbatore of 1842–53.

The books were not in good condition, and two conservation techniques not familiar in more temperate climes were in use. The first was lamination, where the book is disbound (the climate has usually managed this without human assistance), each leaf is then encapsulated in transparent plastic, and then rebound. This is a non-reversible process, but as the books are, in commercial terms, worthless, having gone far beyond any hope of restoration, this doesn't really matter, and this method at least preserves them and makes them readable. What could be called the 'cheese-cloth method' is altogether stranger, entailing the gluing of gauze to both sides of the pages followed by rebinding: the result a monstrously distended tome, from the edges of which fraying threads project like a macroscopic fungal mycelium. The fineness of the fabric used varies, and so, accordingly, does legibility.

This dismal tale is recorded in the hope that, by bringing it to a wider audience, the system might be changed. We have met Mr

Fernandes from Mangalore, but I heard an even worse story from the remarkable Nalini Chettur, who runs Giggles, 'the biggest little bookshop in the world'. A friend of hers had come all the way from Australia to research the history of Indian railways in the Archives. She had only four days, but despite bringing all the proper papers, they wouldn't let her in, so she left in tears and had to return to the Antipodes without having seen a thing. There can only be change from within – if Indian academics (the primary user group) start to make a fuss at State and National level. The ones I met, however, simply shrugged their shoulders, explaining that within the Administrative Service the post of Director of Archives is seen as a 'punishment posting'. This is a euphemism, meaning that there is no possible way to make money on the side. Academics, therefore tend to choose subjects that need little archival research, or if they do and can afford it, then go to London and do it in the British Library, or to the National Archives in Delhi. The people I felt most sorry for were young Ph.D. students who cannot possibly afford to travel. Thanks to the record keeping of the EIC (however 'good' or 'bad' their motivation) the resources available are rich beyond belief, but if access is not made easier, and conservation taken more seriously, then one can only end up by being extremely grateful that so much of the material is duplicated in London, where the climate is much kinder to paper and leather bindings, and where resources are allocated to make the records available to scholars from anywhere in the world.

Madras characters

Among the greatest pleasures of this type of botanico-historical research are the people encountered during its pursuit. Madras was no exception, and everywhere other than within the ambit of Government officialdom, I met with nothing but kindness, generous assistance and warm hospitality. In order to balance the negative picture presented so far, let me introduce some of them. (Tamilians are known by their given name, preceded by initials, which are usually not expanded and refer to their parental name and / or that of their ancestral village).

My first introduction in Madras was to the redoubtable N. Ram, then editor of the influential current affairs magazine *Frontline*, and more recently of *The Hindu* newspaper. The first afternoon of my explorations around Madras I happened to pass the handsome Art Deco offices of *The Hindu*, and so went in. On setting out from the hotel I had not intended to make this visit and so was dressed informally, but from the astonished look on the face of the doorman who let me in, I realised I was about to meet a man of significance. Ram fortunately seemed unfazed by my scruffy appearance and proceeded, in a matter of minutes, to contact by phone several people the British Council had been unable to run to earth, notably Mohan Raman, secretary of the Madras Literary Society. Contact was also made with the historian S. Muthiah and the botanical artist O.T. Ravindran. We went back to Ram's house for tea, where he donned a martial arts jacket to enter a large aviary, and allowed himself to be crawled over by a colourful assortment of parrots and macaws, which took fruit from his hand. Ram also arranged an excursion to Guindy for six o'clock the following morning. In Wight's day Guindy Lodge was the country house of the Governor of Madras, and as Raj Bhavan is now one of the official residences of the Governor of Tamil Nadu. The palatial house is surrounded by extensive policies (now a 270 hectare National Park), with relict dry evergreen

forest and a spectacular fauna. Ram drove Mariam his wife and myself around the park, watching the spectacular introduced herd of 300 blackbuck, leaping through the air like antelope on the Serengeti. Cheetal (spotted deer) feasted woozily on the fermented fallen fruits of the palmyra palm. We were then invited into the vast neo-classical palace for breakfast.

The Madras Literary Society is a venerable one, founded in 1812, and in the 1840s Wight published many important articles in its journal ('of Literature and Science'). It is still extant and has an extensive library that I was keen to see, in case it contained any Wight relics or manuscripts. As Ram had established, its secretary was Mohan Raman, a gentle man of enormous charm. I was somewhat taken aback to learn that he was a retired Rear-Admiral, and could not picture him barking orders at naval ratings, but this anomaly was explained when it turned out that he had been a naval architect. He was greatly concerned for my welfare, worried that I might not be used to the (delicious vegetarian) Madras food, and empathised over what it was like to be alone in an unfamiliar city. He showed me the library but, in truth, for a bibliophile it was a profoundly depressing experience, though through no fault of his. The state of the books was horrendous, due to years of neglect and the ravages of climate and insects. With the growth of universities and public libraries, societies like this largely lost their function, but Mr Raman is doing his best to catalogue the outstanding collection and to raise money for conservation; meanwhile, its most useful function is as a lending library for modern novels, which he delivers to elderly members of restricted mobility. The huge floor-to-ceiling, meccano-like stacks were full of fascinating books (including the 1834 volume of Jameson's *Edinburgh New Philosophical Journal*, to name but one of Wightian relevance), but the filing system was extraordinary – when books were acquired they were given a running number, so that each part of a serial work was separated from its predecessor by all the books that happened to arrive meanwhile. An attempt had at some point been made to label spines with a rudimentary classification system, but the rule used seemed to be 'if in doubt it must be History'.

One of those most generous with his help and time was S. Muthiah. A quietly spoken scholar with a steely determination, the latter being much needed as he is one of the small band of conservationists who is appalled by the destruction of Madras's built heritage and trying to do something about it. This requires considerable courage and has led to a falling out with Jyalalithaa, former Tamil movie star and dancer, but then the State's formidable Chief Minister. The Government had tried to demolish the large neo-classical Police HQ (of 1839, originally a Masonic Lodge) on the stately esplanade, the Marina, but the conservationists challenged this in the courts. The case was won by the conservationists and the building reprieved (and handsomely restored), but the episode has unfortunately left the Chief Minister strongly opposed to the conservation lobby. On several occasions Mr Muthiah entertained me at the extremely grand Madras Club, now (though not in Wight's day) housed in a spectacular late eighteenth-century house called Moubray's Cupola, painted gleaming white, and with lawns sweeping down to the Adyar River. Its airy rooms are arranged in a single storey round a double-height, Vanburghian octagonal hall, on which sits the belvedere that gives the house its name. Muthiah writes a regular column in *The Hindu*, and also publishes a fascinating historical periodical called *Madras Musings*. He kindly wrote a

handsomely illustrated article in *The Hindu* on my search for Wight, appealing for information on the artists, which sadly led to no useful responses. He has also written numerous historical books, including *Madras Revisited*, a richly informative source on the history of the city. Much of the information for this book was unearthed for him in the Archives by a talented researcher who was allowed access to the stacks; but unfortunately this man had since become trapped in Sri Lanka, and was no longer available. Although Mr Muthiah knew nothing about Wight or his artists himself, he provided generous introductions to others whom he thought might be able to help. At a time when I was getting extremely depressed by the Archives, and general lack of progress, Mr Muthiah invited me to a magical exhibition opening, which did something to restore my faith in Madras, and showed that it was not totally devoid of culture. This was organised by a gallerist called Appa Rao and there were just 20 large, brightly coloured oil paintings by Senaka Senanayaka inspired by the Buddhist 'cave' paintings of Ceylon. What made the event unique was that the canvases were exhibited in the open air, placed on easels. The evening was inky black and the paintings brilliantly lit – an unforgettable sight against a richly textured backdrop of the decaying Senate House of Madras University, with a barn owl on ghostly patrol. This building is another of the great public disgraces of Madras. It is the masterpiece of Robert Fellowes Chisholm (1879), in a highly unusual, but for him typically syncretic style, anchored at its four corners by tall, somewhat Byzantine, towers capped with tiled domes. The long walls of its lofty hall are pierced with closely spaced soaring arches filled with glazed screens of gaudy stained glass – green, white and orange, in jazzy Moorish tracery. Today the interior presents a sickening site, echoing to the twittering of bats, the cawing of crows, and thwack of pigeon wings, its painted canvas ceiling hangs in tatters, its windows broken, the floor occupied by sacks of decomposing exam scripts. It is hard to imagine that this glorious space was, in January 1915, the venue for Patrick Geddes's innovative Cities and Town Planning Exhibition. What Geddes, who cared so passionately about Indian cities, and thought so hard about how to improve them by his process of 'creative surgery', would think of Madras today is not hard to imagine. Muthiah and the architect P.T. Krishnan are trying desperately to save this and other major buildings such as the Victoria Public Hall (also by Chisholm, 1887), and the grand, neo-Palladian building of the original Madras Club.

It was through Mr Muthiah that I met V. Sundaram an erudite and widely read bibliophile of the old school, who before retiring had been a Deputy Secretary in the Tamil Nadu Government. A genial bear of a man, radiating boyish enthusiasm, bursting with humour and quotations, some of which were delivered, as Muthiah and Ram had warned me, in authentically Churchillian tones. He (impishly) blamed India's problems on its 'raucous, credulous multitude'. It turned out that he had sold his collection of 20,000 books, and was now involved in publishing historical works through his own Sir William Jones Trust for Indological Studies. Sundaram couldn't really help over Wight, but was interested to hear about his 1836 paper on the harbour of Tuticorin, as he had once been Chairman of the Tuticorin Port Authority, and was proud of having been responsible for the construction there of what was then, at 4.1 km, the longest breakwater in the world (sadly this has now been exceeded – the one at Galveston in Texas is said to be 6.74 miles). He tried to help with my problems at the Archives, but came up against

a brick wall of 'rules is rules', and a strange rumour I had heard before to the effect that some Archives somewhere in India (never specified) had had problems with terrorists (from Pakistan, or the Middle East according to the version). Strange visions of a robed Osama bin Laden consulting the records of the Madras Board of Revenue for 1836 came to mind. One evening Mr Sundaram and his wife invited me to dinner; Padma was working on their family histories, using beautiful calligraphy to write these up in an illustrated album. They are both from Brahmin families originally from Palghat, and both their grandfathers were highly literate. But despite this background it was incredibly difficult to get dates further back than three generations, and even these were impossible for some branches of the family. Dates are simply not seen as important, which made my quest for biographical information about Rungiah and Govindoo seem ever more unrealistic. Another reason for the dinner was for me to meet V. Kalyanam, who had been Gandhi's secretary, and was with him when he was shot. At the end of the dinner Sundaram gave me a little gilded statue of Ganesh, and asked Mr Kalyanam to put a shawl over my shoulders so that I could say I had been honoured, interestingly, not by Gandhi's, but by Lady Mountbatten's, secretary. After Gandhi's death, and following partition, Kalyanam had worked for her women's aid scheme organising airlifts of women between Delhi and Lahore.

Of all the people who helped me in Madras one of the most interesting was O.T. Ravindran. I had been warned that he was 'eccentric', though to me this was a positive recommendation, and I rapidly discovered that this was an assumed facade to ward off oohing and ahing middle class ladies, to whom he did not want to sell his botanical paintings for them to fade on their drawing room walls. He was also not afraid to speak his mind, which no doubt adds to his reputation for being 'difficult'. We got on like a house on fire, and he was the first Indian I have ever met who would agree with me (heretically, for it is a sacred plant) over the hideousness and dreariness of the fastigiate form of *Polyalthia longifolia* – even Wight considered the 'asochum' to have an 'elegant form' – perhaps the most widely used street and garden tree of India. Professionally Ravindran had been Press Officer for the British High Commission in Madras, but his real love and expertise is in botany and art, and he now makes a modest living by designing gardens and writing botanical articles for *The Hindu*. The occasional artistic commission comes his way, such as that from the Government of India for a set of orchid stamps in 1991, but like many other botanical artists I know, his life's work sits at home unseen by most, so I felt honoured to be shown it. Although it was good to know that botanical art is still being produced in the city of Rungiah and Govindoo, Ravindran's work owes nothing to their tradition and is very much in the classical western style. One of his major worries is what will happen to this collection, knowing the ghastly storage conditions the drawings will be subjected to should they end up in any Madras institution. Ravindran was a fund of information and stories about botany, medicinal plants and folklore, which he uses to great effect in his newspaper articles. One such was on the changing cultural use of flowers; for example, how *Couroupita guianensis*, the bizarre cannonball tree, introduced from South America within the last 150 years, is now regarded as sacred to Shiva (displacing the traditional *Aegle marmelos*). I had wondered why its flowers were for sale outside the Kapaleshvara Temple at Mylapore, but it has become known as naga-lingam (i.e., snake-phallus) from its curious floral structure –

the androecium forms a cobra-like hood that arches over the pistil. Another case was the replacement of traditional white-flowered natives such as the Labiate genus *Leucas* (Book 2 plates 101, 102) with introductions such as *Zinnia* (a New World genus) in the Onam festival in Kerala. Another piece of phyto-religious information had a Wightian connection – the large asclepiad *Calotropis gigantea* is sacred to Ganesh, and images of the elephant-headed god are carved from its woody stem base (though as 'mudar' Wight was interested only in its medicinal properties). Ravindran was trying to improve his neighbourhood by planting interesting trees (including *Saraca asoca*, Book 2 plate 34) in his neighbourhood streets, but this was a losing battle as his philistine neighbours uproot them or lop them for firewood.

Madras is not rich in tourist attractions, but one that is recommended by the guidebooks as 'not to be missed' is the Theosophical Society and its gardens on the south side of the Adyar River, so there I went one day with Mr Ravindran. Its renowned giant banyan seemed to be suffering from dieback and therefore rather a disappointment; much more interesting was a handsome group of nipa palms (*Nypa fruticans*) planted in a circular basin. In the sward on the sandy soil was a curious grass (with strange distorted spikelets) that Wight, and Roxburgh before him, had collected in these parts – *Trachys muricata*. I visited the Society's famous library, just in case they had any information on Wight or his artists.

But this turned out to be another rule-ridden place, where a distinguished-looking old lady returning an overdue book was told she would have to return several hours later to be officially reprimanded by the librarian! There were also irritating notices stating that ownership of a library card did not entitle holders to walk in the grounds, but only to 'approach the library as directly as possible'! Such attitudes did not coincide with my admittedly somewhat vague ideas of theosophy and I can't think that Annie Besant would have been amused by such pettiness. After being told that I would have to pay 110 rupees even to use the catalogue, one of the librarians took pity and agreed to look up Wight, Rungiah and Govindoo for me, but to no avail. She had evidently looked properly as she came up with a reference to someone with a similar name – that enigmatic (and botanically inclined) artist Philip Otto Runge, in a book on German art history.

The Agri-Horticultural Society

Like other mushrooming Indian cities Madras has grown unplanned with scant regard for its historic buildings, which are seen by politicians and developers (the two, as is so often the case, are unfortunately intimately connected) as inconvenient impediments to 'progress'. The future survival, and rescue from scandalous dereliction of some of the most important buildings lies with a handful of passionate and historically minded conservationists like Mr Muthiah. Madras was famed until the mid-twentieth century for the grandeur and beauty of its public buildings, and for its neo-classical 'garden houses' built on the Choultry Plain lying to the south and west of Fort St George. This, however, is all under severe threat. With rocketing land prices, there has followed a wanton destruction of the old houses and building on their once spacious gardens. While many trees have been left, so that it still appears a green city from the air, no parks or open public spaces remain in the city centre, with the single exception of the Agri-Horticultural Society garden, and its days seem numbered [fig.22]. This institution,

founded in 1835, had an important place in Wight's life and work, so I was eager to see its library and archives. The tale that follows is another that goes towards explaining my jaundiced view of modern 'Chennai'.

Something was obviously amiss from a visit on my first day in Madras; the gate was manned by security guards, who officiously told me not to take photographs. The garden is still well cared for, though the front part suffers from the hideous contemporary Indian taste in hard landscaping (complete with gaudy carbuncular concrete statues). The further back the better it got, although few of the trees are of any great age (with the exception of an ancient baobab, a large *Tabebouia*, and the macabre cauliflorous *Crescentia cujete* painted by Rungiah, perhaps from this very garden – Book 2 plate 90). Pleasantly umbrageous it is run mainly as a nursery, the compartments between the paths filled with pots containing the usual assortment of low-maintenance, dreary evergreens – codiaeums, crotons and dwarf palms – inexplicably favoured in so many Indian yards and gardens. Beyond this horticultural zone nature had fortunately been allowed to take charge and a lush green shrubbery was disturbed only by the mellow chiming of the cathedral clock, illuminated occasionally with the darting flash of a passing white-breasted kingfisher. In the centre of the garden stood a charming, late nineteenth-century, single-storied building covered with Mangalore pantiles [fig.23], evidently an exhibition hall for the flower-shows that, within living memory, had been a feature of middle-class Madras life. This was now manned by sullen women whose main job was to sell packets of seeds, but who had clearly been instructed to ward off any enquiries about the Society. On repeated visits they denied that there was any such thing as a library, though one day an open shutter of one of the side rooms revealed the untruth of this. They would not even tell me the name of an official I could apply to for further information. Enquiry among my useful contacts revealed that there was indeed trouble at the Society; like most things in Madras it was difficult to get a clear picture, but a scandal there clearly was, and the rumour was that it had been taken over 'by politicians'. This is not the place to go into the intricacies of Tamil politics, populated by ex-movie stars who appear to care more for perks and personal popularity than more important issues. It was not surprising that someone should have a greedy eye on this prime piece of real estate, which had been made over to the Society on a

Fig.22. The Agri-Horticultural Society garden

long lease in 1835 by the Madras Government for a low rent. Its only income at present seemed to come from the seed sales, and from letting out the garden as a backdrop for shooting Tamil movies (hence the carbuncles); but think how much money could be made if it could be built upon! It was impossible to get to the bottom of the story, but one rumour was that 'the politicians' had been able to gain a hold over the Society by claiming it had infringed the conditions of its lease by subletting its large nursery (on the opposite side of Cathedral Road) as a drive-in restaurant. The result was a legal challenge and the whole affairs of the Society were *sub-judice*. Nevertheless it still had a Secretary (whose name could have been told me by the seed sellers, as I eventually discovered it was written in large letters above his desk), but its members were said to be 'type C' and had no voting rights. This is probably as far as I would have got but for a fortunate meeting on one of my many visits trying to breach the bastions of the library walls. On this occasion, while talking to the seed sellers, an elegant and well spoken woman overheard my difficulties and asked if she could help, undertaking to find out more. A visit to the Government's Director of Horticulture ensued, but even a phone call from his assistant to the Society resulted in the continued denial that they had any books or papers other than a few 'technical' ones. It did, however, result in the discovery of the elusive name of the Secretary, who indeed turned out to have close links with Jyalalithaa's party, and was therefore a figure of considerable power. In Madras even to get access to such a person is difficult; ordinary people are slightly frightened of those in power and keep their heads down, there doubtless being ways of making life uncomfortable for those who step out of line or rock the boat.

Mr Muthiah helped once again, by publishing a second article on my researches, which appeared under the heading 'A society that's a mystery' about the shenanigans at the Agri-Horticultural Society. In fact by time it appeared my elegant friend had come up trumps, and established a line of communication with the Secretary who decided it might be rather a nice thing to have someone research 'his' library. Patience was thus rewarded after seven weeks and entrance gained. In the Secretary's office was a whole wall of books, representing the sad remnants of a once fine botanical library, though many volumes were obviously missing, and others were falling apart. Nonetheless, at last I had some very direct contact with Wight, holding books that he must have once held and possibly even ordered for the Society – books such as G.T.F. Speede's *The Indian Handbook of Gardening* (Calcutta, 1842). There were some volumes of the Society's *Transactions* (including, movingly, the one recording Wight's death), but, maddeningly, of the volume whose issue he supervised in 1842, only the front board remained with a handsome, gilt-stamped, red leather label. Searches in libraries all over India and Britain have revealed only a single incomplete copy of this volume, probably Wight's own, in the British Library. The books were all stamped with the Society's handsome neo-classical logo, showing a figure of Ceres, the legend Omnis Feret Omnia Tellus and the date 1835. The optimistic, if somewhat unspecific, motto ('every land will bear everything') is taken from Virgil's utopian fourth Eclogue, and interestingly in 1861 was also chosen as the motto of the Acclimatisation Society of Victoria in Melbourne, whose work was zoological. The die for this stamp was almost certainly made in the Madras mint by a craftsman whose grasp of classical agricultural implements was somewhat shaky – judging by the bizarre plough that trails rather limply from Ceres' left hand. In an interesting form of cultural adaptation this image had been modified for a stained glass roundel hanging in the exhibition hall, in which Ceres had acquired a deep suntan and wore a sari. Disappointingly there were no manuscripts or minute books on the shelves – doubtless lost, deliberately destroyed, or possibly held in some courtroom.

Sadly this is not end of story. In January 2004, a friend in Bombay sent me an article from Muthiah's *Madras Musings* entitled 'The Old… & The New', the former showing a photograph of the Agri-Horticultural exhibition hall as I had seen it a year previously, the other a recent view from the gate showing that the building had been demolished, with the sardonic and doubtless over-optimistic comment:

> What's coming in its place behind the thatch, no one seems to know. We only hope it will not be something to mar the garden ambience by not being in consonance.

What happened to the books? Were they demolished with the building, or sold for scrap paper? I can't help feeling a huge sense of sadness, tinged with guilt, that perhaps my interest might have hastened its destruction. Perhaps, beyond the questions of greed and suspected corruption, the Society has failed because it has failed to adapt to the times. Unless these old institutions (and the same applies to the Calcutta Botanic Garden run by the national government) can adapt, and find new roles in a society that has changed radically since they were set up, then they are doomed. The original *raisons d'être* for the Agri-Horticultural societies really ended around 1870 after a massive amount of pioneering work, with results that are still visible in the gardens and fields of India. After this their role became largely a social one. Interestingly, as will be seen later, the Calcutta society still thrives based on this function, as a venue for flower-shows, but this has not been the case in less sophisticated Madras. The tragedy is that in India the concept of using botanic gardens as environmental educational centres has simply not taken hold and this function has passed to NGOs like those run by Father Matthew and at Gurukula to be described later.

The Cathedral

Next door to the Agri-Horticultural Society lies the immaculately cared for Cathedral of St George, its Gibbsian steeple providing one

Fig. 23. The now demolished exhibition hall of the Agri-Horticultural Society

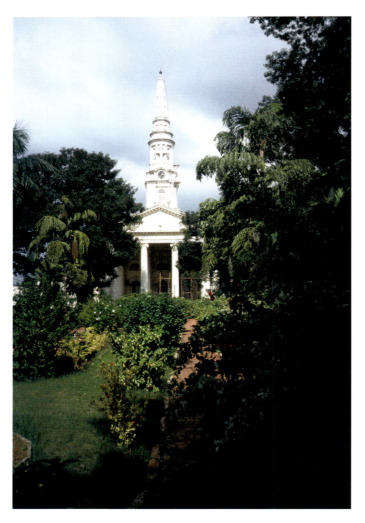

Fig.24. St George's Cathedral, Madras – exterior from the west

of very few vertical elements in the ground hugging sprawl that is Madras. Despite being designed and built by two military engineers (Colonel James Caldwell and Major Thomas de Havilland respectively) it is a structure of very considerable elegance dating from 1816. The interior is seen to best advantage when the sun is shining, and the large louvered doors that run along its northern and southern walls are thrown open, flooding it with light. It has a fine arcade of Ionic columns and the shallow planked barrel vault is decorated with a network of plaster lace. This building is full of Wightian interest, for it was here that he was married to Rosa Harriette Ford. On one such sunny day, in January 2003, in an abortive visit to find the record of their marriage in the registers (which survive only from 1843), I found the church decorated with flowers for a similar event – a floral arch over the entrance to the nave, and the pew ends decorated with pretty yellow, mauve and white posies. Perhaps Rosa's sister Helen (who witnessed the wedding, and was already married to her husband's nephew Arthur Cleghorn Wight), and the friends who painted flowers in her album might have decorated the church similarly on a day of the same month 166 years earlier. Arthur Wight's middle name almost certainly commemorates Hugh Cleghorn (1752–1837), and, reflecting the tight-knit nature of this expatriate Scottish and botanical community, it was in St George's Church (it only became a cathedral in 1835) that Hugh Francis Clarke

Cleghorn, his grandson was baptised in 1820. The younger Cleghorn became a close friend of Wight's in India and was the (indirect) donor of the most important part of the RBGE's collection of Indian botanical drawings, possibly including the Wight material itself.

As always in Indian churches the monuments are a source of fascination both to historians and to lovers of neoclassical sculpture: St George's is no exception, and several monuments have direct links with Wight. The finest, in the inner porch, is Chantrey's 1819 statue of Dr James Anderson [fig.25]. Life-size, seated on a chair, half-turned towards the viewer, this work is a masterpiece, not least for the expression of profound seriousness tinged with melancholy captured by the sculptor. It must also be unique in a neoclassical portrait sculpture in showing a carved representation of an herbarium specimen. This rests on Anderson's lap and makes the link with Wight. Anderson is known for the 100 acre private botanical garden he had in Madras in the late eighteenth century (its remnants were visited in 1810 by Maria Graham, Robert Graham's sister-in law) and for his economic botanical work that was a forerunner of Wight's own. Anderson worked on silk and cotton, but also on cochineal, a red dye made from the exudate of an insect that feeds on species of *Opuntia*, which at that time was a valuable commodity produced only in Mexico, over which Spain had a monopoly. In a case of phyto-industrial espionage (as with cinchona and rubber later on), Anderson was partially successful in obtaining cacti and insects from Mexico, for which he created an exotically titled garden – the Honorable Company's Nopalry (*nopal* being the Mexican name for the host plant), at Saidapet at the southern end of Mount Road in Madras. Anderson put his nephew Andrew Berry in charge of the Nopalry, who on retiring to Edinburgh, by a strange coincidence, lived in Great King Street, next-door-but-four to Robert Graham. The Nopalry was short-lived, but it was this same garden, belonging to a man called Mooniapillay, that was again leased by the Company in the 1820s for use by Wight's predecessor as Company Naturalist, and where Wight himself was based during his brief tenure of that office.

Two less spectacular wall tablets in the Cathedral had more direct connections with Wight: the first being to Henry Valentine Conolly. Conolly is best known to botanists for his establishment of teak plantations at Nilambur in Malabar and, in connection with these, he asked Wight's advice on how best to germinate teak seed, with which he had been having difficulty. The plaque recorded that Conolly had met a sticky end in 1855, aged 49, felled 'by the hands of a band of fanatics'. These were Mapillas, the Muslims of the Malabar coast, who were causing trouble for the British at the time, and whom Conolly had crossed in his position as District Magistrate. Four of this often violent group had escaped from Calicut jail and took their bloody revenge on the veranda of Conolly's bungalow, in front of his horrified wife.

The second tablet is to William Griffith, another EIC surgeon, supremely gifted botanist, and perhaps Wight's closest botanical friend, though it is not even certain that they ever met. Wight was still in Britain when Griffith went to Madras in 1833, and Griffith was only in Madras for a relatively short time (though long enough to coach Rungiah on 'the use of the microscope and the delineation of microscopic views') before embarking on his extensive travels that took him 'from the banks of the Helmund and Oxus to the Straits of Malacca' (to which could be added 'via Bhutan'). Their

friendship was conducted largely by correspondence (some of which was published), and Wight described many new species based on Griffith's collections from Burma and Malaya after his 'deeply deplored' death in 1845 at the age of 34. His monument, a more or less two-dimensional sarcophagus on lion paw feet (Book I fig.35), was erected 'by a few of his medical brethren of the Madras service' of whom we can be certain Wight was the prime mover.

A life-size figure by Henry Weekes (Chantrey's assistant and successor) also gave pause for thought [fig.26]. This was of James S. Lushington, another young man cut down in the prime of life, who died in 1832 aged only 28. He was secretary to his father, Governor Stephen Rumbold Lushington, and it was perhaps he who took down the letters his father dictated decreeing the abolition of Wight's beloved post of Madras Naturalist in 1828. If so, it was probably given a rather wistful look when Wight walked down the aisle to be united with Rosa.

To the east of the Cathedral lies a spectacular graveyard, entered through a grand neoclassical lych gate resembling one of the gates of Caius College, Cambridge. One can imagine the huge bell that hangs in its cupola tolling for the numerous all-too-young corpses that passed beneath. Here are some stunning tombs, and a scene worthy of Arthur Rackham where the tentacular aerial roots of a massive banyan are taking over part of the graveyard, encasing iron railings with a living skin of bark [fig.27]. Here too a link with

Wight is to be found, this time a botanical one. In addition to the banyan, the graveyard was also dominated by several enormous ghostly trees, at this season devoid of leaves, but with spectacularly gleaming white trunks. This species was originally described by William Roxburgh as *Pentapetes arjuna*, but Wight & Arnott in their great *Prodromus* realised that it should be placed in the genus *Terminalia*, and its name is thus cited botanically as '*Terminalia arjuna* (Roxburgh) Wight & Arnott'. Rungiah also painted this species, which he knew by its Tamil name *maruda*.

The Nopalry

One of the places associated with Wight that I was keen to see was the site of the old Nopalry, where he was based in 1826–8, by which time it was known as Mooniapillay's Garden. One of Mr Muthiah's friends and collaborators on a ground-breaking book on the architectural heritage of Madras was the architect P.T. Krishnan. For this work copies of old maps of Madras were required, which, strange to say, were more easily obtained from Cambridge University Library than from any institution in Madras. Ravenshaw's 1822 map showed the location of Mooniapillay's garden, and the site was

Fig.25. Dr James Anderson, sculpted by Sir Francis Chantrey – an herbarium specimen of the *nopal* lies on his lap.

Fig.26. Interior of the Cathedral showing the statue of James Lushington

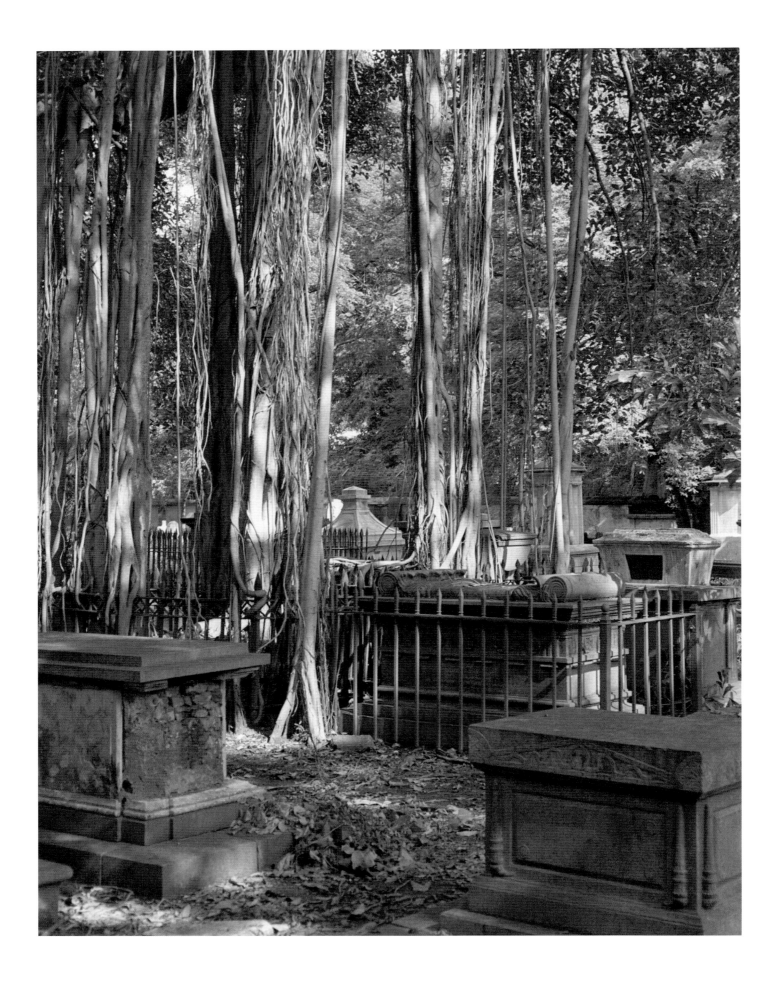

easily found as it is still bounded on two sides by a channel that in Wight's day drained the large tanks that lay to the west of the Choultry Plain. The area is now built over by a City Improvement Trust development called CIT Nagar, a quiet area of suburban streets and houses, but at the centre of the former garden site is a whitewashed, two-storied mansion called Lushington's Garden, with colonnaded verandas on both floors. It is difficult to date such neoclassical houses, but although it seemed not to date from before about 1850, it doubtless occupies the same site as the house where Wight lived. Its owner, S. Ramanathan, kindly showed me into one of the cavernous and gloomy downstairs rooms, but knew nothing of its history before about 1900 when his great grandfather bought it. According to the *Vestiges of Old Madras* in 1837 the site belonged to a General Campbell (when it was still known as the 'botanical garden'), and so its present name would appear to belong to one of the later members of the Lushington family (who were active in Madras over several generations) than to Wight's foe.

Sir Thomas Munro, graveyards, and the ice-cream creeper

Mount Road (now Anna Salai) is the main thoroughfare of Madras, and the start of the great highway leading from Fort St George south

Fig.27. *opposite* The Cathedral graveyard
Fig.28. *below* St Mary's Cemetery with ice-cream creeper

to Trichy, Madurai and Cape Comorin. It takes its name from St Thomas Mount on which the doubting apostle is supposed to have lived in a cave, and which lies just beyond the Adyar River on the southern edge of the city. Heading from the Cathedral in the other direction, northwards, before one reaches the Fort, just after passing the grounds of the old Government House with its grand banqueting hall, a stinking river, the Cooum, is reached, filled, though scarcely flowing, with what appears to be black sump oil. Crossing this one reaches 'the Island', dominated by an outstanding equestrian statue of the great Governor of Madras Sir Thomas Munro (1761–1827). This 1839 bronze is one of Chantrey's later and finest works, and gains greatly from its lofty position on a soaring plinth designed by the Madras architect and sculptor John Law. When it arrived (having cost the astonishing sum of £8012), the horsy people of Madras were mortified that the great man was seated on his horse on a cloth with no stirrups. They imagined the sculptor had made some terrible blunder, not realising that the intention was to show an imperial proconsul and that equestrian statues in classical times did not have stirrups (Londoners voiced no such complaint about Chantrey's equally stirrupless sculpture of Munro's friend the Duke of Wellington outside the Royal Exchange). Munro, a Glaswegian, had an extraordinary military and political career in India and, like many others Scots of his generation, had a genuine care for the well-being of the Indian tenant farmers (*ryots*) and was concerned that

extraction of taxes from them should be reasonable, fair, and based on historical precedent. Munro also believed that the period of the British *raj* should be limited, and that 'when in the fulness of time your subjects can frame and maintain a worthy government for themselves' the rulers should 'get out and take the glory of the achievement and the sense of having done your duty as the chief reward for your exertions'. Munro was the originator of the *ryotwary* system of revenue collection whereby *ryots* obtained title to their land by paying annual rent in cash – the rents to be fixed low and extend for thirty years. This was the system of land tenure with which Wight was familiar when dealing with the *ryots* who grew his cotton in the 1840s. Munro became Governor of Madras in 1820, the year after Wight had first arrived there, and whether or not they ever met Munro certainly knew of Wight's existence and talents, as it was he who signed the paperwork for Wight's short-lived veterinary appointment at Seringapatam in 1824, and as Madras Naturalist in 1826. Munro died of cholera in 1827, and it was his successor Lushington, who, to Wight's chagrin, abolished the latter post.

Also on the Island is a huge cemetery – the overflow from St Mary's Church in the Fort [fig.28]. This is now in a shocking state of decay and used as an extensive outdoor lavatory by the inhabitants of surrounding shanty towns. It is overgrown by an attractive pink-flowered member of the knotweed family, *Antigonon leptopus*, the ice-cream creeper. This plant was described in Glasgow in 1838, from specimens collected on Captain Beechey's voyage, by none

other than Wight's old friends Hooker & Arnott. All three botanists would doubtless be astonished to witness the 'success' of this invasive plant on the other side of the world from its original home in Mexico, and it powerfully demonstrates the potential dangers of the sort of introductions that Wight and his contemporaries strove so hard to achieve. Exploration of this graveyard, with its tangled shroud of vegetation, was undertaken with some trepidation not only for the recent human deposits, but for fear of lurking snakes, so I was fortunate to stumble upon a tomb with a place in the Wight story: a handsome sarcophagus in grey granite (*charnockite*) signed by C.S. Trotter and inscribed 'J.B. Pharoah's family vault'. The strangely named Pharoah (doubtless of Portuguese rather than Egyptian origin) was an important Madras printer and publisher – of books, periodicals (such as almanacs) and newspapers, and it was he who in 1838 'published for the author' the first volumes of Wight's *Illustrations* and *Icones*.

Fort St George

The Fort [figs.29–33] was the centre of administration for the Madras Presidency, and when one feels inclined to become dewy-eyed about the British period of Indian history, one has to remember that this was first and foremost a military installation. This said, Fort St George is a jewel of eighteenth-century architecture, from the first landward sight of its concentric defences of star-shaped ravelins, bastions and moat (the latter now choked with water

lettuce and water hyacinth). Wight's first view of the Fort, like that of my great great grandfather 17 years earlier, however, would have been from the other side, from the sea.

On my first visit, while it was possible to admire the architecture, I was frustrated at not knowing the original functions of any of the buildings. These are of brick, covered in *chunam* (stucco) painted an attractive buttermilk colour, and although most of the eighteenth-century buildings survive, many are now semi-derelict. One (that I later found to be the Town Major's House) is suffering badly from that curse of Indian historic buildings: *Ficus religiosa*, the peepal. Birds egest the seeds of this fig into nooks and crannies, where they germinate and take root with an ability that surpasses even that of the Chinese interloper *Buddleia davidii* in Edinburgh. The roots spread inexorably downwards, a trunk and crown develop, looking impossibly picturesque, but wreaking their havoc unmolested as the tree is considered sacred, and therefore not weeded out. The buildings vary greatly in size and some vast colonnaded blocks were clearly barracks. The church of St Mary is a handsome neoclassical building of Roman severity, built in 1680, with a mortar-proof stone vault, and a detached tower containing the gallery where the Governor and his Councillors sat for worship. Its yard is paved with curious grave slabs, their backgrounds carved away leaving exotic Armenian script, skeletons, and cypress trees standing out in high relief. An interesting museum now houses Thomas Banks's statue of the Marquess Cornwallis, its original elegant Ionic rotunda still

Fig.29. Fort St George, quadrangle within the building labelled on the 1838 plan as 'Park'

Fig.30. Fort St George, lower loggia of the 'Park'

Fig.31. Fort St George, upper loggia of the 'Park'

stands outside looking somewhat bereft. Other highlights of the museum include a silver alms dish given by Elihu Yale to St Mary's church in 1687 and some grand full length portraits, including a widowed one of the Marchioness of Tweeddale by Sir Francis Grant. I later found her other half, the 8th Marquess, who tried to stop Wight's cotton experiments in 1848, in the Connemara Museum. There was an odd link here as when I was at Oxford, the only other undergraduate in my college reading botany was Alistair Hay, a great great grandson of this same Marquess. The anti-scientific chip on his ancestor's shoulder had, however, been quickly exorcised – the Marquesses son Arthur was a noted ornithologist, and Alistair has made a major contribution to the study of Asian aroids based, until recently, at the Royal Botanic Gardens, Sydney.

The only jarring element in the Fort is a hideous building housing the offices of members of the Tamil Nadu state assembly, which looks from the sea like an unrolled version of the Pisa campanile, but stretched both horizontally and vertically. From the land it resembles a nuclear power station, dwarfing the surrounding buildings. The only positive thing to be said of it is that its narrow footprint resulted in the destruction of very few of the old buildings. The Archaeological Survey of India is partly responsible for the Fort, but the only labelled building is the one that houses its own offices, once Robert Clive's house, and later occupied by his son Edward, as Governor of Madras.

It was, therefore, a relief to find in the Archives library a plan of the Fort from Wight's time, on which the buildings were all identified. This transformed the experience of visiting the Fort enabling flesh to be put on the architectural bones and a feeling of closeness to Wight. The Fort was a small town in its own right, with all needs catered for – in addition to accommodation of various sorts, and the expected army buildings, were the Government Offices and more domestic and recreational buildings, such as the Garrison's bazars, a bank, a charity school, and even a fives court. The Clive Building was then the Quarter Master General's Office, and it was now possible to identify two buildings of particular importance to Wight at two different stages in his career. A building with a shady porch, and heavily hooded windows turned out to be the Medical Board Office, now occupied by the 'Asst. Garrison Engineer (Navy Andaman)' – the very building where the Naturalist's collections were originally stored [fig.32]. Its rooms, which are entirely unaltered, are spartan, but the wooden staircase extremely grand, with elegantly turned balusters and the ends of the steps ornamented with finely carved acanthus scrolls. The other 'must-see' was the government Lithographic Office, where Dumphy and Winchester worked so hard to produce all those prints based on Rungiah's and Govindoo's drawings [fig.33]. It too survives, now the headquarters of an army Signal's Company. In an attempt to get official permission to take photographs I was taken into the building, but a kindly Major was unable to contact the appropriate Intelligence Officer, so I had to make do with the two unauthorised snaps taken as a precaution in case of such an outcome. The interiors had all been modernised, but the printing presses, with their heavy stones, must surely have been in the ground floor rooms.

The Madras School of Art

The third of the major institutional horrors of Madras, on a par with the Archives and the Agri-Horticultural Society, was the

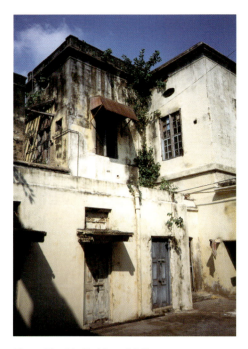

Fig.32. The Medical Board Office

Fig.33. The Lithographic Press

Government College of Arts and Crafts. This was founded in 1850 by Dr Alexander Hunter, a Scottish surgeon known to Wight. It was initially called the School of Industrial Arts, so it seemed likely that botanical drawing might have been on the syllabus. Might Govindoo have been employed for such a purpose after Wight left India? There ensued a run-around of the sort to which I was by now almost inured. Although arranged around a now gloomy, *Polyalthia*-ridden courtyard, the place must once have been handsome, as some of its buildings were designed by R.F. Chisholm, who in its late nineteenth-century heyday was Principal of the college. But times have changed. A first meeting with his successor showed him to belong to the same type as the Director of Archives, and that I faced another 'Punishment Posting' situation. From his dour response it was clear that the simple request to see their museum and archives was not going to be easily achieved. In fact it took five weeks, and would not have happened even then, but for a fortunate introduction to Theodore Baskaran, former Post Master General, who is involved with an institution called the Roja Muthiah Research Library. This Library had obtained funding to microfilm some of the College's collections and Baskaran confirmed that there was indeed some important material – including botanical drawings and photographs by the great, if bizarrely named, Madras photographer of the 1860s, Linnaeus Tripe.

I was allowed a brief visit to the College Library run by a sad little man who had no knowledge of the collection and, after a short time, decided I needed the Director's permission even to look at books on the open shelves. This obtained he was still edgy, but I managed to find a few interesting things including printed reports on Government Education from 1855–6 and 1862–3. These recorded that plant drawing had indeed been taught at the School, as – even at this early date – was photography. It also turned out that the School had produced designs for ornamental terracotta pilasters for the Agri-Horticultural Society, evidently for a building that no longer stands.

The College museum was deemed out of bounds and there was a story that some foreigner had stolen something, so that all the valuable library material had been secured in a locked room. The Principal himself had never been into this room and for it to be opened a committee would have to be convened.

With the help of the Muthiah Library staff, after the usual series of visits and prevarications, a meeting was set up for a certain date. An hour after the appointed time the Director and his committee of four eventually summoned the librarian, and our ragged little procession made its way across the courtyard. We entered a dingy passage, on one side of which lay the library, opposite which was an unpromising padlocked door. A rusty key was taken from an envelope sealed with wax, the cloth pouch removed from the padlock, and the door creaked open. I had thought that by now nothing in Madras could shock me, but I was wrong. What greeted the eye was a scene of unimaginable horror – a tropical version of Miss Havisham's library. The room hadn't been opened for a year since the Muthiah Library had abandoned their microfilming and the sealed room, with shutters closed, had acted as an incubator – the walls suppurating with damp, a sinister dew on the floor, the books left sitting on the table covered in thick white mould and looking like large rectangular camemberts. In fact it was like a fridge full of food that one has forgotten to empty and returned to after a long holiday. What of the books? A simply priceless collection, notably a fabulous series of bound volumes of photographs taken by College members from 1862–76, which had been bound in-house and were proudly labelled to the effect that even the leather had been tanned and dyed in the College in 1904. The photographs covered a wide range of subjects from examples of student wood carving, to the temple architecture of South India. Most exciting were three volumes of photographs of the Nilgiri Hills, of extraordinary documentary importance, though surprisingly these included no pictures of the Ooty Garden. The Committee watched my every move

and kept consulting the letter of request written on my behalf by the Muthiah Library, eventually deciding that I could look only at botanical works. I was in torment, my eyes greedily scanning the shelves to see what was there before my hosts' limited patience ran out. There was the handsomely illustrated book *An Account of Indian Serpents Collected on the Coast of Coromandel* (1796) by Wight's predecessor as Madras Naturalist, the Edinburgh-trained Patrick Russell. There were also numerous fine nineteenth-century art historical folios from Sir William Hamilton's 'Vases' onwards. Of botanical volumes there were only two, each containing 13 fine paintings, but sadly having no connection with Govindoo. There was a coincidental connection with Wight, however, as one of the volumes (referred to in the 1862 Education report), contained paintings of different cotton species. Their style, however, was nothing like Govindoo's, and the artists appeared to have taken as their model eighteenth-century European artists such as Ehret. Interestingly they were signed, and so gave the names of a slightly later generation of Madras botanical artists: J. Chengalvarayan Raju, P. Vijiarangan, C. Abboy and M. Rangaswamy Modly.

I was torn with all sorts of conflicting emotions. Anger was the first, that such priceless material should be left in the hands of this incompetent bunch, but also concern lest my interest made matters even worse, and that the whole collection might be destroyed out of a sense of embarrassment. It certainly seemed likely that the efforts to microfilm them had made matters worse, and that job had not even been completed. A few days after this ghastly experience I was taken aback to see one of the Nilgiri photographs shown at a Conference on environmental history in Delhi, leading me to wonder if what had annoyed the Art College staff was not a theft of material, but the publication of images on the internet. This raises a further issue: the worrying thought that if people consider that so long as an object or document has been microfilmed or digitised, then it doesn't matter if the original item decomposes.

St Mathias Vepery and J.P. Rottler

There was still one more connection I wanted to make in Madras, and this concerned the man linking Wight with the Tranquebar Missionaries. This was to be found in the church of St Mathias, Vepery, the burial place of J.P. Rottler. His tomb lies in a muddy little graveyard and the gravestone records, rather precisely, that he died at the advanced age of 86 years and 7 months, in 1836. Many of the Tranquebar specimens that Wight bought from him are still in the Edinburgh herbarium, and in the library we have Rottler's slightly wormy copy of Willdenow's rare illustrated *Phytographia* (1794), which Cleghorn must have picked up in Madras. The church is a spiky gothick box, much pinnacled and crocketed, with a west end tower that seems to be based on one of those of York Minster.

The pastor who now shares the church with a Malayalam-speaking congregation had just been in hospital with typhoid, so when offered a cup of tea I was somewhat torn between squeamishness and etiquette, but fortunately no ill effects ensued. He was happy for me to look in the church, but had never noticed the monument to his predecessor, the venerable and distinguished Tamil scholar, missionary and botanist. The monument is by the younger Richard Westmacott, and shows Rottler expounding the New Testament (with symbolic text in English and Tamil) to a Brahmin squatting beneath a banana tree.

JOURNEY TO THE SOUTH

By now I had had more than my fill of the frustrations of Madras: it was time to escape and to retrace Wight's steps in the South. The escape turned out to have been timely, and during my absence the weather got even worse; newspaper reports told of 71,540 families displaced by flooding in the city, and 45 people killed in Tamil Nadu, mainly from 'electrocution or lightning'.

I had only two weeks to do what had taken Wight nine months in 1826–7, and it was not possible to follow his route exactly. My journey started by train, leaving from Egmore railway station, just opposite the Archives. It was a blessed relief to be borne effortlessly through the flat Tamil countryside, passing fork-tailed drongos on telegraph wires, and vignettes of agricultural life – goats tended by women in brightly coloured saris, bullocks ploughing muddy fields, the skyline fringed with ragged palmyra palms and the occasional rocky knoll. My goal was Trichy (Trichinopoly to Wight, now the tongue-twisting Tiruchirapalli), and a meeting with Father K.M. Matthew, doyen of South Indian botanists, and Wight's botanical heir [fig.37].

Trichy and Father Matthew

After 5½ hours to cover only 200 miles, passing the soaring *gopura* (gate-tower) of the great temple at Srirangam [fig.34], the looming rock of Trichy hove into view and I stepped into a town that represents a living testament to the best sort of cultural hybridity. The spire of a French gothic church with an illuminated red cross reflected in the waters of a vast stepped tank marked as a Hindu site by its white and ochre bands. Floating above the town, like a toy fort, is a Shiva temple, its crenellations picked out in lights at night. An eighteenth-century church testifies to the long tradition of religious tolerance here, built by the German missionary Swartz on land given for the purpose by the Muslim Nawab of Arcot. In St Joseph's College, and especially in its Rapinat Herbarium [fig.35], it was a relief to enter an institutional world of order and efficiency. The exhilarating mayhem of India returned in the evening, however, and even noisier than usual for the festival of Deepvali (as Diwali is called in the South) was in progress. Fireworks illuminated the sky and deafening fusillades assaulted the ear: walking the streets was a perilous pursuit, as groups of small boys gleefully threw bunches of jumping-jack firecrackers.

Father Matthew showed me his botanical fiefdom with a quiet, but justifiable, pride and on hearing of my difficulties in Madras explained that when visitors came to his herbarium 'the answer is never no'. A wonderfully eclectic museum contained, among much else, life size statues of Christ and the Evangelists, a letter from Queen Victoria, cases full of shells and rocks, elephant skulls, a skeleton of the Indian bison, a case of World War II gas masks and temple models made of shola pith. I was then shown the herbarium and the fine botanical library that Father Matthew has built up, the only cause for regret being that his team of artists was on holiday. As Father Matthew is Wight's botanical heir, so are these artists the heirs of Rungiah and Govindoo, and under his close supervision they have produced literally thousands of clear line drawings, all based on recent plant collections. Outside the herbarium was a tiny botanic garden, like a garden of simples attached to a medieval abbey, including a handsome deep purplish-pink convolvulus (*Ipomoea nervifolius*) with leaves worth ¼ rupee each as a cure for skin complaints. Father Matthew explained the taxonomic part of his

life's work on the Tamil Nadu flora, which had been targeted to cover the areas of major diversity. It is worth giving some statistics here, to show the truly Wightian scale of this endeavour. Published over the previous 22 years have been illustrated Floras of the Tamil Nadu Carnatic (three volumes of text covering 2020 species, with almost 3000 pages of text and two volumes containing 1794 analytical plates), and the Palni Hills (three volumes of text covering 2478 species, with over 2000 pages of text and two volumes containing 1223 analytical plates). In addition to these major works, Father Matthew has also edited a *Flora of the Sirumalai Hills* written by a late colleague, and an annotated version of a paper originally published in an obscure German journal in 1803 by J.P. Rottler on the botany of the coast between Tranquebar and Madras. Current work was towards a Flora of Northern Tamil Nadu, with more distant sights on a Flora of the Nilgiris. Work on the former was well underway and he told me it had been set up so that it could be completed should anything unfortunate befall him. At the time this seemed a little

Fig.34. Gopuras of the Ranganatha temple at Srirangam

melodramatic, as he was in vigorous good health and looked nothing like the 74 years I later discovered him then to have been. But he was to be dead in less than eighteen months. His death came as a complete shock, and has left an irreplaceable gap in Indian botany – to me personally it was a great sadness not least as it meant he would never see the Wight works in which he took such an interest. A man of vision, integrity and vast achievement, his work was supported largely by the Jesuits, with the help of only a few external grants. Ironically the Indira Gandhi Paryavaran Puraska Award for the year 2002, awarded to him by the Government of India for 'outstanding and consistent merit' in the field of the Environment, was not announced until 17 July 2004. It thus came too late for him to know of it, but I doubt that he would have cared over much for such formal recognition. We discussed religion as Jyalalithaa had just passed a law against 'forcible conversion' – a characteristic act, in this case not to curry favour with the 'credulous multitude', but with the fanatical element within the BJP party then in power in Delhi. Father Matthew explained that it was now extremely rare for the Jesuits to baptise anyone, and only when people specifically asked,

Fig.35. Museum and herbarium building, St Joseph's College, Tiruchirapalli

and he saw his scientific work as the expression of his faith; he also pointed out the irony that the Chief Minister herself was a beneficiary of their work, as she had attended one of their schools in Madras. Abdul Kalam, the nuclear-physicist President of India, had been at school with his brother at St Joseph's, showing the quality and importance of their educational work, which started in Trichy in 1838, the year Wight started publishing his *Icones*.

However, taxonomy, was only part of this enormous project. The equally important conservation and educational side to Father Matthew's work was to be seen in the next leg of my journey.

The Palni Hills

On leaving Edinburgh I little imagined finding myself staying in a damp cell in a Jesuit seminary, but such are the unexpected quirks of fate that make travelling in India such a delightful adventure. Sacred Heart College, Shembaganur, at 6000 feet in the Palni Hills (Wight's Pulney Mountains) is an outpost of St Joseph's College now run as a 'Socio-Spiritual Educational Training Centre'. Despite the damp bedding, it was a relief, after the sweltering plains, to be in cool and misty hills again and in the bliss of utter silence, bar the odd passing truck and croaking frog.

To reach Shembaganur Father Matthew and I had left Trichy by bus at 6.30 one morning. We passed through Dindigul with its huge, fortified, orange-coloured *roche moutonée*. The 'Dindygul Hills', so familiar as a name on Wight specimens, probably refer to a detached

range that rises to the south-west of the town, now known as the Sirumulais, and which were wreathed in mist. Soon after passing these we started the ascent of the Palnis, up the Law Ghat road, with a mounting sense of expectancy at the prospect of seeing some of the places Wight had visited and written about in 1836, and some of the plants he collected in three (rather than two) dimensional form. The slopes were still pretty well forested and we passed what was said to be the ninth highest waterfall in the world (road sign: 'Caution Distractive View'). It was not long before we were surrounded by Wightian plants – the road was lined with the pretty pink balsam *Impatiens balsamina*, a variable species which (with Arnott) he had treated in a complex manner in the *Prodromus*; the rocks were covered in a beautiful pale lilac streptocarpus-relative (*Henckelia incana*) which Wight described under the name of *Didymocarpus tomentosus*. The higher we got, however, the more disturbed was the vegetation, with introduced Australian trees such as *Grevillea* and *Eucalyptus* – a sign of horrors to come.

The college itself dates from the late nineteenth century and consists of two large three-storied quadrangles, the haunt of chattering wagtails; its verandas used for discussions by circumnambulating monks. Like St Joseph's it had a fascinating museum, and exhibits included the skin of a 17–foot king cobra, and models of local dolmens made by the polymath Father Anglade. One did, however, slightly wonder at how Jesuit Father's had come by a rather complete series of pickled human foetuses. The main library has a valuable archive relating to the activities of the Jesuits in South India (including a seventeenth-century relic in the form of a bone from the arm that gave the first Tamil blessing), and Father Matthew's botanical library has volumes of botanical drawings made at the end of the nineteenth century by Fathers Anglade and Gombert. In the garden threatened Palni endemics were being propagated for reintroduction to the wild, including the palm *Bentinckia condapanna*, and two from groups that Wight was particularly fond of – *Sonerila palniensis* (Melastomataceae) and *Hoya wightii* subsp. *palniensis* (Asclepiadaceae).

Next day during an early morning walk I was slightly surprised to encounter several plants familiar from the Himalaya. The tree *Exbucklandia populnea* turned out to have been introduced from a Jesuit house at Kalimpong, but the sedge *Carex myosurus*, described by Nees von Esenbeck from specimens collected by Wight in these parts, is one that occurs naturally in both mountain groups, but with a gap in between. A plant familiar from a Rungiah drawing was the beautiful blue-flowered *Clerodendrum serratum* (Book 2 plate 103). The thick early morning mist suddenly broke into wisps to reveal a view of a valley plunging steeply down to the plains, with glimpses of a rushing torrent, and what looked like pristine evergreen shola forest spreading up the highly inaccessible slopes to some impressive rust-coloured cliffs [fig.36].

The environmental educational programme is organised in courses lasting 3½ days, and targeted at 'grass roots' level – for senior school pupils, teachers and villagers in groups of 50 at a time. Since 1984 an astonishing 57,000 people have benefitted from such instruction, which is provided free of charge. The following day I accompanied a group of teachers from Erode, all immaculately dressed as though for a day at the office [fig.37]. We started in a wood called Bombay Shola, close to the centre of the hill station of Kodaikanal, where I saw the first of many plants that day named after Wight – a holly (*Ilex wightiana*) – and Father Matthew told the group about

Fig.36. Looking towards Pambar Shola from Shembaganur

basic forest ecology. Around Kodaikanal, however, the dissected plateau of the upper Palnis (above 6500 ft) is a sad ecological wreck due to introduced Australian trees that have taken over and smothered the indigenous grasslands in the depressingly short space of time since Father Matthew first came to these hills about 40 years ago. The worst offender is the legume *Acacia mearnsii*, introduced in an attempt to make India self-sufficient in tan bark when imports from South Africa were stopped in 1947. This tree has in places blanketed the ground with hideous, and literally impenetrable, thickets. In other places *Eucalyptus* has apparently similarly run riot, but such is the inflexibility of legislation that it is illegal to fell any tree, including these noxious species, though Father Matthew's Palni Hills Conservation Council has at least managed to make it illegal to plant any further *Eucalyptus* within the watershed area.

Bob Stewart and Tanya Balcar are two dedicated expat Britons who live here and run the Vattakanal Conservation Trust. They face enormous difficulties, and at the time of my visit had recently been turned out of their home beside the excellent plant nursery they have set up, when a jealous official suddenly discovered a rule that foreigners were not allowed to occupy government land. Nonetheless they persist and are achieving great results. They are still allowed access to the nursery where native plants are raised for re-introduction. I was keen to see one of the sites visited by Wight in

September 1836, described in his publication as a spectacular valley (or 'strath' – he must have been feeling homesick) running north from the village of Poombarry. We found the village, resounding to the sounds of a noisy wedding, but the weather was against us and the valley choked with cloud, but Bob and Tanya later sent me a photograph taken in better conditions. We found one nearly pristine habitat not over-run with *Acacia*, a marshy area where a thin skin of vegetation clothed the rock, supporting some interesting plants associated with Wight, including *Osbeckia aspera* var. *wightiana*, a small bush covered in magenta flowers (Book 2 plate 47). A handsome white flowered shrub, with beautifully veined leaves, was *Hedyotis articularis*, a name given by Robert Brown to specimens sent by Wight to Wallich from the Nilgiri Hills, but first validly published by Wight & Arnott in the *Prodromus*. Grasses, which must once have been dominant over vast tracks, included a *Chrysopogon* and *Arundinella mesophylla*. Native plants still clung on along the roadsides, many belonging to genera familiar to me from the Himalaya – *Mahonia leschenaultii*, *Berberis tinctoria*, *Smilax aspera* (Book 2 plate 137) and *Vaccinium leschenaultii*. I was particularly pleased to see some faded white trumpets of the handsome *Lilium neilgherrense* and the spectacular blue and gold flowers of the giant gentian *Exacum wightianum*. The odd patch of shola forest still survived among the acacia, in one of which was the laurel *Cinnamomum wightii*.

Courtallum

The place that provided Wight with more specimens than any other single locality was Courtallum, and this was my next port of call. It is a small town at the base of the eastern flank of the southernmost part of the Western Ghats, and was used as a sanatorium in Wight's day. It was to visit military patients that he first went there from Palamcottah in 1835. Wight visited again the following year in order to report on its spice gardens, and left his collectors there to make their prolific harvest. It was on this occasion that Wight discovered the riches of a mountain he affectionately dubbed 'Botany Peak', but it was also here that he caught the severe malaria that led to a recuperative trip to Ceylon. This being monsoon time Botany Peak was shrouded in mist; however, it was enough merely to be here and to see the sacred waterfalls for which Courtallum (or Kuttalam) is now best known. These were looking at their best, in full spate fed by the mountain mists. The tallest of the falls, at about 200 feet, is in the town itself, with fans of white water cascading over a series of polished rock terraces. A fine spray drifts over the Kuttalantha Temple that sprawls at its base, beside which squatted mendicants holding half shells of *coco de mer* as begging bowls. Men bathed and women scrubbed clothes in the river – the scene had not changed at all since Thomas Daniell painted it in 1796, and Wight would certainly have recognised the blood-thirsty mosquitoes.

The mountains rise very steeply above the town, and are fortunately still thickly wooded. However, they are classed as Reserved Forest and nobody could tell me how to obtain the necessary permit to go up into them. One would in any case have needed a guide as there was no obvious approach route, and it would have been somewhat frustrating as one would certainly not have been allowed to collect specimens. What is required is a major botanical survey of the area, to see which of Wight's plants still survive – the area lies well outwith the geographical scope of Father Matthew's projects, and the only recent documentation is a pitifully incomplete local Flora. On visiting a small local Forest Office I learned that there was something called a Government Orchard nearby, which might perhaps be a link with Wight's spice work, and someone kindly offered to take me to the one accessible part of the mountains, an area above the main waterfall, the following morning [fig.40]. This made up for the lack of access to the hills, as this valley was the site of the spice gardens visited by Wight. The town was bustling with pilgrims and Indian tourists, and there is still the odd bungalow that could possibly date back to the early nineteenth century. In the market locally grown spices were on offer – mace, star anise, cloves and lusciously shiny nutmegs [fig.39]. Also for sale were bags of a grey lichen (possibly a *Parmelia*). Here was another link with Wight as in 1837 he had investigated these strange dual fungal-algal organisms

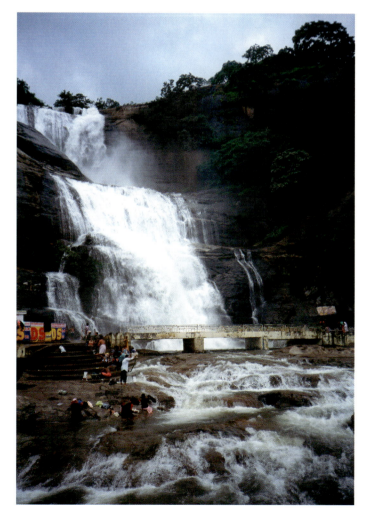

Fig.37. Father K.M. Matthew teaching at Bombay Shola, Kodaikanal

Fig.38. The great falls at Courtallum

for their dye properties, and got Rungiah to draw a selection. Wight himself lithographed these drawings and sent the prints to Calcutta to be distributed with the *Transactions of the Agricultural and Horticultural Society of India*.

The next morning I set off for the Government Orchard, which was beside one of the other waterfalls, just outside the town. It was closed so I set off up a track leading through a teak plantation and was thrilled to stumble on a spice garden, evidently recently laid out, in which were betel palms, nutmegs, cloves and black pepper vines twining up the trees. The owners, however, were decidedly unfriendly and I had to beat a hasty retreat – there was a slightly odd atmosphere, and I suspect they were illegal squatters. The Government Orchard was by now open and turned out to be more of a nursery garden, but it had more spice trees and some exotic fruit trees including rambutan and breadfruit. Back to the Forest Office to meet the man who was to take me to the top of the falls. I assured him it would be fine if he merely pointed me in the right direction, but he insisted on coming with me because of 'wild animals'. The view from the rocky ledge at the top of the falls down over the picturesquely paved roof of the temple was spectacular, and we headed upstream into a secret glen, completely hidden from view from below the falls. It was lush and green, and extremely beautiful, the water in the river of an incredible clarity, but there were no signs of the old spice gardens, though some glaucous tussocks of a lemon grass might perhaps have been relics of cultivation.

The Coast of Coromandel

It was now time to head east to Palamcottah, to see the place where Wight was stationed after his furlough in 1834. This had come as rather a shock to his system, to be back 'doctoring sepoys' after three years in Britain spent in an orgy of taxonomy. Palamcottah (now Palayancottai) was then a major garrison for the EIC's Madras Army, based in the largest fort of the South, originally built by the Nayaks who ruled from Tinnevelly (Tirunelveli) on the other side of the Tambraparni River. Not a single trace of this fort is now to be seen, but the large church of Holy Trinity that lay to its west, built by the Church Mission Society in 1826, must have been familiar to Wight. Its elegant spire, however, was not added to the tower until 1845 [fig.48].

Wight published on Tinnevelly senna in 1837, and in 1850 made a tour of its cotton growing districts. I was therefore disappointed not to see a single field of either crop on my various bus journeys, though it has always been rather a mystery to me as to why senna was ever a necessary crop in a country of notoriously loose bowels.

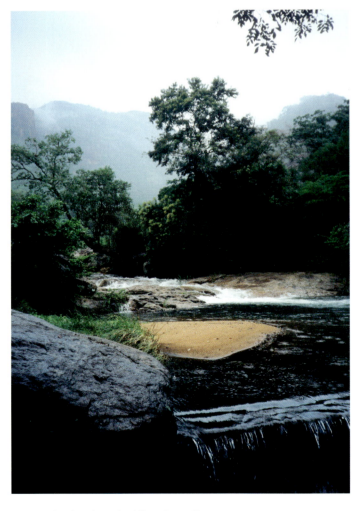

Fig.39. Nutmegs and mace from the bazar at Courtallum. Photo Debbie White

Fig.40. The glen above the falls at Courtallum

Fig.41. Garland makers in the temple cloister, Tanjore

The port of this region is Tuticorin on the Gulf of Manaar, about which Wight wrote a prescient article in 1836 urging its development, and the use of steam locomotives on the rail roads even then being planned to carry produce to it. These developments did indeed happen from the 1840s onwards, but Wight would be astounded, and doubtless gratified, to see the port now, and the developments of the 1970s. I first went to the old port, its harbour full of handsome, deeply-keeled wooden fishing boats sheltering from the monsoon swell. Boat building activities were under way and a huge hawser was being manually twisted along the length of the shore road. The new port lies some 12 km to the south and passing some salt pans I was thrilled to see a flock of 32 flamingos; improbable pink fowl, necks bent double, as long and almost as slender as their legs, sweeping the water with their sinister beaks. Far out to sea lay V. Sundaram's pride and joy, the longest breakwater in the world. Brightly painted containers labelled with familiar logos such as P & O, and ones from countries as far afield as Korea and Indonesia, reflected the tentacles of modern international trade – one of the port roads was even called 'World Trade Avenue'. The hulk of a thermal power station and an oil storage depot were visible manifestations of the energy sources we now depend on, and the only things Wight would have recognised here were some gargantuan tree trunks, though these were far larger than anything India could now produce, and must have been imported from Indonesia or Burma.

This was the southernmost point of my journey, and it was now time to turn northwards. Time and again I was struck by the barrenness of the land, even at the wettest time of year, and the flat-topped acacias gave the landscape an almost African look. These trees were probably *Acacia planifrons*, described by Wight & Arnott in 1834, based on specimens collected in these parts by the Tranquebar Missionaries, who recorded its name as the 'Umbrella Tree'. The red soils are certainly poor, and can only be made to yield crops with irrigation, and therefore limited to areas close to rivers, or around wells or tanks. The next stop was the great medieval city of Madurai to visit its Brobdingnagian Nayak Palace and the sublime Minakshi Sundareshvara Temple. Wight cannot have avoided these spectacular temporal and spiritual edifices, and must surely have written of them, and the Indians whose lives revolve around them, in letters to his family and in his private journals. With the destruction of these documents, however, we can never know what he thought about them, and the picture we have of him is tragically lopsided, limited to his professional life and his abiding passion of botany. We know that he was a Christian, but of what shade we cannot tell, and even if it were of the narrow evangelical sort it is hard to imagine him unmoved at the thrilling architecture, smells and rituals of the great temples of South India. The Madurai temple is one of the most imposing of all, and the ceremony of processing the image of Shiva to spend the night in Minakshi's shrine, with moths fluttering around the lights, bats swooping along infinitely receding columned vistas, accompanied by ticking crickets, plangent oboes, cymbals and drums is never to be forgotten. From here I continued to Tanjore, passing though Puddukkottai – in Wight's time a small princely state of the Tondaiman Rajas that he knew as Pathucottah, a name that appears on some of his specimens.

Tanjore (now Thanjavur) is dominated by the great, early eleventh-century Bridhadishvara Temple. When I visited a festival was in cacophonous progress and a bamboo-framed *pandal* had been constructed beside the temple. To the canvas skin of this huge tent were pinned small panels made of strips of palm leaf adorned with geometric patterns in brilliantly painted purples and orange, and given a thrillingly shimmering surface with pieces of silver foil [fig.45]. The cloister around the temple court was lined with shiny black lingams, its walls painted with frescoes, and the temporary home of a family of garland makers, creating magnificent ropes of tuberoses, marigolds and chrysanthemums.

Figs 42 & 43. Catamarans on the Coromandel Coast

Fig.44. The Bridhadishvara temple, Tanjore, with *pandal*

Fig.45. Ornamentation of the *pandal* in palm leaf and silver foil

One of the joys of South India is the plethora of flowers for sale on every pavement; these are threaded with dextrous rapidity into garlands, which are offered to gods, or tied into women's hair. Wight wrote of the 'fragrant ornaments for the hair' and necklaces formed of the flowers of the white jasmine, which retain their fragrance the whole day. Another favourite flower for such purposes is the salmon pink form of *Crossandra infundibuliformis* (Book 2 plate 106).

At the time of Wight's visit to Tanjore in 1826 its ruling Maratha dynasty was represented by the outstanding Raja Serfoji II (1777–1832) [fig.47]. Serfoji's palace is now a museum preserving many relics from his time, not least a stunning statue of him by John Flaxman, but also his extensive library. There is sadly no record of whether or not Wight met him in 1826, though it seems likely as Serfoji was deeply steeped in both eastern and western culture, having been educated by a German missionary, the Rev Christian Friedrich Swartz. Swartz instilled in Serfoji the virtue of religious tolerance and a taste for European enlightenment learning and languages. The library he assembled in the Sarasvati Mahal is an astonishing survival, and is not only beautifully maintained but actively conserved by a dedicated staff. In addition to palm leaf manuscripts (*olais*) inscribed in Tamil, there are western musical scores in

Serfoji's bold hand, and works in several European languages. Among these were botanical books such as Thomas Martyn's translation of *Rousseau's Botany* and Colin Milne's *Principles of Botany*, and also Woodville's *Medical Botany* that Wight had in his own library. Serfoji was also interested in the visual – he had Uvedale Price's *Essay on the Picturesque* and, among many fine illustrated works on display, was a series of weird engravings by Charles le Brun on metamorphosis – showing wild animals transformed into human faces. Tanjore was renowned for its school of Telugu speaking painters and when the Rev Bernhard Schmid was looking for a botanical artist to work in Ooty in the 1840s, it was suggested that one could easily be found in Tanjore, and it seems possible that Rungiah and Govindoo (or at least their forebears) might have come from here. The Tanjore school is best known for its fine depictions of Hindu deities (in fresco and on paper or glass) [fig.49], and paintings made for British patrons such as those on mica showing castes, trades and religious festivals. In the library however were two volumes of botanical drawings, made by local artists, dating from around 1800, and showing a mixture of native plants and introductions, including, somewhat surprisingly, the South American 'nasturtium' (*Tropaeolum speciosum*). Back in the British Library I would see a

related volume of paintings of birds of prey, perched on ornate gilded cushions, which formed part of Serfoji's menagerie.

From Tanjore it is a three-hour bus ride to Negapatam (now Nagapattinam), which lies at the southern end of the Coromandel Coast. Here at last the route passed through fertile, rice-growing country, thanks to irrigation from a canal that sinuated its way along an embankment, or *anicut*. The canal is now heavily silted, but provided just enough water for a gorgeous russet-bodied, snowy-headed, Brahminy kite, to take a bath. After the abolition of the Naturalist's post, and before his furlough in Britain, Wight was stationed at Negapatam, and it was from here that he started to send large numbers of specimens and drawings to Hooker in Glasgow. In medieval times it was an important international port, and in Wight's time a brick tower built for Chinese Buddhists was still

Figs 46 & 47. *left and upper right* Statue of Raja Serfoji II by Flaxman
Fig.48. *lower right* Holy Trinity, Palamcottah

visible, but it has declined since being taken over by the British from the Dutch in 1781. There are still a few old bungalows, a gem of a local museum from the days when the now almost derelict Madras Museum was capable of an outreach programme, and a handsome church built by the Dutch in 1774. The fishing boats were lying in a small creek sheltered by an island and there was nothing to suggest the horror that would strike this peaceful community on Boxing Day 2004, when it was to be one of the worst affected of Indian settlements hit by the great tsunami, with the loss of several thousand fishermen and their families.

My northward journey up the Coromandel Coast continued to Tranquebar (now Tarangambadi), one of the most picturesque of all the places I visited, not least in the eerie light of an early morning haar. Although entered through an archway decorated with martial symbols, the atmosphere of the village, with its sandy streets, was one of a quiet and orderly piety. The large colonial houses are well cared for; one was a teacher training college, and others hostels for its students. However, it is the two large Lutheran churches, and the fort of Dansborg, now a ghostly shell with fretwork parapets and a strangely asymmetric tower rising straight from the strand, that dominate this haven of tranquillity. On the beach fishermen mended nets and cows chewed cud among frail-looking log catamarans drawn up on the sand after a night at sea; Wight stated that these craft were generally made from the wood of the beautiful red-flowered leguminous tree *Erythrina indica*. The surf pounded implacable and a domed Hindu temple was being smashed to smithereens and tumbled into the sea [fig.50]. Although no trace of their garden remains, the churches are where the botanical Missionaries preached – the Rev C. S. John, who raised William Roxburgh's illegitimate 'Eurasian' son, lies in the graveyard of the grand Church of New Jerusalem founded by the Rev Bartolomeus Ziegenbalg in 1718 [fig.52]. This is built on a Greek Cross plan and painted peppermint green; its windows could come from a painting of de Hooch, a chequerboard of small glass panes above an openable wooden shutter. Across the street is the Church of Zion, a simpler cream structure with a beautiful vaulted roof, externally expressed like an upturned boat [fig.51]. The Danes hung on here until well into Wight's time, and the town was not taken over by the EIC until 1846. Wight collected plants at Tranquebar, doubtless while based at Negapatam, but most of the specimens he had from here were among the materials he obtained from Rottler. These latter included the climbing legume *Bauhinia vahlii*, cited when Wight & Arnott published the name in their *Prodromus*.

Pondicherry

The former French city of Pondicherry is a living reproach to the squalor of Madras, and demonstrates that it is possible to have a clean, buzzing and sophisticated city on the Coromandel Coast. Almost nothing is known of Wight's relations with the French in India, but he visited Pondicherry on his 1826 tour, and it is possible that this was the occasion when he gave duplicates of his fern collections to Charles Bélanger, who had set up the botanic garden there this same year. Wight must surely also have had dealings with George Samuel Perrottet, at one point also based at Pondicherry, and who was connected with the establishment of tea cultivation in the Nilgiris, and who, along with Wight, advised H.V. Conolly on teak. Botanical activities are still undertaken in Pondicherry and I visited the French Institute, where an excellent series of ecological maps of South India has been produced, and work is currently focussed on the ecology of the Western Ghats. I also visited the Sri

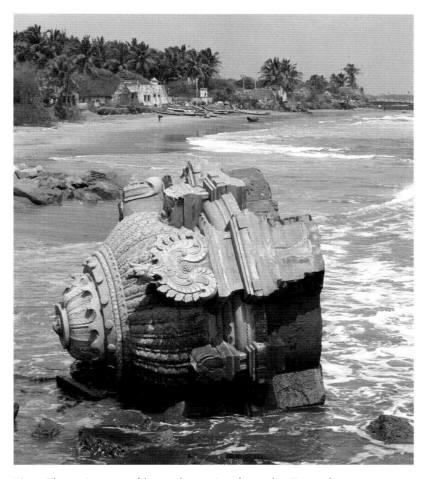

Fig.49. Frescoes (and lingam) in the temple cloister at Tanjore

Fig.50. The erosive power of the sea: the remains of a temple at Tranquebar

Fig.51. Interior of the church of Zion, Tranquebar

Fig.52. The church of New Jerusalem, Tranquebar – the top of the tomb of the Rev C.S. John is just visible left of centre

Aurobindo Ashram where, as at the Tanjore library, some basic paper conservation work was being undertaken, of the sort that could easily be done by the institutions in Madras, were the will only there. The archive relates to the philosopher Aurobindo Ghosh and his chief disciple, Mirra Alfassa, 'The Mother', both of whom have large cult followings. The randomly chosen box that Barbie, the American volunteer who was undertaking the conservation work, showed me contained letters to Aurobindo from a Post Master in Sylhet, and gave graphic descriptions of his bowel movements and the quality of his stools! The main purpose, however, was to visit Auroville, ten kilometres to the north, a model new-age community founded in 1968 based on the principles of 'The Mother'. I was not about to turn into a hippy or join a commune, and the reason for going there was to meet Walter Gastmans, an expat Belgian whose work Father Matthew had told me about. With EU funding, Gastmans is running a project on tropical dry evergreen forest, of which only tiny fragments survive in the coastal plain, as at Guindy, but mainly as sacred groves associated with temples. On a 30 acre plot, which he has been developing for the past 17 years, native trees from seed collected in the sacred groves are being grown, which will be available for use as seed sources for reintroduction programmes if and when the Forest Department decides to give up planting euca-lypts. I was shown some young trees of *Hildegardia populifolia*, which Gastmans had recently 'rediscovered' in the wild, but which like many species in the Indian Red Data book is not extinct – it is just that nobody has bothered to go and look for it. A building has been built to house a herbarium of plants of the coastal plain, which, un-like any of those in Madras, will be air-conditioned.

Excursion to Gingee

From Pondicherry I made an excursion to the fortress of Gingee [figs.53–5], about an hour and a half to the north-west by extravagant taxi. Wight went to Gingee in 1826 and collected several plants there including the climbing passion-flower relation *Adenia wightiana*, but the rugged grandeur of this site came as a pleasant surprise. There are three hills, their slopes covered in huge granite boulders, their summits each crowned by a citadel and linked by a series of massive machiolated walls that march over the wild terrain regardless of any obstacle. The walls are intricate vertical jigsaws of hewn blocks, fit-ted with consummate precision, bearing pepper-pot sentry turrets and articulated with bastions resembling Martello towers. Rajagiri is the tallest of the hills, a 165 metre sugar loaf, with apparently unscaleable crags rising vertically from the jumbled boulder-field. When contemplating this sublime scene, and knowing of Wight's love of mountains, I could feel a bond with him over the intervening 176 years. The scenery had a surreal, richly textured quality, the man-made melting into the natural – massive fortifications, cliffs, barrel-vaulted granaries, temples, and pillared halls, with lush green shrubberies between strangely weathered Henry Moore boulders. Here was the small tree *Wrightia tinctoria* (Book 2 plate 86), with paired vanilla pods the colour of dark verdigris, the source of an indigo that Roxburgh experimented with, and of which Wight sent specimens to Calcutta. The genus was named by Robert Brown after another Edinburgh pupil of John Hope, William Wright, who found fame in Jamaica. At the centre of the site, on more or less flat land, in a meadow of the grass *Heteropogon* that rippled in the breeze like ruffled velvet (from the white hairs on the glumes of the homoga-mous spikelets), is a royal complex with step wells and an arcaded, multi-storeyed tower. One learns to arrive at Indian archaeological sites early in the day, before hordes of noisy tourists descend and spoil everything, and before the sun starts to burn. Rajagiri proved

not unscaleable once I found the hidden path that leads to the summit, skirting the base of vertical cliffs hung with lamellar honey combs blanched with age. Another small tree of these rocky habitats is *Sterculia urens* with spectral white or slightly flesh-tinted bark. As a miniature dinosaur (a huge monitor lizard) crashed through the undergrowth I recalled that this was the 'megatherium tree' of Captain Forsyth (a Victorian naturalist/hunter who wrote on the Central Highlands of India). It was in fact a reptilian paradise, with lizards of all sizes basking on the rocks and scuttling for shelter when disturbed. There was a pinkie-sized one marked like the underside of a red admiral butterfly's wing, with a thread-like tail, that moved in a series of comical runs and skips. Here also was the much larger bloodsucker (*Calotes versicolor*), with a black body and red head, but which can change its colour, and whose insectivory Wight wrote

about as an example of design in the created order. O.T. Ravindran had told me that this lizard is considered unlucky by Muslims because one had once given away Tipu when he was hiding in a well. It is hard to think that Tipu ever stooped to such concealment while alive, but could this refer to the finding of his corpse by Sir David Baird after the fall of Seringapatam?

The views from the top of Rajagiri were thrilling: to the north and west the wild landscape extended into the distant haze, looking

clockwise from left

Fig.53. Fortifications with sentry tower on Rajagiri Hill, Gingee

Fig.54. One of the granaries near the palace complex, Gingee

Fig.55. Crenellations on fortifications at the summit of Rajagiri

as though angry giants had hurled gigantic boulders on top of a forest. Eastwards, beyond the royal complex, lay luminous rice fields and tanks filled with jade green water.

In the modern town of Gingee was a fruiting Talipot palm (*Corypha umbraculifera*), one of the wonders of the vegetable world. It grows for 40 to 70 years – a rosette of massive fan-leaves on a stout and ever lengthening grey trunk. Suddenly a giant spear emerges and unfurls as a vast branched, pyramidal inflorescence. The leaves gradually turn brown and fall, their carbohydrate reserves and those from the trunk flooding into the maturing inflorescence, which Hugh Macmillan at Peradeniya in 1899 estimated contained 60 million flowers. The tiny cream flowers turn into globular fruits over the period of a year or two after which the whole structure has achieved its purpose and the spent trunk collapses in a spectacular detumescence.

FURTHER TRAVELS

After the southern trip, and some further weeks in Madras, I had to go north to a conference in Delhi on Indian environmental history organised by Richard Grove and Deepak Kumar. The plan was to return to Madras by a route that took in the most important of the remaining Wightian pilgrimage sites – Bangalore, Mysore, Ooty and Coimbatore. From Delhi I flew to Bangalore to visit the Lal Bagh garden, where Wight spent the summer of 1840, and which was later extensively developed by his friend Hugh Cleghorn. It proved to be beautifully maintained, with some interesting old trees, and an excellent library. The climate here being much drier than Madras (the Mysore Plateau is a surprising 3000 feet above sea level), the books are in much better condition, but unfortunately there were none of the hoped-for early volumes of the Madras Agri-Horticultural Society. There was, however a substantial collection of botanical paintings, including a fine set of some 750 made between 1888 and 1897 by K. Cheluviah Raju, 'son of K. Ramanjooloo Rajoo, descended from a family of Tanjore artists of the Kshatriya caste, formerly in the service of the Rajahs of Tanjore'. From their format and layout, they were clearly modelled on the plates in Wight's *Icones*, and I would later discover that they were possibly done by a relation of Rungiah's. In a beautiful old café called Koshy's, I met up with the historian Ramachandra Guha who gave me a copy of a book he had recently edited – a collection of elegant natural history essays by M. Krishnan, originally published in *The Hindu* newspaper.

Interlude in Seringapatam

The main goal of this part of the expedition was Mysore, to try to see if anything was left of the cattle breeding establishment at Seringapatam where Wight worked as a doctor and vet in 1824. I didn't really imagine there would be much to see, but at least there might be some specimens of the breed for which the establishment was famed – the Amrit Mahal, developed by Tipu as draft power for his artillery. This search was to lead to quite an adventure. I took a

Fig.56. *Nymphaea stellata*

Fig.57. The Cavery River looking east

luxury 'air-bus' – referring to the cooling system rather than the mode of locomotion – from Bangalore to Mysore, passing fields of flowering sugar cane (tattered prayer flags above a spiky green sward), and some spectacular rocky *droogs* rising from the plateau. Browsing through the Krishnan book what should leap out but an essay entitled 'Amrit Mahal' originally written in 1951. Fate was evidently on my side as this gave a rather precise description of the bullocks of the breed as 'nearly five feet high … about 800 lbs … long, tapering tails, ending in a bushy tuft of black hair, well below the hocks… iron-grey in colour, darker on the head and forequarters and almost white on the flanks… big powerful beasts, endowed with a mile-eating stride and tireless, quick muscles'. It should be easy to identify the beast from this description – in fact wasn't that one right over there? Little did I know at this stage that bovine taxonomy and identification is even more fraught than its botanical cousin.

The next day I went to Seringapatam (now Srirangapatna) on an island in the middle of the Cavery River, north of Mysore, to meet the curator of the Daria Daulat, Tipu's summer palace. This jewel-like building, lies to the east of the ruined walls of Tipu's mighty fortress. The only substantial buildings remaining within the fortress walls (his main palace was dismantled after 1799) are the Jumma Masjid mosque he built in 1787, and the Vaishnavite Ranganatha temple (of various periods back to the ninth century), which, despite being a Muslim, Tipu allowed to remain. I arrived at the summer palace early, so there was no sign of the curator and when he eventually turned up, several visits and several hours later, he couldn't really help. This did, however, provide the opportunity to study the impressive murals showing Tipu's victories, which include, among much else, depictions of what are presumably Amrit Mahal bullocks. Given the 'unhealthiness' of the situation of the Cattle establishment it seems most likely to have been on the flat land called Ganjam, between the summer palace and Sangama at the eastern end of the island.

The latter was a beautiful spot – cormorants dried their wings on rocky reefs, sacred ibis and pond herons strutted on weedy mats; circular coracles, frail baskets covered in tarred cloth, oscillated around their single paddles; two aquatic, pot-bellied Brahmins were diving to submerge urns of human ashes in the river. Ganjam was dotted with attractive Tipu-period dovecotes, and everywhere were handsome bullocks pulling carts of harvested sugar cane, which I convinced myself must be Amrit Mahals. I eventually saw a man shoeing a trussed up beast, but he disabused me of the idea, and directed the driver of my scooter rickshaw to somewhere I could see the real thing. Thus began a series of mad toings and froings across the island; but rattling over bumpy roads in a rickety three-wheeler

is not something I would recommend to others. First stop, to my astonishment, was a Hare Krishna Ashram called the Sri Nara-singha Chaitya Mutt, where a helpful swami (Mr Nandakishor) redirected us to a priest friend of his called Vijayasarthi in the Ranganatha Temple. He was found in the gloomy sanctuary, anointing pilgrims in front of the image (Anantashayana – Visnhu reclining on the coils of the serpent Ananta) of the main shrine. He pulled out a rather incongruous mobile phone to check with the ashram what it was that I really wanted, then rather impatiently got rid of some rowdy devotees so that the god could have a siesta, and shut up the shrine with much clanking of chains and bells, and the snapping of myriad padlocks. There ensued a 17 kilometre trip in another three-wheeler, over even bumpier country roads, to a place called Mahadevapura. This turned out to be an ISKCON model farm, surrounded with a rather off-putting stone fence topped with barbed wire. 'Swami-ji' was said to be out on the farm and I awaited the return of what I expected to be a venerable saffron-clad figure borne on a litter. Up swept a snazzy white Tata Sumo jeep, and out stepped a dashing young man called Jai Chaitanya Dasa, shaven headed and pony tailed, dressed in immaculate white, accompanied by an equally elegant American disciple and her young daughter. After all this it turned out that the farm had no Amrit Mahals, but the swami proved a fund of useful and accurate information. The Amrit Mahal, it emerged, has been usurped by the tractor, and is now a rare breed to be found only on certain government farms near Tarikere in the Hassan District. What I had been seeing were Hallikars, the breed from which Tipu's was derived. There was, however, an example of another rare cattle breed on the farm, in the shape of a fabulous Gir bull, reddish-brown in colour with large droopy ears. The swami did, however, know of a single accessible

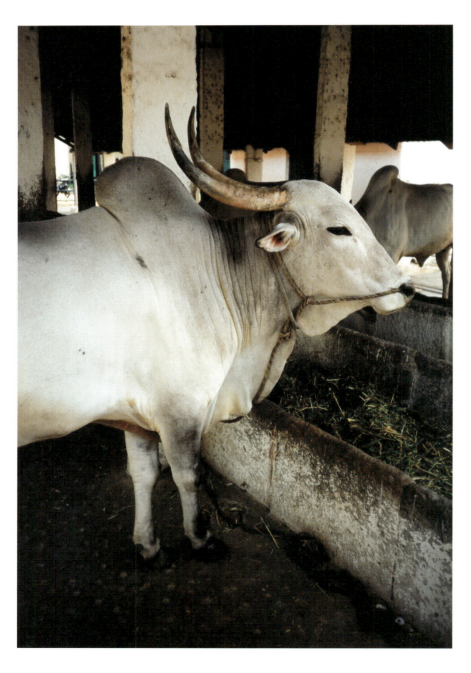

Fig.58. Amrit Mahal bullock, Dairy Institute, Bangalore

Amrit Mahal bullock, at the National Dairy Research Institute in Bangalore, and he gave me contact details for a Dr Reddy there. Hogmanay 2002 thus found me back on a bus to Bangalore.

This has been rather a long digression, but the whole hare-brained escapade was somehow typical of the frustrations and elusive goals of my Indian trip – 7½ hours on a bus, retracing my steps, to pay my respects to a bullock of the sort that Wight might, perhaps, have dissected in 1824! The Dairy Institute, founded in 1923, was interesting as an indirect descendent of Wight's cattle establishment, though its aims realigned to modern needs – the emphasis now on dairy rather than draft power, and the research molecular rather than anatomical or pathological. Dr K.P. Ramesha explained their work on rare breeds and told me that there were now only about 1200 Amrit Mahals left in the government herd. He showed me their single specimen, a handsome and stolid creature [fig.58], but which looked very little different from those I had been seeing over the previous few days – apart, perhaps, from being lower slung and more hefty about the shoulders. My conclusion was that the only way to identify an Amrit Mahal is if it is in one of the government herds, or if its owner says it is. As far as taxonomy is concerned I will in future avoid cattle and stick to sedges.

There was, however, another reason for visiting Seringapatam, as it was here that Wight first employed an artist. The artist's name, or even what he did, is not recorded but one person I met had suggested that there could, perhaps, be a link between the name Rungiah and the Ranganatha temple (though this being India, others disagreed). I asked Vijayasarthi, the temple priest, about this and he introduced me to an artist friend of his, Mr Srinivasan, who worked for the Mysore Tourist Department. Although he did fine work on religious themes, he was self taught, and here, as elsewhere, I was unable to find any living, continuing painting tradition that might have led to information about Rungiah.

Gurukula

From Mysore I took a bus to the inspirational Gurukula Botanical Sanctuary near Manantavadi, just over the border from Karnataka in northern Kerala. This is an area (including Coorg) from which the ornithologist T.C. Jerdon sent botanical specimens to Wight. As at Shembaganur, here is another NGO doing inspirational and effective conservation and educational work. It was started by Wolfgang Theuerkauf, an expat German, 30 years ago on land given to an ashram following land reforms in Kerala, when individuals' holdings were restricted in size, and much surplus land was given to charitable and religious bodies. This is partly a botanic garden, with plants grown in a semi-natural environment, but Wolfgang, Suprabha Seshan, and their team of volunteers are also undertaking habitat restoration work, with the reclamation of botanically depauperate tea plantations as adjacent ones become (at a price) available for purchase.

In the garden are many living links with Wight, and Wolfgang's interests coincide with two of his favourite groups: orchids (most of the 260 South Indian species are grown, many of which were known to Wight, but almost none were flowering in January), and *Impatiens* (about 60 species, collected from all over the south, including most of Wight's species, many more recently described ones, and about 20 that are probably undescribed). Among the most beautiful of the balsams are the stemless lithophytic and epiphytic species, generally hard to cultivate, but here running wild on mossy boulders. Following Rungiah's example Sandy, Wolfgang's 24 year old son, is making outstanding analytical line drawings of the complex flowers of the various *Impatiens* species. One of the most spectacular plants then in flower bore Wight's name – the aroid *Anaphyllum wightii*, with waxy chocolate spathes, ending in a sculptural spiral like the column of a large gastropod; it was described by Heinrich Schott from specimens collected by Wight at Courtallum. On nearby roadside banks was another reminder of Wight, the stemless palm *Arenga wightii*, with huge arching pinnate leaves, just about managing to persist, though its natural forest habitat has been largely destroyed. Environmental educational work is also extremely important at Gurukula, and thousands of school children benefit from visits every year. The team is currently working on floristic surveys of the rich and largely unspoiled Mukurti National Park in the Nilgiris and it was to this range of 'blue mountains' that I headed next.

Ootacamund

The slow bus from Manantavadi to Ooty is a milk-crate on wheels and takes 6½ hours, via Sultan's Battery (a locality familiar from Wight literature), passing coffee plantations where maroon berries were spread out on cloths to dry. From there the meandering road ascends gradually through tea estates (one was called Liddesdale) to Gudalor, where the final steep ascent of the Nilgiris begins. All the while the great mass of mist-covered hills loomed above. There was the odd patch of semi-natural forest, but many more eucalyptus plantations – one, of *E. grandis*, had a notice stating that it was planted in 1967, but its ramrod straight trunks were already a hundred feet high. The extraordinary persistence of tradition in India was demonstrated in a road sign reading 'Negapatam 427km' – its presence, and antiquated spelling, a flashback to the town's importance as a garrison in Wight's day, rather than anything to do with its present status as a minor fishing port. The bus passed through Neduvattam (Wight's Nedawuttim, and the source of many of his collections) and, as in the Palnis, some old Himalayan plant friends began to make their appearance by the roadside – *Mahonia*, *Rubus ellipticus* (Book 2 plate 40) and a single bush of the Nilgiri subspecies of *Rhododendron arboreum*, the sun streaming through its brilliant, if premature, blood red flowers. Potatoes and bright orange carrots were being harvested in the fields.

The first view of Ooty is not encouraging. A sprawling jumble of low-rise concrete boxes in ice cream shades (pink, yellow and mint), among which almost no old buildings were visible at first sight. The town occupies a wide, flat-bottomed valley, around a lake and a disused boomerang-shaped racecourse; on the horizon the surrounding ridges are fringed with savagely lopped, stag-headed eucalypts. Fortunately, on closer examination, it is found that many of the old buildings do in fact survive on the lower slopes. Sir Frederick Price's scholarly book on the history of Ooty records that Wight owned a house here from 1841 to 1847; it was then called Kelso Cottage, but was renamed Bellevue after he sold it. Here was the explanation for the unusually precise locality given for one of Wight's orchids (*Disperis neilgherrensis*): 'woody ravine behind Kelso Cottage'. The first aim was therefore to see if, by some miracle, the house had survived. After a false start at a different house of the same name, I set off up the Kotagiri Road one bright morning under a blue sky with fleecy clouds, and there it was! A picture-postcard cottage set on a terrace overlooking the town, its trellised veranda covered in tiny

Fig.59. Kelso Cottage (now Bellevue), Ootacamund

yellow pompoms of *Rosa banksiae*, and fully living up to its second name. This was the closest I had yet been to Wight, and it was thrilling to have breakfast in the very place where he and his family had lived. Mr Lingaraj was welcoming and interested in my quest – the house belonged to an aunt and uncle of his who lived in Bangalore but seldom visited. When Wight first bought the cottage it was too small to accommodate his herbarium, and it has evidently been added to on various occasions. The original front part, with the view, was T-shaped in plan, but was currently shut up. The main limb of the T contained a large drawing room with a three-angled bay, surrounded by an outer, covered passage projecting into the garden. Peering in from the outside, though the veranda and passage, into the drawing room a handsome marble fireplace could be made out, decorated with a neo-classical panel, where Wight and his family must have warmed themselves on chilly evenings. The room, however, was forlorn and empty, the fireplace partly obscured by the only furnishing, a moth-eaten leopard skin that had slipped from the wall above.

The Horticultural Gardens

The military personnel of the committee who ran the Ootacamund Horticultural Gardens had been giving W.G. McIvor, its first Super-intendent, a hard time (too much botanical nonsense and not

enough lettuce was the gist), and in July 1852, his last Indian summer, Wight was asked to write a report on the management of the garden. Wight came out strongly in support of Hooker's protégé, and I was keen to see how the garden had fared 150 years on. The answer was extremely well; it is without doubt the most attractive botanic garden in India, and lovingly maintained by the Tamil Nadu Horticulture Department. It occupies the next valley north of the one sloping down from Bellevue, and is dominated by tall and somewhat gloomy trees that must have been planted by McIvor himself. These show the wide range of sources from which plants were even then obtained – cypresses from the Himalaya (*Cupressus funebris*) and California (*C. macrocarpa*); eucalpyts and the bunya-bunya pine (*Araucaria bidwillii*) from Australia. McIvor is best remembered for his role in the establishment of the Indian quinine industry (Wight's son Robert briefly and unhappily worked on this project), and this garden was its cradle, but there were no signs of *Cinchona*, though an 1894 fern house has been named to commemorate McIvor. The garden has a fine library, in which were two of Wight's great works – the six volumes of the *Icones*, and the two of his *Spicilegium Neilgherrense*, a colour-plate book intended to stimulate botanical interests in residents of the hills. There were also many works by Ferdinand von Mueller, testifying to close early links with Australia that in the Nilgiris, as in the Palnis, have led to such

Fig.60. The Horticultural Gardens, Ootacamund

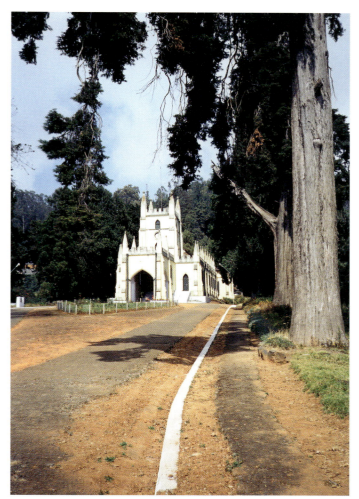

Fig.61. St Stephen's Church, Ootacamund

disastrous consequences. Disappointingly there were no copies of the ever-elusive Madras Agri-Horticultural Society *Transactions*. Dr V. Ramsundar, who was in charge of the tissue culture lab, proudly showed me the volumes of botanical illustrations made by Lady Bourne and her friends, of which he kindly later sent me a CD. Sir Alfred Bourne was a Madras civil servant of the generation after Wight, but he and his wife were also extremely able botanists and made vast collections in the Nilgiris and Palnis (now at Kew), which proved invaluable to J.S. Gamble when writing his *Flora of Madras*. Father Matthew has researched their lives and written an account of this fine collection of paintings.

At the top of the garden I made a detour to visit the Toda Village that lies just outside its boundary. From here was a fine view over to Bellevue – with its outbuildings and pantiled roofs, it looked just like a Tuscan farmstead, perched above a newly ploughed ginger-nut brown field. The Todas are one of the original indigenous peoples of the Nilgiris – pastoralists whose lives revolve around the buffalo. Only about 1600 are left, belonging to 15 clans, and I learned something about them from Tarun Chhabra, a dentist by day, but by inclination an active conservationist working both on plants and habitats, and on Toda culture. The Toda Village is no mere tourist attraction (as I had cynically suspected), but one of their most important settlements, predating upstart Ooty by millen-

nia. These people must have been Wight's closest neighbours in 1841, but curiously the village has been airbrushed out of the panoramic views of this hillside made by various military artists of his day. At its heart lies a rather Celtic circular walled enclosure surrounding a Dairy Temple, a tent-shaped wooden structure, thatched with bunches of grass tied down by ropes of plaited grass. This was an occasion when I had fortunately not let curiosity get the better of me – Tarun later told me that had I entered the enclosure, the purification ceremony required after such defilement would have taken months.

St Stephen's Church & the Nilgiri Library

Another place I hoped might preserve vestiges of Wight and his family was the church of St Stephen – a gothic structure rather similar to St Mathias, Vepery. Although this is dedicated to the first Christian martyr, it was put up in the Governorship of Stephen Lushington, Wight's great enemy, and it speaks volumes of the overweening pride of the man that he allowed such a dedication, though even he could surely not actually have suggested it himself. The graveyard slopes up into now much disturbed shola forest and is full of introduced European weeds, including two species of quaking grass – *Briza maxima*, and *B. minor*, purple viper's bugloss (*Echium plantagineum*) and the more plebeian hedge mustard (*Sisymbrium*

offcinale). The interior of the church is handsome if slightly gloomy, borne down upon by a hefty roof made of teak timbers recycled from Tipu's palace in the fort at Seringapatam. There were two outstanding Victorian stained glass windows in a style I did not recognise. These sumptuous, painterly works were not without botanical interest – the one commemorating Mrs Wentworth Watson of 1895 showed Jesus the Good Shepherd, but in the foreground was what looked uncommonly like a blue Himalayan poppy, and around the figure was a rich tapestry of interwoven passionflower and vines bearing luscious purple grapes. McIvor is known to have been something of a wheeler-dealer, and a memorial tablet to his wife showed that he also had social aspirations, having taken a Colonel's daughter for a spouse. The Pastor fetched the Baptismal Register for me, in which was the following entry:

> 157. On the 28th March (born 30th January 1842) Eliza Anne daughter of Robert and Rosa Harriette Wight of Ootacamund was baptized by me H.W. Stuart, Chaplain.

this start of a young life was not, however, to have a happy ending, for poor little Eliza died just under four years later and lies buried in Coimbatore. Gardner recorded that Wight was 'very cut up' about this loss, reminding one of Darwin and his beloved Annie. The register was full of interest and recorded the births of children of two of Wight's naturalist friends – the Missionary-Botanist the Rev Bernhard Schmid (one of the founders of the Horticultural Gardens), and the Jedburgh-born ornithologist Thomas Caverhill Jerdon, who with his wife shared a deep interest in orchids. Flora Jerdon (née Macleod) painted orchids, a volume of which survives in the Connemara Library in Madras, and sent some of them to Wight, which he published in his *Icones*. The Jerdons' marriage had taken place in this same church and was witnessed by her uncle, General Lewis Wentworth Watson – the striking window was therefore a memorial to Mrs Jerdon's aunt, who outlived her husband by 34 years.

Near the church, beyond the red-brick, raj-gothic enclave of the law courts, is the Nilgiri Library, housed in a building built in unusually restrained style by R.F. Chisholm in 1865. I paid my temporary membership of 50 rupees and entered a wonderful time-warp – a perfect jewel of a Victorian library. Thanks partly to the climate the books are in excellent condition, and, if someone would light a fire in the grate, one could imagine being holed up there for months browsing through nineteenth-century classics – Ruskin's *Stones of Venice*, Newman's *Apologia*, Lyell's *Principles of Geology*, and of course Wight's *Icones* and *Illustrations*.

Coimbatore

It was time to continue this whistle-stop tour and return to the plains of Tamil Nadu. The bus passed through Coonoor, but there was no time to stop and look at the botanic garden – Sim's Park. Soon after Coonoor begins the vertiginous descent of the southern escarpment of the Nilgiris, through thick, semi-natural forest (interplanted with jak fruit and betel palms). What was incredible was that the road followed a narrow-gauge railway track. Those Victorian engineers! In three hours we reached Coimbatore, a bustling, largely modern, industrial city, but a clean one. The following day I went to the offices of the Botanical Survey of India's Southern Circle in the campus of the large Tamil Nadu Agricultural University. I had, over the years, sent various xeroxes to its director Dr P. Daniel,

Fig.62. *top* 'Oopum' cotton in flower

Fig.63. 'Oopum' cotton in fruit

Fig.64. *opposite left* 'New Orleans' cotton

Fig.65. *opposite right* Painting, possibly by Govindoo, of 'Oopum' and New Orleans cotton from Rosa Wight's album

but never thought that I might one day visit him. Nor, from the expression of surprise that my unannounced arrival elicited, had he ever expected to meet me. The following few days, however, were a pleasure from start to finish thanks to Dr Daniel's overwhelming generosity with his time and help. The BSI building was modern, clean and efficiently run; a delight compared with the disgraceful state of the herbarium of its parent body in Calcutta. The point of visiting Coimbatore was that it was the base for Wight's work on the introduction of American Cotton between 1842 and 1853. In the herbarium I was able to see specimens of various varieties including the native, short-stapled 'oopum' that the EIC was trying to supplant. Dr Daniel took me to the Coimbatore branch of the Central Institute for Cotton Research, were Dr T.P. Rajendran and Dr K.N. Gururajan gave me a crash course in cotton taxonomy and cultivation, and, even better, were able to show me the various species growing and flowering.

I also met Mr Santhanam a distinguished man who had started his cotton research under Sir Joseph Hutchinson in 1947, and who told me more about the history of cotton in India. The information gleaned from the Institute, like much else in India, was complicated and at times self-contradictory, and it was clear that much work would be required back home on the fraught subject of cotton taxonomy. The general conclusion, however, seemed to be that the short-staple diploid species (*Gossypium arboreum* and *G. herbaceum*) have now been replaced (except in dry areas such as southern Tamil Nadu) by the long-staple tetraploids (*G. barbadense* and *G. hirsutum*), but not as a result of Wight's work, of which they were unaware. It

seemed that the successful American varieties were eventually introduced from places such as Cambodia, but not until the early twentieth century. The scientists thought that the failures of the early experiments were likely to have been due to problems in transporting the cotton bolls to Manchester. All four species were growing in a field behind the institute – all have beautiful yellow flowers, of various shades, which, like some other members of the family Malvaceae, turn wine red after their first day. The base of the petals of some species are marked with attractive, deep maroon spots. Seeing these plants I was reminded of a plate from a Victorian lady's album at Edinburgh showing two cotton plants. I now realised these were 'oopum' (once known as *G. herbaceum* var. *wightianum*, but now as *G. arboreum* var. *obtusifolium* race 'Wightianum') and *G. hirsutum*, and that the plate represents a touching testament to her husband's work painted for Rosa Harriette.

Dr Daniel and I went on a church crawl in search of old registers, but in vain. Coimbatore appeared to be in the grip of an evangelical Christian revival and there were several huge modern Anglican churches and a vast Catholic cathedral. The only old church we found was called Immanuel, built around 1830 by the London Mission Society, but this had no interesting monuments and the Pastor was unhelpful and couldn't tell us if any old registers existed. It turned out later, however, that we had missed something in Coimbatore. Mark Carine of the Natural History Museum in London, while pursuing research on Acanthaceae, found near the Coimbatore Club an old graveyard where he stumbled upon Eliza Wight's grave. There are very few traces left of old Coimbatore, but

the Forest Department occupies a fine two-storied house with a first floor Tuscan loggia, a *porte cochère*, and an intriguing addition at the back. Could this by any chance have been Wight's house, and the addition the room he built for his herbarium? There seems no way of finding out, as no plan of Coimbatore in the 1840s appears to exist. An item of ethnobotanical interest, which must have been familiar to Wight, though he recorded almost nothing on such subjects, was apparent during this visit. This coincided with the start of the four day harvest festival of Pongal, celebrating the retreat of the north-east monsoon, and bunches of *Aerva lanata* (an amaranth with silvery-white bracts) were being sold on the roadsides for use in ceremonies during the festival.

The Shevaroy Hills

Part of Dr Daniel's responsibilities included the running of India's National Orchidarium near Yercaud on the Shevaroy Hills. I was delighted when he suggested a trip there, though this involved a terrifying journey on a busy, narrow highway and the worst driving I have ever encountered in India, with buses and lorries vying to overtake each other at the most dangerous points possible. To make matters worse, squashed in the back of the jeep with me was an extremely large plastic jerry can full of petrol: images of funeral pyres came to mind. The route passed through Erode, and we crossed a very dry looking Cavery River (more rock than water), where Wight collected what he thought was a new species of *Ehretia* and described as *E. cuneata* (now *E. aquatica*). A big religious festival was at this time in progress at Palani (which, as 'Payanee', Wight visited in 1826), towards which streams of pilgrims were making their way westwards – all male, with boys as young as eight, unshod and in orange lunghis, carrying the most minimal Dick Whittington baggage. After four hours we reached the curiously named Salem, though without encountering any witches; it is now a big industrial steel manufacturing town, but Wight had cotton dealings there with its European zemindar George Frederick Fischer. Despite this we had not seen a single field of cotton from the road, which traversed only dry red soils, on which the main crop was sorghum, with a little sugar cane and tapioca. Just beyond Salem the ascent to the Shevaroy Hills begins. The Orchidarium is some way out of Yercaud town, and we stayed in a luxurious BSI guest house called 'Kurunchi' after the synchronously flowering *Strobilanthes kunthiana*. It formed part of a brand new complex, including houses for the garden staff, which was not quite finished and had cost two crores of rupees to build. That night I was excited to see a large gaur (Indian bison) ambling along the road, a creature that looks like an eighteenth-century primitive painting of a yeoman farmer's prize ox, with a glossy chocolate coat and endearing white ankle socks. The next day we visited the 18 acre Orchidarium (founded in 1963) and I was pleased to see living specimens of *Sirhookera* – a genus originally described by Wight as *Josephia*. As the latter name had been used earlier Otto Kuntze, a fanatical German nomenclaturist, gave it its curious replacement name, evidently not so hot on the conventions of British knightly nomenclature as he was on botanical. One of the ongoing projects of the garden was the propagation of endangered orchids, including Wight's *Eria pauciflora*. We made a brief excursion to the highest point of the hills (only 1500m) that lay nearby, passing some heavily disturbed forest remnants *en route*. This was semi-natural, mixed evergreen and deciduous forest, with species like *Syzygium cumini*, *Anogeissus latifolia* and *Pterocarpus marsupium*. As

might, perhaps, have pleased Wight the upper hills have largely been turned into plantations for coffee, with some pepper, oranges and jak fruit. It was now time to return to Coimbatore, which involved a wild goose-chase of a detour, as I had mentioned to Dr Daniel that I would like to see and photograph a *churka*, the mangle-like instrument used by Wight's *ryots* for removing the wool from cotton seed. In addition to trying to persuade the ryots to grow American Cotton, Wight was also trying to replace the *churka* with a much more complicated contraption called Witney's Saw-gin. Dr Daniel thought that a Ghandi ashram near the spectacular rocky outcrop at Tiruchengode might have a *churka*. We eventually found this, only to discover that it was closed on Sunday. Even had it been open a caretaker told us that they didn't have a *churka*, and the somewhat forlorn scene seemed to speak volumes about what has happened to Ghandian principles in modern India.

Departure from Madras

This was nearly the end of my Indian expedition, and it remained only to wind up in Madras, including some final depressing sessions in the Archives. Some interesting leads had been given to me by historians at the Delhi conference, one of which led me to the reports Wight wrote in 1837 about the possibility of setting up an experimental farm, and his suggestion of using it for teaching young 'Anglo-Indians', by which he meant the offspring of inter-racial unions. I also discovered that some private enterprise on the part of one of the staff, meant that xeroxing a document didn't have to take a week. There were other institutions and individuals who had been recommended to me, which just might turn up leads, but visits to the Museum, to the Medical College, and another attempt at the Cathedral registers, were all abortive. The Connemara library, however, yielded some interesting botanical books (including Wight's *Icones* and *Spicilegium*) the best of which was a volume of 138 drawings of Orchids from Ceylon, Wynad and Malabar apparently painted by Mrs Jerdon. Interestingly many of these bore Wight names (bearing the suffix 'RW'), and had probably been identified by him, though the writing did not seem to be his. Also here were the great illustrated tomes of Rheede's *Hortus Malabaricus*, possibly the very set that Governor Lushington refused to lend Wight in 1828.

Another introduction I had been given was to Dr Nanditha Krishnan who runs a foundation named after her great grandfather C.P. Ramaswami Aiyar, Diwan to the Court of Travancore. This NGO undertakes educational work with underprivileged women in order to make them economically more independent, including helping tribal women to exhibit and sell arts and crafts, and instruction in the identification and preparation of traditional herbal remedies. The headquarters is in the ancestral mansion in Madras, with a museum in another family house at Kanchipuram, and an outpost that I had noticed in Ooty. I had come across Nanditha's name as the author of an illustrated book on the treasures of the Sarasvati Mahal library in Tanjore, and as she is an art historian (with a Ph.D. on Hindu iconography) I hoped that here at last might be someone able to throw some light on Rungiah and Govindoo. She could not have been more charming, but like everyone else I met, could not really help, and as in all such conversations there followed a litany of names of others who might be able to. By this time I had met them all, with universally negative results. As with the others, Nanditha agreed that both artists' names were Telugu, and she told me that some Telugu artists still lived in some streets off Netaji Subash

Chandra Bhose Road in George Town, where they made a living by framing modern prints. I went looking for them, but could find no trace. Nonetheless it was a fascinating area of narrow streets, off which ran fantastic labyrinths, so that at times it was uncertain if one was on a street or inside a building. Though the overall sense of bustle must have been similar in Wight's time, the goods for sale (with the exception of brassware and jewellery) were all different, with suppliers of computing accessories and electrical goods predominating. I did, however, stumble on an 1820 church built by the Church Mission Society (known as 'Tucker's Church') in which was a memorial tablet to R.C. Cole. Cole was editor of the *Madras Journal of Literature and Science* in which many of Wight's articles were published, though his stream of consciousness prose must have caused Cole many a headache.

In Madras there was a nerve-wracking television appearance to be faced, an interview about my quest in a programme called 'In Conversation' devised and presented by the scintillating Anuradha Ananth. The only reason for agreeing to do this was that it provided the last remaining hope of reaching any surviving descendents of Rungiah or Govindoo. Sun News TV is one of the largest networks in the South, owned and run by the DMK party, not then in power, but one of the two Dravidian political parties that alternate in running the state of Tamil Nadu. Despite reaching an audience of many millions, and the fact that the interview was repeated five times during the course of a single Sunday, it disappointingly led to nothing in the way of information.

A Burns Supper
The search for Wight in India ended on a slightly nostalgic note, thanks to the warm hospitality I received from Eunice Crook, director of Chennai office of the British Council and her husband Phil. On the last evening of my somewhat difficult time in Madras the Crooks invited me to a memorable Burns Supper under the auspices of the Scottish Country Dancing Society of Chennai. Eunice comes

from Campbelltown, and Phil, an honorary Scot, is Chieftain of the Society; another of the events they had kindly asked me to was a St Andrew's Night Ball. These were reminders of the long and continuing tradition of the Scots in Madras, and it is likely that Wight himself attended such events. Today these are fortunately very different, being genuinely bicultural, as expats in the Society are greatly outnumbered by Indian members. The expats consist mainly of staff of the British Consulate (which has premises on the site of Dr Anderson's eighteenth-century botanic garden) and British businesses based in Chennai. The largest of the latter is Cairn Energy, a Scottish company involved in oil exploration that employs about 300 people in Chennai, of which only 25 are British. The St Andrew's Night Ball had been an imposing occasion in the ballroom of the Madras Club, the women in white dresses with tartan sashes. The Burns Supper was a more intimate *al fresco* event, on a balmy evening in a romantically lit garden. It was authentic (someone had brought a haggis from Scotland), movingly sincere, masterfully orchestrated by Phil, and truly Indo-Caledonian. The 'Rights of Woman' and the 'Henpecked Husband' addresses were delivered by Mr and Mrs Chada, and a touching 'Immortal Memory' (based on the initials of Burns's name: brotherhood, universality, religion, nature, song) given by Ken McAllister, a geophysicist with Cairn Energy. It gave one pause to reflect on why the Scots had got on so well in India. This example of the eloquence of Celtic rhetoric, and lack of self-consciousness, perhaps provided at least one answer, so different from the more formal and inhibited approach, that is perhaps a not unfair characterisation of the English, and was perhaps always a begetter of affinity with the people of India.

I had discovered many things that added to the picture of Wight's life and work during my time in India. These provided a context for his drawings and specimens, and first-hand experience of many of the places he knew. But there had been many disappointments, the biggest of which was the failure to discover anything whatsoever about Rungiah or Govindoo.

PART III
POSTSCRIPTS

Return to Britain

Wight retired to Britain in 1853, but not, as at one time he had intended, to Scotland. The lure of London – its scientific society, and the Hookers and their herbarium at Kew – played a part in this decision; doubtless his English wife also had a say in the matter. Through lack of documentation we know very little about Wight's retirement, but there were two leads to follow up, the first relating to one of the only botanical events he is known to have attended during his later years; the second to his last home and final resting place.

ALBERTOPOLIS REVISITED

Across Exhibition Road from the Natural History Museum in London is that greatest of museums of the applied arts, the 'V & A'. It was in this building (or rather its precursor, the South Kensington Museum) that, somewhat surprisingly, the International Botanical Congress of 1866 was held, and attended by an elderly Wight. The Museum was a direct spin-off from the Great Exhibition, housed in Wight's time in a building irreverently known as the 'Brompton Boilers' built by Sir William Cubitt from 1856, and which gradually evolved into the Victoria & Albert Museum. It was opened in 1857 by Queen Victoria, and in the year before the Congress she lent the Museum the seven great cartoons painted by Raphael as designs for tapestries to be hung on the lower part of the Sistine Chapel showing scenes from the lives of Saints Peter and Paul, acquired by her ancestor Charles I. These were then regarded as among the loftiest peaks of European (and therefore world) art, but are now sadly taken rather for granted, and it was in the shadow of these mighty papal commissions that Wight witnessed the inaugural address of the Congress on May 23, given by Alphonse de Candolle on the reciprocal advantages of Horticulture to Botany. This must have brought back memories of Madras Agri-Horticultural Society days, but if Wight's attention wandered it might have alighted on the cartoon of the Miraculous Draught of Fish, the most interesting from a natural historical point of view. Not only for the three gracefully dancing cranes rather naughtily counterpoised against three *deshabillés* fishermen, fetchingly draped to show the awesome musculature of their shoulders and arms. There are also the curious black dive-bomber birds in the sky (Renaissance artists never quite mastered the depiction of avian flight) commonly said to be ravens, but clearly choughs, having red beaks and legs. The decidedly marine-looking skate in the boat could certainly not have been found in the Sea of Galilee, but whether its inclusion was a deliberate sign of the miraculous nature of the event, or a natural-historical solecism on the part of Raphael is not clear, but gives food for thought to the naturalist of pedantic bent. Such an international meeting was a sign of the increasing professionalisation of botany, a world away from what the 70 year old Wight had learned in Edinburgh half a century earlier and one can only speculate on what passed through his mind as the following day he read a paper 'On

the phenomenon of vegetation in the Indian Spring'. This was delivered in another picture gallery, but from the imperial scale and lofty subject matter of Raphael, the Sheepshanks Gallery was a descent to the suburban. This gallery housed a collection of 233 paintings and 289 drawings donated to the nation in 1857 by John Sheepshanks, a cloth manufacturer from Leeds, regarded as representing the best of modern British painting. The works, in their locked and gilded frames, are domestic in scale, and sentimental in subject matter, the most heavily represented artists being the best-forgotten C.R. Leslie and William Mulready, with titles such as 'Palpitation', 'Maiden Meditation', 'A Mother Teaching her Child' and even 'Open your mouth – shut your eyes'. The Landseers are his highly anthropomorphised dogs ('There's no place like home' and 'A Jack in Office'), rather than his Scottish subjects that might have taken Wight back to his Blair Athol days, as it was in nearby Glen Tilt that Landseer first acquired a taste for the Highlands and its blood sports. Wight might, however, have been drawn to a charming David Wilkie based on Burns's song *Duncan Gray*. At this time the V & A was undergoing spectacular building works overseen by Henry Cole – the Sheepshanks Collection was displayed in a purpose built, top-lit gallery designed by Captain Francis Fowke, and it was in the year of the Botanical Congress that Edward Burne-Jones, Philip Webb and William Morris started the decoration of the refreshment rooms that became a meeting place for artists and writers, and which in 1877 would witness the anti-Semitic outpourings of Richard Wagner. Today these galleries with their spectacular ceramic decorations are at last being restored, and it is here that the Sheepshanks Collection has recently been sympathetically rehung.

READING AND GRAZELEY

Prior to his return from India in 1853 Wight had asked Hooker for help in finding a suitable home, with room for his family and collections, and within easy reach of London. The result was Grazeley Lodge, a 66 acre estate just south of Reading, which fitted the bill having 'three lines of railway' that afforded 'constant and rapid communication with the metropolis, the sea-side, & all parts of England'. It was ideal not only in terms of its accessibility, but in offering scope for small scale farming activities for which Wight apparently also had a yearning. After following Wight around India, it was time to visit Grazeley and Reading, which I did at Easter time, when the fritillaries were flowering in the Thames water meadows.

The first port of call was the excellent local history section of Reading Public Library, where traces of Wight's later years were indeed to be found. It came as a surprise to discover that Grazeley had been sold with almost indecent haste, less than three months after Wight's death, hinting that he may have overstretched himself financially. This appears to be confirmed by a copy of his will obtained from an office in High Holborn, annotated with the value of

his effects at the time of his death as 'under £2000'. His widow Rosa and spinster daughter Augusta moved to a house called Westholme at Staines, which sounds distinctly suburban, and perhaps explains a certain bitterness implicit in the said spinster's nickname, for she was known in the family as 'Aunt Disgusta'. A benefit of this sale is that a description of the house was drawn up and a beautiful, hand-coloured map of the estate made, illustrated with a now faded sepia photograph of the house. From the shadows at the edge of the lawn emerge the ghosts of crinolined ladies, doubtless Rosa and Augusta (Book I Fig. 39). Also in the Library was a copy of an advertisement for an earlier sale of the estate, in 1842, which shows that Estate Agent's hype is nothing new. The house was described as an:

> elegant and very chaste villa … placed on a Lawn of extraordinary beauty … resplendent in every thing that is recherché in the Botanical world, with full grown Timber in Limes and Chestnuts, studded about in pleasing negligence, with Plants and Shrubs without an apparent termination'. The house 'an Italian villa in the best taste imaginable … [whose] Walls seem to claim relationship with perpetuity, and as it regards convenience and internal comfort it cannot be exceeded. The principle suite of rooms are adapted to a first-rate Family … [and] if a Gentleman of fortune and character be tempted into this purchase there is no good reason why he may not count upon adding M P to his present honours.

Wonderful hyperbole, and although Wight was not tempted into politics, it was to an extent accurate as the 1872 photograph shows that Grazeley Lodge really was a rather elegant, if somewhat severe, Italianate box. The loggia 'so beautifully constructed as to be the great feature on the road' must have reminded Wight of the garden houses of Madras, but its 'relationship to perpetuity' was to prove illusory, for the house was demolished some time before 1951. It was a house with an interesting history, having been built in 1802 by Dr George Mitford.

Mitford (or Midford as he then was), like Wight, trained originally in Edinburgh, but continued his medical studies in London with the renowned John Hunter. Given that Mitford was a compulsive gambler, his life can only be described as charmed. He married Mary Russell who conveniently brought to the union a house, some land, and £28,000 in cash. This he proceeded to run through, and thereafter had to settle his wife and daughter in Lyme Regis. There he abandoned them and went to London, where his destitute family eventually joined him, and it was here, on a sight-seeing excursion with his daughter Mary, that Mitford bought a lottery ticket for her tenth birthday. Incredibly the ticket was a winning one that bore a prize of £20,000, which the doctor unwisely did not pass on to his wife or daughter for safe keeping. They moved to Reading, where in 1800 he bought the Grazeley estate, demolished its Elizabethan house, and built the Italianate villa that he named Bertram House, after an illustrious ancestor. The gambling compulsion unabated, Mitford spent his way through the second fortune, and in 1820 was compelled to sell up, and took his long-suffering family to live in a labourer's cottage in the nearby village of Three Mile Cross. Here the daughter, Mary Russell Mitford, saved the day by taking up her pen, writing articles for the Lady's Magazine that were collected in book form, to huge popular acclaim, as 'Our Village'. It was Dr Mitford's house, by now renamed Grazeley Lodge, that Wight bought in 1853.

In the library the local newspapers were consulted and the account of Wight's 'spirited address' given to the Reading Farmers' Club in 1860 found, which turned out to be only mildly radical. A visit to the Berkshire County Record Office revealed Wight's ecclesiastical activities as a churchwarden, and the Census records showing the Grazeley household in 1861 and 1871. It was with some excitement that I drove to Grazeley, even although I by now knew that the house had been demolished. It is still well placed for commuting to London, being a couple of kilometres from Junction 11 of the M4; but with its proximity to Heathrow Airport, the ease of travelling to India would have been more surprising to Wight. Although the mansion has gone, the outbuildings survive, turned into a house called Grazeley Court Farm. The land, being on the Thames floodplain, is flat, and the parkland shown on the 1872 map has all been turned to the plough. The lodge is still there, as is the drive, and it is obvious where the house once stood. On what was once the front lawn is a large Californian conifer that elicited a sudden flashback to Alexander Gibson's house, Auchenreoch. This, however, was not *Sequoiadendron giganteum*, but its relation, the coast redwood *Sequoia sempervirens*, another mid-Victorian arboreous status symbol, and visible as a young tree in the 1872 photograph (a case of *arbor longa, domus brevis est*?). I couldn't discover what had befallen the house, but no doubt it was a casualty of the immediate post-war years – possibly requisitioned and wrecked by the Army, or a casualty of punitive taxation.

Across the fields is Wight's final resting place, beside the church of Holy Trinity, of which he was churchwarden from 1857 to 1863. It was designed in 1850 by Benjamin Ferrey, Pugin's biographer, and although Ferrey's churches have been described as 'timid, orthodox and harmless', it is a perfect unaltered example of a small Tractarian church. Covered in knapped flints, with stone dressings, it consists of a chancel and unaisled nave with a bell-cote on the west gable. On entering the churchyard Wight's tomb is immediately visible, standing on its own, in the shadow of the nave, a slightly unusual arcaded chest tomb of once white marble, but discoloured and shedding the lead lettering that also commemorates his wife and three of their children. Inside the church is a stained glass window of 1899, in the same sumptuous colours and undoubtedly by the same hand as the two remarkable ones that had caught my eye in Ooty – a curious demonstration of the length of the cultural tentacles that stretched across the nineteenth-century British Empire. This one, however, was signed – by T.F. Curtis of the firm of Ward & Hughes. On the south wall of the chancel is a handsome marble memorial to Wight, his wife and eldest son (one time Post Master of Birmingham). The wording is slightly inaccurate, stating that he was for 'many years naturalist in the Honble. East India Company's Service'. Did Wight suggest the wording himself, and deliberately exaggerate the length of a particularly happy period of his life? The recollection of his birth at Milton and its antiquated abbreviation 'N.B.' for North Britain, and of the by then defunct E I C, are reminders of how much the world changed within Wight's lifetime, and also (given the harsh Indian environment he withstood for 30 years) of his surprising longevity. Below it is a brass plate to his youngest son Colonel Ernest Octavius Wight, 'Assistant Director of Medical Service 49th Division, killed by a shell on the bank of the Yser Canal near Ypres while gallantly attempting to save the lives of others'.

TO WILTSHIRE

These books were supposed to have been completed in time for an exhibition of Rungiah's and Govindoo's works that had long been scheduled into the Inverleith House programme for the summer of 2006. The work was not complete, so the exhibition had to go ahead *sans* catalogue. It was enthusiastically received by large numbers of visitors from as far afield as Japan and New Zealand by way of Madurai and Coorg, and by contemporary artists who found Rungiah's composition and control of line inspirational. Gillian Moore and her sister Annette Cosens were, of course, invited to the opening so that they could bask in the achievements of their great great great grandfather, and as a result of this they contacted a cousin of theirs, of whom I had been only vaguely aware. This resulted in an email from Rear-Admiral Nick Wilkinson of Great Bedwyn, in Wiltshire. The Wight military genes are evidently still exerting their influence, and, though retired, Nick is working on a book on the history of relations between the Military and the Media (having been secretary of the 'D Notice' Committee after leaving the Royal Navy). He came up to Edinburgh to see the exhibition and brought with him some extremely exciting photographs – including the first image I had ever seen of Rosa, and two wonderful family groups with the aged Wight looking (but for a smoking cap) like an Old Testament patriarch seated in front of Grazeley (Book 1 Fig. 40). The most exciting black and white photograph, however, was of a stupendous painting – a conversation piece in the grandest of styles in a quite extraordinarily elaborate and overblown gilded frame, showing Rosa and three of her children set in an English garden. This made sense of a comment of Wight's in a letter to Hooker, that when she returned to Madras in 1849 after a two and a half year maternity leave in England, she had to leave the children behind and in their place brought out a picture, which 'though a fine one' was no substitute for reality. I had assumed this referred to a photograph or daguerreotype, but the reality was far more interesting [fig.66].

One late July day, when the country was burning up in a heat wave, I found myself on a train to Great Bedwyn, passing unexpectedly through Reading once again, past its notorious Gaol and one of Pugin's few Norman revival churches. The countryside greened

Fig.66. The Wight family, 1849. Oil on canvas, 937.5 × 775 mm; artist unknown. N.J. Wilkinson.

noticeably westwards, with lush hedgerows, lines of Lombardy poplars, and silvery ripplings of *Salix alba* along the Kennet and Avon canal. As I alighted, in what I took to be an auspicious sign, a clouded yellow butterfly rose from a patch of the most noble of British grasses, *Glyceria maxima*. The village was a self-consciously immaculate brick one, with rows of model estate cottages and an extraordinary building bedecked with samples of the wares of the local stone mason's yard going back two centuries – everything from a Last Supper to busts of periwigged gents. Opposite this Manor Farm is a discretely handsome 1840s building set in a well ordered garden next to a low slung church covered in dark flints. It was here that I came face to face with Rosa, James, Augusta and Robert (junior) as they were in 1849.

The composition of the painting is stunning – Rosa is seated on a chaise-longue, six-year old Augusta stands on a Paisley shawl next to her offering a pelargonium and, appropriately, a rose – or perhaps she is about to plait them into her mother's hair. On Rosa's other side stands a ten-year old James armed with a bow and arrow, and tip-toeing on a footstool young Robert reaches up to a vase of flowers on a two-tiered Regency rosewood sewing stand. The flowers though semi-abstract, are beautifully painted, among which lupins, roses, sweet peas and pelargoniums are recognisable. Behind the group is a dark brown brocade drape and to the left is a view of a garden. A few stray tendrils from a vine dangle outside an open French window, and a glimpse is caught in the distance of some greenhouses, with what looks like a banana plant taken out for a summer airing. The colours of the painting are sumptuous – the pale blue satin of Rosa's embroidered dress and Augusta's white one forming a pale centre flanked by James's sombre frock coat and the rich, lace-trimmed blue of Robert's skirt, the bright spots of the flowers forming a jewelled link between the two younger children. But there are some strange and unaccountable things about the painting, whose artist has so far defied identification (W.P. Frith has been suggested, but discounted – the brushwork is too free, and the childrens' faces are much better and more characterful than Frith's generic Victorian cherubs). Some of the painting is shaky, such as the hands, and Augusta's dress – Rosa's one visible foot is too small, and her head too large (and the face bears little resemblance to a photograph of her taken only four years later). What is even more interesting is the social statement this grand painting is making about the sitters – Robert was, after all, only an East India Company Surgeon, and at this time Superintendent of the Cotton Experiments in Coimbatore – but this picture might be of a duchess and her brood. At this time Rosa was staying with her own family, so was it the Fords who had such pretensions (and her father was only another Madras surgeon)? Where is the grand garden, or is it merely imaginary or a painted backdrop? Another odd fact, given the magnificence of the painting, is the brooch pinned to the bosom that swells above Rosa's wasp waist – the family still has it, a pretty enough object of blue enamel with three seed pearl flowers, but by no means of aristocratic quality. Could it be that the painting was done in a rush just before Rosa left England and was still unfinished when she had to take it back to Coimbatore? In which case could it have been finished (including the painting of her head) by a less skilled artist in Madras? Then there is also something odd about the frame – even given the excesses of mid-Victorian taste it seems overblown and too large for the painting. Could it perhaps have been made in Madras, where one can see it fitting perfectly into one of those gilt-encrusted, mirror-walled, chandelier-dripping rooms of a Westernised *raja's* palace?

Calcutta

In Wight's day Calcutta, as seat of the Supreme Government, was the capital of British India. It was therefore also its botanical capital, and it was here that Nathaniel Wallich occupied the EIC's most senior botanical post, Superintendent of the Calcutta Botanic Garden. Wight had met Wallich when they were both on leave in Britain in 1831, and although Wight never went to Calcutta, the two botanists corresponded extensively and exchanged specimens, drawings, seeds and even living plants. I had not intended to return to India for this project, let alone visit Calcutta, until prompted to do so by an exciting email correspondence with Christopher Fraser-Jenkins, a fern expert based in Kathmandu, which began in November 2004. This came about through his discovery, while working on the botanical and pteridological history of Nepal, that at least some of Wallich's correspondence has survived in the archives of the Calcutta Botanic Garden.

THE CALCUTTA BOTANIC GARDEN

Wallich was the Garden's longest serving Superintendent, and a very distinguished one, holding the post (initially in an acting capacity, and interrupted by intervals of leave) from 1814 to 1846. After 1831 he did almost no taxonomy and his main work revolved around garden administration, lecturing at the Medical College and the pursuit of economic botany. This last included a major role in the establishment of tea cultivation to India, but what seems to have occupied most of his time was the distribution of a vast range of useful, horticultural and economic plants (both Indian natives and introductions) both within India and to gardens (private and institutional) in Britain and other parts of the expanding British Empire. When Wallich eventually retired (his wife had conveniently inherited £20,000), Wight was an obvious successor to the Calcutta post but when sounded out much earlier had declined on the grounds that he wanted to complete his work on the South Indian flora.

Despite Wallich's huge contribution, perhaps the Calcutta Garden's greatest heyday was between 1871 and 1898, during which period Sir George King was firstly Superintendent then founding director of the Botanical Survey of India. He not only turned it into a place of serious taxonomic research, but spectacularly remodelled the gardens with a geographical planting scheme based around a series of radiating lakes, and naming the Garden's paths and roads after illustrious Indian botanists [figs.67,68]. The Garden and its scientific establishment were closely modelled on Kew, and opposite the mansion built by William Roxburgh, King put up, on a vaulted basement to raise it above the damp riverine soil (and occasional inundation), a beautifully designed combined herbarium and library. Sadly this handsome building was abandoned in the 1970s and its contents moved into an ugly concrete box designed by the Public Works Department. The staff failed to measure the shel-

ving required even for the existing books and many were left behind to rot in the abandoned building. Chris had managed to obtain permission to enter this appalling book morgue where among the wreckage he found a hand-written catalogue of the library dated 1885–6, which listed no fewer than 31 manuscript volumes of Wallich's correspondence. One of the surviving volumes found by Chris in the new library was an index to the entire correspondence, listing about 231 letters from Wight, covering the period 1826 to 1848 – twice the number existing anywhere else in the world! The correspondence was truly prolific – up to five letters a month, reaching a peak in 1840 when Wight wrote Wallich no fewer than 42. On learning of this I headed for the nearest travel agent and bought a plane ticket to Calcutta.

I had last seen this once noble institution in 1994 and knew that the garden and its library were in a similar state to the institutions of Madras. But forewarned was forearmed and I promised myself not to let the conditions affect me the way Madras had done. The result of this mental resolve was that I had a wonderful time in Calcutta, helped greatly by several invaluable introductions. The first of these was to Aditi Nath Sarkar, who curated the archive of the great Bengali film maker Satayajit Ray, and was a fount of knowledge on matters relating to Calcutta and the arts of Bengal. The second was to Dr M. Sanjappa, Director of the Botanical Survey of India and authority on the legumes of India. He and his scientific staff at the Garden, notably Dr H.J. Chowdery and Dr P.V. Prasanna, are doing the best they can in difficult circumstances and could not have been friendlier or more helpful. The Director, however, faces almost insurmountable problems arising from his non-scientific staff, controlled by militant trade unions in what is still a Communist-run state (West Bengal). The unions that control the Garden staff have been described (and not unreasonably) as 'gangster-like' and seem hell-bent on cutting off their noses to spite their faces. The Garden is almost completely untended and the staff spends most of its time in noisy meetings, planning strikes and go-slows, and plastering notices about these unhelpful activities around the herbarium entrance and hallway. I was amused to note one that referred to a complaint that might be voiced anywhere in the modern academic world: 'Scientists of BSI are busy in clerical work and scientific works have been damaged', but the rider 'Director must reply' probably explained why his office is not here but in Salt Lake City. This is not quite the eponymous metropolis in Utah, but is certainly as far away from the Garden as it is possible to be in Calcutta – a mushrooming suburb, the building of which has largely destroyed the marshes on the eastern side of the city that were until recently its combined natural sewage treatment plant, giant fish farm, and vegetable nursery. The once great Calcutta Garden is now nothing but a decidedly threadbare park, with current effort being devoted to developing a brand new garden in the much harsher climate of

Fig.67 & 8. Wight Avenue, Calcutta Botanic Garden

Delhi. What happens to the herbarium, library and research programme in Calcutta remains to be seen.

The Garden, founded by Colonel Robert Kyd in 1786, is on the right bank of the Hooghly River at Sibpur, downstream from Calcutta, but now easily accessible across the Vidyasagar Setu, the elegant suspension bridge that is Calcutta's second vehicular river crossing. The herbarium and library lie at the far end of the garden, and the fact that the main route leading thence from the main gate was called Wight Avenue seemed auspicious – it forms an artificial Wallace's Line, separating as it does the areas of the garden once devoted to Malayan plants from those of Australia. The state of the garden seemed to have declined even further since my visit of eleven years previously. The old monuments, however, still survive, including John Bacon's superb neoclassical urn commemorating Colonel Kyd, with its frieze of figures, some strewing the globe with flowers, others bearing potted plants for the Garden in a Grecian boat. Two of the monuments commemorate players in the Wight story: a handsome Roman altar (with inscriptions in Latin, English and Persian) dedicated to William Griffith, and a somewhat meanly proportioned obelisk to Wallich, erected long after his death.

By this time, with regular email updates from Chris on the progress of his investigations, I knew what lay ahead, and that only six of the 31 Wallich volumes could be found in the new library, and these in frightful condition. One felt a strong sense of guilt even touching the pages, whose edges flaked as though from a bad attack of psoriasis. Interestingly the ones written on English paper were in rather better condition than those on Continental, and Wallich's correspondence was truly international, with letters in English, German, Danish and French. What came as a surprise was that what remained of the volumes' bindings were stamped 'Royal Botanic Gardens Kew'. It emerged that Wallich had bequeathed his letters to Kew in 1854, and why Kew sent them to Calcutta remains a mystery, and one that is to be profoundly regretted. For, along with that of the Hookers and Ferdinand von Mueller, this must surely be the most important correspondence relating to nineteenth-century colonial botany. The diversity of the correspondents is as fascinating as their international scope. Beyond the expected letters from professional botanists, were ones from Charles Babbage discussing his 'great machine' (the first computer), and ones making links to the past (for example from William Roxburgh's widow begging Wallich to use his influence to reclaim the botanical drawings her husband had paid for from his own pocket, but which the E I C had claimed as its own). In this same category were long gossipy ones, full of poetry from Pleasance, widow of Sir James Edward Smith. More surprising were quite incredible numbers from the upper ranks of the British aristocracy, mainly concerning the enormous quantities of plants that Wallich was sending for their stoves and gardens (of Dukes: Bedford, Devonshire and Northumberland; of Earls: Powis, Auckland, Derby, Fitzwilliam and Amherst).

Of direct relevance to my quest, and deeply frustratingly, all that could be found were a mere three letters written by Wight to Wallich. Where were all the others? There were the 25 missing volumes, but those that had survived seemed to represent complete, chronologically arranged series from numerous correspondents, among which the Wight letters were scattered, but that from the index should have contained many more, so it appears that Wallich simply did not keep most of Wight's effusions. Of the surviving letters one is of no interest, the second of only minor (concerning the exchange of some plants between Calcutta and Madras). The third, however, is more important showing that Wight's earliest experiments with American Cotton started in Madras in 1837, appreciably before his Coimbatore period. It came as something of a surprise to find that Wallich used carbon paper, and there were copies of nine of his letters to Wight, mainly about Wallich's major concern – economic plants (sugar cane and tea, and the timber trees sal and sissoo), but also, more interestingly, about the copies of the Roxburgh drawings that Wallich sent Wight for publication in the *Icones*, and which I had found in Edinburgh University Library.

Compared with Wallich's effusive and light-hearted tone in his early correspondence with Robert Graham and R.K. Greville, and later on to aristocrats such as members of the Amherst family and even the Governor General Lord Auckland, the letters to Wight are markedly reserved. It is hard to know what to make of this, and perhaps one should not read too much into it. Perhaps it is mainly because the correspondence was so prolific and frequent, and restricted to business matters, or perhaps to Wallich's tendency to increasing irascibility, rather than to any coolness between them prior to their undoubted falling out in 1845.

Despite the enormous frustration and disappointment of the missing 229 Wight letters, there was much of relevance to be gleaned from the six surviving volumes, not least the sidelights on Wight given in the letters of his contemporaries, especially Arnott, Graham and Greville. The best one, which Chris had already told me about, was a letter from Greville describing Wight's antics in Glen Fee during Graham's summer botanical expedition of 1831. These letters also show a completely different side to Greville – a highly developed sense of humour, and the passionate commitment to the anti-slavery cause of which Wight took such a jaundiced view. It was also fascinating to discover more about Graham about whom so little is known – he appears as something of an extrovert and an extraordinary story emerged of his role *in loco parentis* towards Wallich's spendthrift son George, who as a medical student in Edinburgh was only just saved from the debtor's prison, but who later made good as a pioneering marine biologist. There were also a few letters to Wallich from correspondents in South India that touched on Wight, including some from R.C. Cole, editor of the *Madras Journal of Literature and Science*, asking Wallich's opinion of Wight's work and for him to review the *Illustrations*.

There is a coda to this story as Chris Fraser-Jenkins does not give up easily and returned to Calcutta in December 2005, to try to find the missing volumes for his Nepalese work, as the index showed numerous letters from important figures such as Brian Houghton Hodgson and the Hon. Edward Gardner. This time a stack of lumber had been moved in the cramped new library and revealed some previously hidden cupboards. In these he was thrilled to find 17 of the missing volumes, which had, after all, been moved from the old library. In these was much of interest for Chris's own work, but disappointingly for me, only one further letter from Wight. This, however, was a real gem, and in great excitement he emailed a transcript to the cold bishop's house in County Mayo where I was spending Christmas with my god-daughter's family. This fascinating letter revealed the previously shadowy reason for Wight's furlough of 1831. From a letter to Hooker I had suspected that it had something to do with Governor Lushington. This confirmed it, but gave an additional medical reason, that Wight had a hernia and couldn't obtain a suitable truss in India!

THE AGRI-HORTICULTURAL SOCIETY OF INDIA

The second Calcutta botanical institution with which Wight had dealings was then called the Agricultural and Horticultural Society of India, founded in 1820 by Roxburgh's friend, the scholarly Baptist missionary, the Rev William Carey. The Society was a success from the start, with the Governor General as Patron (from 1848 to 1856 this was Lord Dalhousie, son of Wight's correspondent Christian, wife of the 9th Earl) and its Presidents were drawn from the upper echelons of Calcutta Society. From the beginning it also had strong support from the rich, land-owning, Bengali 'Babus' (Dwarkanath Tagore, Rabindranath's grandfather, was a Vice President). By Wight's day the Society had an active extension programme via satellite societies each running their own gardens. The largest of these were in Bombay and Madras, but there were smaller ones in places like Kathmandu and even Darjeeling. The fascinating proceedings and transactions of the Society were published at the time in a surprisingly large edition of 500, though it is not clear if this number included the 300 copies printed in Bengali at the Serampore Press (another of Carey's enterprises). The botanical affairs and direction of the Society were overseen to a great extent by Wallich, and at one point Griffith was a Vice President. The Society originally met in the Calcutta Town Hall, but its considerable prestige was demonstrated by the grandeur of the peristylar Grecian temple designed to house it, jointly with the Calcutta Public Library, into which it moved in 1846 [fig.69]. The building was designed by C.K. Robinson, an active member of the Society, who on its opening presented two lobby tables made from wood of teak and sissoo (*Dalbergia sissoo*) from the Botanic Garden given to him for the purpose by Griffith – no doubt a by-product of his horticultural deforestation activities. The Society left the Metcalfe Hall long ago, but the building survives and has recently been beautifully restored by the Archaeological Survey of India.

At this period the practical side of the Society's activities was undertaken in a small experimental garden within the Botanic Garden. This moved several times before taking root on its present site in the prosperous district of Alipore in 1872. This magnificent oasis is now used by wealthy local residents for rest and recreation, and has acquired a certain notoriety as a hunting ground for well-heeled kidnap victims! It was here that I was taken one sunny Friday morning by Aditi, and we could not have turned up on a better day as it turned out to be that of the winter Flower Show. The central lawn was ablaze with scarlet, white and yellow, from pots of brilliantly coloured Chinese asters, petunias, salvias, stocks and the largest mop-headed dahlias I had ever seen [fig.70]. The contrast with the Madras Society could not have been greater – either in the glories of the garden or the warmth of our reception by the president, Mrs Alka Bangur, and secretary, Deepak Erasmus – despite being up to their eyes showing an international team of judges round the exhibits. In addition to the open air displays there were marquees with exhibits of bonsai, cacti and ikebana. Clearly this was not the best time to see the library, so I arranged to return later.

The Society's office building is entered through a porch guarded by a bust of Carey by J.G. Lough that turned out to have a fascinating history. The library was in infinitely better shape than that of the Botanic Garden, but sadly the copies of the Madras Society's transactions, whose arrival were carefully documented in the minute books, were no longer extant – elusive to the last. These minute books, written in laborious copperplate, have survived, and, although most were published verbatim (with a set at Kew), it was fascinating to study the originals and to find items omitted from the printed versions. Among these was another example of Wight's hyper-sensitivity – a storm in a teacup over the unlikely topic of the identity of Egyptian Cotton. Wight joined the Society (proposed by Wallich) in 1836, doubtless as part of his shift of professional botanical interests towards the economic, and from then to the end of his time in India, he sent the Society reports on his work and samples and seeds of economic plants, starting with 500 copies of his plate

of dye lichens. Most items related, not surprisingly, to his cotton work, but he also sent seed of *Wrightia tinctoria*, the tree I had seen at Gingee.

Another interesting name emerged from the minute books – that of Sir John Peter Grant, President of the Society from 1842 until he left India in 1848. Connected with him was the story of the Carey bust, but also links back to Edinburgh and even with Dapuri. This is not the place to go fully into the details of the story of the bust, the commissioning of which was first mooted by Wallich at a meeting in 1842 chaired by Grant. What is interesting is that as part of the process the Society commissioned an Indian sculptor who worked for Dr Frederic Mouat at the Medical College to make a clay model based on a portrait of Carey in the Society's possession. The model was sent to London to help the British sculptor in carving his marble bust. Although use of the model was spurned, and J.G. Lough used another portrait as his source, Nubboo Comar Pal (who from his name belonged to the caste who still make clay images of deities for Calcutta festivals) was rewarded for his effort by the award of a Silver Isis medal by the Royal Society of Arts. Here is a case of a medic using an Indian artist to produce three-dimensional naturalistic work, as Wight did for two-dimensional artwork: this might have been a one-off, but offers a fascinating topic for future investigation.

Grant's name struck a chord because after the Dapuri book came out someone asked me if I knew that the great diarist Elizabeth Grant (Sir J.P.'s daughter) had visited Dapuri? I didn't, and it led me to re-read that remarkable work, which gives such a rich and fantastically detailed picture of Edinburgh society at the time of Wight's youth (she was born in Charlotte Square, a year after Wight). Despite the legal bent of her father's social circle Wight's father sadly makes no appearance in the journal, and perhaps Alexander Wight was too much of a wheeler-dealer for her fastidious and refined tastes. The diary tells the extraordinary tale of her father, Laird of Rothiemurchus, and his flight from bankruptcy, being spirited at night onto a ship in the middle of the English Channel, that bore him to a Judgeship in Bombay. Elizabeth thought that the position was a reward for the ptarmigan and Glenlivet that Grant supplied for royal consumption on the occasion of the King's Jaunt to Edinburgh in 1822. From Bombay the Grant family visited Sir Charles Malcolm, Admiral of the Indian Navy, who was staying at Dapuri the year after his brother Sir John, Governor of Bombay, had started the botanic garden there. There were other links in this complex web, as (quite apart from the whisky and game) it was actually through his distant kinsman Charles Grant, that J.P. Grant was able to flee his creditors and make good in India. Charles was brother of Sir Robert Grant, a later Governor of Bombay, who appointed Gibson to be Superintendent of Dapuri. Elizabeth's diary ends in Bombay and there is no reference in it to the falling out with Sir

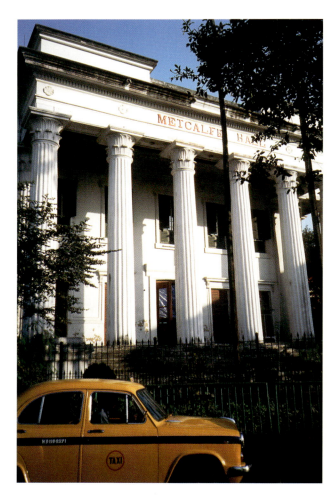

Fig.69. The Metcalfe Hall, Calcutta

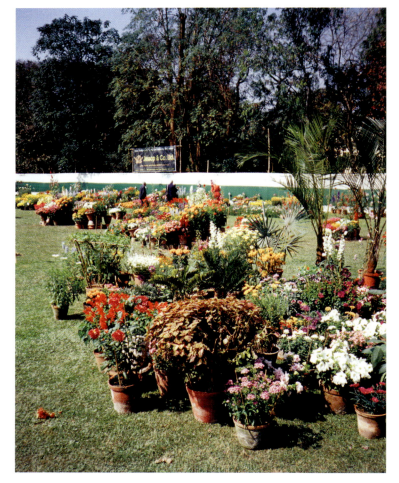

Fig.70. Winter show at the Agri-Horticultural Society's garden, Alipore, Calcutta

John Malcolm that led to her father's going to Calcutta in 1830. Here Grant practised as a barrister for three years, before once again being appointed a judge, which doubtless did much to restore his finances. Grant's presidency of the Agricultural and Horticultural Society was also a success, and the Society intended commissioning his portrait when he got back to Britain with which to adorn the Metcalfe Hall. This was not to be, as Grant died at sea on the way home.

IN SEARCH OF THE ARTISTS

The Madras trip had yielded no information about Rungiah or Govindoo, but on their drawings are many faint pencil spider trails in two South Indian scripts that remained to be investigated. One sort, consisting of the name of the species depicted, was in Tamil script (annotated 'Tam'), the word usually also being given in Roman transliteration. The other inscriptions, usually much longer, were more problematic, and Indian friends had suggested that the script was either Telugu or Kannada. These can only have been written by the artists, and therefore provided an important link with Rungiah and Govindoo, and might perhaps provide valuable information about them if only they could be read. But being little more than scribbles of what appeared to me to be rather ill-formed characters, I had suspected that they were indecipherable.

Some initial work by Mr Kotraiah, a former ASI officer in Mysore, had shown this view to be unduly pessimistic, so I took xeroxes of the annotations with me to Calcutta on the off-chance of finding someone there who was able to read them. This was not perhaps the place one would, with better planning, have chosen for such work, but Calcutta is, as it always has been, an amazing academic melting pot, and luck was on my side. It turned out that Dr Sanjappa's wife had a degree in Telugu literature, and could read and transliterate the annotations with little difficulty. Two of the BSI scientists, Dr Sampat Kumar and Dr Prasanna, also came from the south and were able to read them, though the differences between the resulting versions showed that transliteration is not an exact science. What emerged was that although the script was indeed Telugu, the language was mainly Tamil. Many, as expected, were plant names, doubtless noted down from Tamil-speaking locals as the plants were collected and painted, some of which still made sense, but most of which were archaic and obsolete; other words represented localities, and Govindoo's name also made an appearance. More interesting were instructions to printers, such as the '367 pulled off', revealing the edition size of the *Icones*, and a shopping list for the supplies for a religious ceremony (*puja*) that involved the sacrifice of a cock and a goat! Many, especially the longer ones, were unfortunately not comprehensible to Mrs Sanjappa or the botanists. As with any difficult manuscript, a great deal depends on the previous knowledge and outlook of the person reading it, so it had greatly helped to show these in the first instance to people with a botanical background. I also showed them to Mrs Nalini Presad at the British Library, primarily a Tamil scholar, but who at the briefest glance was able to read a scribble that had defeated the others –the name 'Ramaswami' on the back of three drawings. This instantly rang a bell, as Wight humorously mentioned a man of this name in a letter to Bentham, evidently some sort of factotum, who addressed Wight as 'your honor'. Perhaps it was he who delivered the drawings to the lithographer. Throughout this project one felt to be clutching at such tiny straws.

The most concrete information yet to emerge about Rungiah came about through a curious series of coincidences. In the late Mildred Archer's last book on Company School painting is an unsourced reference to the fact that Mountstuart Elphinstone Grant Duff employed a botanical painter called Rungiah Raju. Not only was the source not given, but there was a mistake over dates, those given referring to Mountstuart Elphinstone, the friend of Grant Duff's father James (historian of the Marathas). This was deeply tantalising, as there seemed little hope of establishing anything about this 'other' Rungiah. Did Archer mean Elphinstone? – in which case the reference would be to the 1820s and might refer to Wight's Rungiah; or did she mean Grant Duff, the Victorian statesman, Whig MP for the Elgin burghs, who was Governor of Madras 1881–6. If the latter, the artist surely couldn't have been Wight's man, but was the forename merely a coincidence, or was the surname an important clue linking Wight's Rungiah to the family of Tanjore artists whose work from the 1880s I had seen in Bangalore? Approaches to various people at the V & A and British Library led nowhere, but shortly afterwards in that cold house in Co. Mayo the title of a book leapt off the shelves – a volume of diaries by M.E. Grant Duff. The reason it was there was itself interesting; his granddaughter Shiela Grant Duff had been a parishioner of my friend Richard Henderson in a previous living in Co. Cork. She was a remarkable woman who had tried to build bridges between the two cultures she loved, Germany and Britain, in a brave and touching attempt to prevent the Second World War. Her other grandfather was Darwin's friend and neighbour Sir John Lubbock, and she had given Richard (who read botany with me at Oxford) one of Lubbock's books, and this single part of Grant Duff's 14 volumes of published diaries. On returning home 'abebooks.com' once again proved its worth and the two volumes relating to his time in India quickly reached me from a bookshop in, of all places, Blair Atholl! I had not the slightest hope that such a grandee would have mentioned anyone so lowly as a botanical artist, but I decided to read the two volumes from the beginning, and found them to be fascinating period pieces, showing a considerable and informed interest in Indian botany. I didn't even think of looking up the index, which would have saved me time, for on page 200 of the second volume – there it was, a reference to Rungiah Raju, and the *c.*150 paintings he made for Grant Duff. But not only this – he was explicitly stated to be related to Wight's painter. The next step was to try to trace these paintings, which Grant Duff had bound into three volumes in Madras. More emailing, one of which I sent to Niall Hobhouse, a friend of the Dinshaws, who had come to the Dapuri launch, and who deals in Company School paintings: the unlooked-for reply was as follows:

> Do know album since M.E. Grant Duff my great grandfather! Sold at Sothebys in early eighties by my cousin. Could ask if they can't be found.

Unfortunately they can't, though at least one is reproduced in the sale catalogue. They were sold in 1982 for the extraordinary sum of £42,000, and by now have probably been broken up, and the provenance of the individual drawings lost. But at last we now have a family name for Rungiah, and therefore a firmer base from which to try to discover more.

Index